IMAGES *of* GREATNESS

IMAGES *of* GREATNESS

An Intimate Look at the Presidency of Ronald Reagan

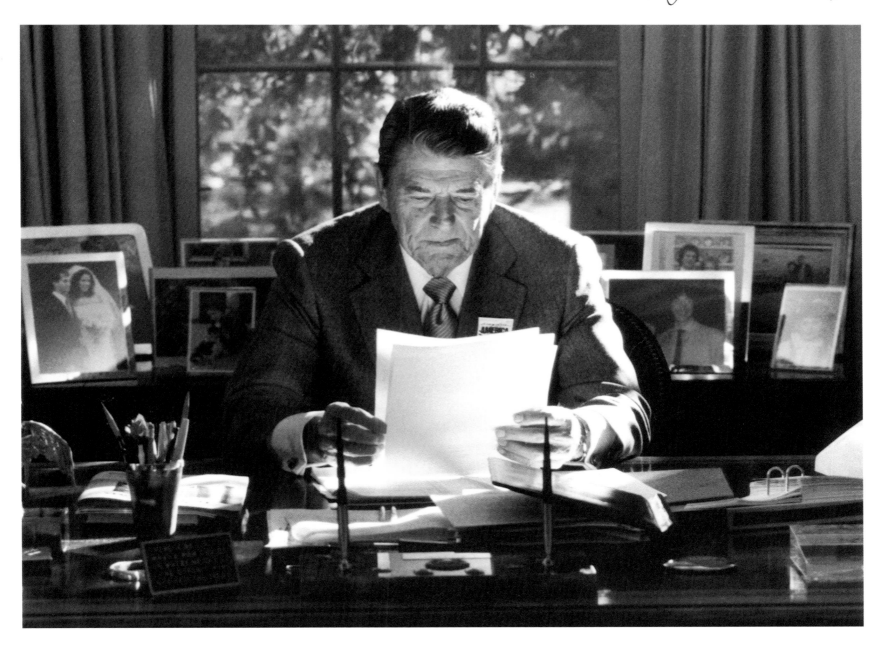

PETE SOUZA, *Former Official White House Photographer*

Foreword by HOWARD BAKER

TRIUMPH
BOOKS
CHICAGO

Library of Congress Control Number: 2004108803

This book is available in quantity at special discounts for your group or organization. For further information, contact:

Triumph Books
601 South LaSalle Street
Suite 500
Chicago, Illinois 60605
(312) 939-3330
Fax (312) 663-3557

Printed in the U.S.A.
ISBN 1-57243-701-4
Design by Eileen Wagner, Wagner/Donovan Design, Chicago, Illinois
All photographs courtesy of Peter J. Souza, former White House photographer

CONTENTS

FOREWORD

For about a year and a half, I had the honor of serving as White House chief of staff under President Ronald Reagan. I must confess that this was not the job I wanted. I wanted to be president, and if I couldn't be president, I wanted to be the White House photographer.

Making the best of the situation, I did carry my camera around rather more than most chiefs of staff were wont to do, in hopes that my proximity to momentous events would give me an enviable and extraordinary vantage point from which to indulge my lifelong passion for photography.

I soon learned, however, that my vantage point was exactly the wrong one, that I was on the wrong side of every important scene I witnessed, that what I was producing was the world's finest collection of pictures of the back of Ronald Reagan's head.

Pete Souza was on the right side of the picture, and as the photographs in this book demonstrate, he made the most of his special vantage point, recording some of the most intimate, honest, and humanizing scenes of the presidency that I've ever seen.

The White House photographer, more than almost anyone else on the president's staff, has virtually unfettered access to the Oval Office and to the president's every activity, from his travels abroad to his most sensitive meetings in the Situation Room.

The presidential photographic archives, then, are a far more thorough record of presidential activity than any other source. A good photographer—and Pete Souza is a very good photographer—has the unique opportunity not only to record history in the making, but to give it the spark of originality and insight that's almost impossible to achieve with the written word.

All the White House photographers that I've known—and I've known them all since the days of Lyndon Johnson—have been superb practitioners of their craft. A few, such as Pete Souza, have been great artists as well. This book is his gallery and a visual treasure for anyone interested in the presidency of the United States.

—Howard H. Baker Jr. is the U.S. Ambassador to Japan. He served as Ronald Reagan's chief of staff from February 1987 to July 1988. First elected in 1966, Baker was a three-term U.S. Senator from Tennessee. His tenure in the Senate included his role as Senate majority leader from 1981 to 1985. He ran for the Republican nomination for president in 1980 against, among others, Ronald Reagan.

INTRODUCTION

For five years and seven months, I was one of President Ronald Reagan's shadows.

From June 1983 to January 1989, I followed him in public and in private, often in intimate moments known only to a few. Sometimes, it was just Reagan, my camera, and me.

I was an official White House photographer, and thus, I saw him when he was far less guarded and less scripted than he was in public. In private, I also came to admire how he treated people in all walks of life.

The president was comfortable with my presence and understood the historic value of documenting behind-the-scenes moments of his life on film. As a result of his trust, I had virtually unfettered access to the Oval Office. The only time he asked me not to photograph him was when I once saw him putting in his hearing aid.

Many of the moments I witnessed were extraordinary for their historical impact: Reagan consoling families whose loved ones were killed in the U.S. Marines Beirut barracks bombing attack in 1983, agonizing over the Iran-Contra debacle in late 1986 and early 1987, grimacing while watching a rerun of the space shuttle *Challenger* explosion in January 1986, and storming out of a summit meeting with Soviet leader Mikhail Gorbachev in October of that same year.

It was at the breakup of that meeting, in Reykjavik, Iceland, that President Reagan was the angriest that I ever had seen him. Gorbachev had tried to get Reagan to stop research on the Strategic Defense Initiative, known as Star Wars. And Reagan had said no, bringing the summit to a stalemate. Reagan normally was very reserved in his emotions and facial expressions; this in itself

made him a challenge to photograph. But at that moment in Reykjavik, as he emerged from the meeting room of the Hofdi House into an adjacent foyer, anger and disappointment were etched on his face. The meeting obviously had not ended well.

I photographed the two leaders as aides helped them put on their overcoats.

Gorbachev approached Reagan one last time in the foyer, but Reagan had had enough. Gorbachev escorted the grim-faced Reagan into the cold twilight. The two stopped at the door of Reagan's limousine, and I was only a few feet away as I photographed them. KGB agents then blocked my view, but I was able to hear the leaders' final words to each other.

When I jumped into my car in the motorcade, I turned to seatmate Pat Buchanan, who was White House communications director at the time, and told him of Reagan's anger and final conversation with Gorbachev. Buchanan barked: "Write it down! Write it down!"

"I don't know what else I could have done," Gorbachev had said to Reagan.

"You could have said yes," Reagan replied angrily. And with that, he disappeared into his limousine.

Buchanan told White House Press Secretary Larry Speakes that I had heard those parting words. Along with the substance of what was said inside the meeting room, Speakes later released the last words of their conversation verbatim from my notebook to *Time* magazine.

Our motorcade returned to the U.S. ambassador's residence in Reykjavik, where Reagan had been staying overnight, and I found myself alone with the president and a Secret Service agent. Reagan

was waiting to formally thank the embassy staff for their hospitality before returning to Washington. He was still visibly distraught as he stood silently in a doorway.

"I hope I didn't let people down," he said somberly, almost in a whisper.

Reagan's personal aide came to escort him to the embassy staff, gathered in another room. Reagan was always so good at this—posing for keepsake photos—a firm handshake, a twinkle in his eye as he looked at each person, a few words of thanks, and finally a nice smile. He always made people feel special in what was likely their only chance to meet a president of the United States.

But Reagan was obviously distracted this day, which he explained to the embassy staff, apologizing for this rare difficulty in "smiling for the camera."

Other scenes during my White House tenure were extraordinary for their sheer normalcy, except that they happened to include the president of the United States. Those included feeding the squirrels on the White House colonnade, putting a golf ball aboard *Air Force One*, and tossing a paper airplane off the balcony of a hotel.

During Reagan's annual August vacation to California in 1986, I walked into his Los Angeles hotel suite with speechwriter Ken Khachigian. Reagan was seated on a sofa folding a piece of White House letterhead paper into the shape of an airplane.

"I'll be right with you, fellas," he said, glancing up at us.

Reagan finished his precise folding and walked out onto the balcony, some 30 floors up. With a flick of the wrist, he fired his paper airplane into the afternoon sky. After snapping a few pictures, I joined the president and Ken, the three of us hanging over the edge of the balcony watching the airplane finally land on the balcony of an unsuspecting guest some 25 floors below.

Months later, when I showed Reagan a copy of the photo, he said he didn't like it because it didn't look very presidential. I told him I thought it showed that there was a little bit of a kid in each of us, even in the president of the United States.

I later had a print made for him and inscribed on the white border: "Mr. President, Bombs away!" After Reagan left office, a friend of his told me Reagan had the photo framed and prominently displayed on a shelf in his home office near a signed photo from Queen Elizabeth II.

As a White House photographer, I captured a diverse array of events, including the well-known dance-floor whirl of John Travolta and Princess Diana. But I also captured many poignant moments, such as those between the president and First Lady Nancy Reagan.

The Reagans truly loved each other; it was no act. They held hands often, joked with each other, and exchanged multiple cards on special occasions. I rarely saw them argue, and if they did, it inevitably concerned something that was hurting him politically. For instance, in 1985, Reagan had agreed to visit a cemetery in Bitburg, West Germany, at the invitation of Chancellor Helmut Kohl. It was then revealed that Nazi soldiers were buried there.

A political uproar ensued, with many calling for Reagan to cancel the visit.

Members of the Jewish community were incensed. Nancy Reagan pleaded with the president not to go, to cancel the visit. But I heard him tell the first lady and others that he had accepted an invitation from another head of state, and if he couldn't keep his word to a fellow head of state, then "my word means nothing."

It was as simple as that. While those around him framed the visit as a political liability, Reagan was determined to keep a promise, political damage be damned. Even the first lady couldn't change his mind.

The Reagans' close relationship was evident even when they weren't together.

Once on a flight to Europe aboard *Air Force One*, Reagan came back to the staff area of the plane to find me. Nancy Reagan had stayed in Washington, and the president needed a favor.

"Pete, can you come up here?" he asked. "I have a picture I want you to take."

Reagan motioned me inside his cabin at the front of the plane. He explained that the first lady had pestered several aides to "make sure Ronnie gets some sleep on the plane." She knew he never slept well on trips if she wasn't with him.

"Please get a picture of this," the president asked me. He then laid down on the small bed in his compartment and feigned sleep. I snapped several frames.

After arriving in Europe, we had the film processed and faxed a copy of the picture to the White House with a handwritten note to the first lady: "The president got some sleep on the plane."

When we got back to Washington a few days later, I asked Mrs. Reagan if she had gotten the fax. She just smiled.

In Washington, Reagan would count the days before an upcoming trip to his ranch in California, Rancho del Cielo, or "Ranch in the Sky." I likened his visits there to a bird being freed from a cage. At the White House, he was trapped inside a big, protective bubble. But at the ranch, there were 688 acres where he could roam at will.

The president called the shots on what he would do for the day. Mornings usually meant horseback riding on his favorite horse, El Alamein. Afternoons usually were spent chopping wood, trimming trees, or working on a project like building a fence. When he dressed in blue jeans, a workman's shirt, and some sort of hat, one could easily mistake Reagan for one of his workers. The only giveaway would have been members of the Secret Service in the woods, not needing to conceal their Uzi machine guns.

Most of the staff stayed away from the ranch, with the exceptions being the ever-present military aide carrying the black bag containing nuclear missile codes and the White House doctor carrying his medical bag.

Reagan clearly was more relaxed at the ranch than anywhere else. Though it wasn't her favorite place, Nancy Reagan definitely recognized the good it did for her husband. Primarily, it gave him a chance to leave the protective bubble and clear his mind in the Santa Ynez Mountains.

Reagan knew that some of the networks set up television cameras miles away on a ridge overlooking the ranch, which he viewed as an invasion of privacy. He once tricked the reporters by going to an area where he knew the cameras could see him and clutching his chest with both hands as if he were having a heart attack. White House Chief of Staff Donald Regan looked as if he might have a heart attack when I later told him what his boss had done.

I will always cherish my personal moments with the president. Reagan and I usually exchanged "good morning" greetings each day. In between meetings, he often would tell his personal aide and I a joke, and if it went over well, I would hear him tell the same joke later to a larger audience. That made me realize that I'd better not laugh if I heard a lousy joke.

He often would wink at me if he spotted me photographing him in a Cabinet Room meeting that was dragging on too long.

In a lighthearted way, he mentioned a couple of times that Nancy Reagan relied on an astrologer, years before it became public. I didn't think he took it as seriously as was later reported.

Reagan enjoyed all kinds of people and often would extend a small, personal gesture that went unnoticed except to a few. One weekend in 1988, my younger sister Amy, then still in college, visited me in Washington. I brought her in to watch the president's radio address from the Oval Office. She was no fan of Reagan

politically, but I introduced her to Reagan and mentioned that she had to analyze one of his recent speeches for her rhetorical theory class. He told her he could select a speech for her.

Later that day, as Amy and I headed to the National Zoo, I was paged by the White House.

"Mr. Souza, please hold for the president," a White House operator said after I checked in.

"Pete, I hope I'm not interrupting anything," he said. "If it's not too much trouble, can you come up to the residence? I have something for your sister."

"Sure," I said to him. "I'll be there in about 10 minutes."

When we got back to the White House, I walked to the residence, logged in with the Secret Service agent, and took the elevator up to the Reagans' living quarters. The president was in his study.

"Oh, Pete," he said, handing me several sheets of typewritten paper. "Tell your sister this is the speech she should analyze for her class. I wrote this a long time ago. It was in my files. I don't really get to write my speeches these days; the fellas do."

I thanked him for helping my sister. And as I departed the residence, I glanced at the speech he had given me. It was from 1964, a speech in support of Barry Goldwater, who was the Republican nominee for president that year. The speech had launched Reagan's political career.

Reagan's last day as president, January 20, 1989, was also my last day as an official White House photographer. I photographed him as he surveyed the Oval Office one last time. Reagan wasn't one to outwardly show his emotions, but I thought he looked almost sad in the resulting picture. His "temporary custody" of the Oval Office had come to an end.

After George H. W. Bush was sworn in as president, the Reagans boarded a Marine helicopter at the U.S. Capitol en route to Andrews Air Force Base. The pilot circled the helicopter over the Capitol and then flew above Pennsylvania Avenue toward the White House. As the helicopter flew over what had been their home for the past eight years, Reagan said to his wife, "Honey, there's our little bungalow down there."

At his new "bungalow" in the Bel Air section of Los Angeles, I put my cameras aside and joined a handful of other staffers in bidding the Reagans farewell. I shook hands with the now-former president and thanked him for the opportunity to document his life for the past five and a half years. He, seemingly, was embarrassed in saying, "You're welcome."

I saw him twice after that and continued to receive handwritten notes from him in response to my occasional letters. Our correspondence ended when his Alzheimer's disease became apparent in 1993. For whatever flaws he had, Ronald Reagan was as good-hearted a man in private as he appeared to be in public. There was not a prejudicial bone in his body. I admired him because he was genuine in showing respect to all people—whether they were a head of state or a White House butler.

Looking back, I am perhaps even more grateful for my experience as White House photographer now. While my personal political philosophies didn't necessarily mesh with Reagan's, I am glad that fate and good luck put me inside his White House.

—*Pete Souza*

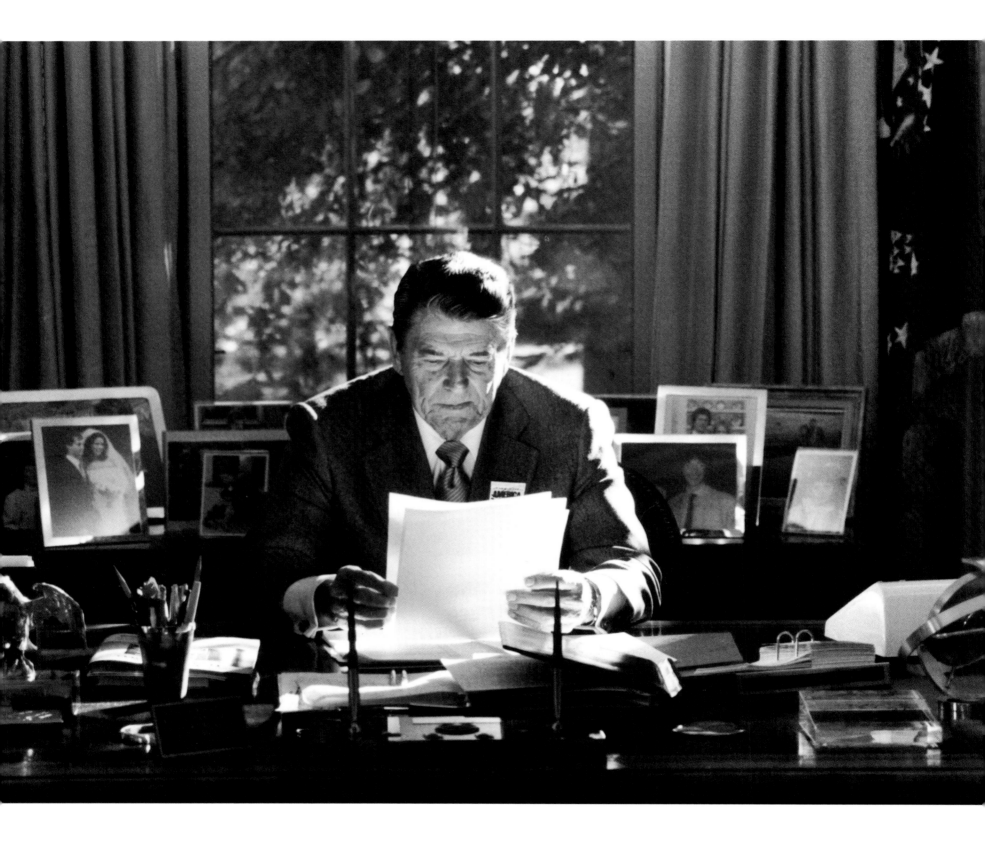

AT WORK

◄ He was a very formal guy in an old-fashioned sense. Most executives, I suspect, shed their suit coats as soon as they get to the office every morning. President Reagan never took his suit coat off in the Oval Office. I asked him about it once, and he said he thought to do so would show disrespect to the office of the presidency.

On this particular afternoon in 1988, I walked into the Oval Office a few minutes before a meeting was due to start. The light streamed in from the window behind the president; the briefing papers he was reading reflected the light back into his face. I had probably been in the Oval Office four or five times each day for five years and had never seen light quite like this before. I only had the chance to take a few pictures before the president put the papers down and began his next meeting.

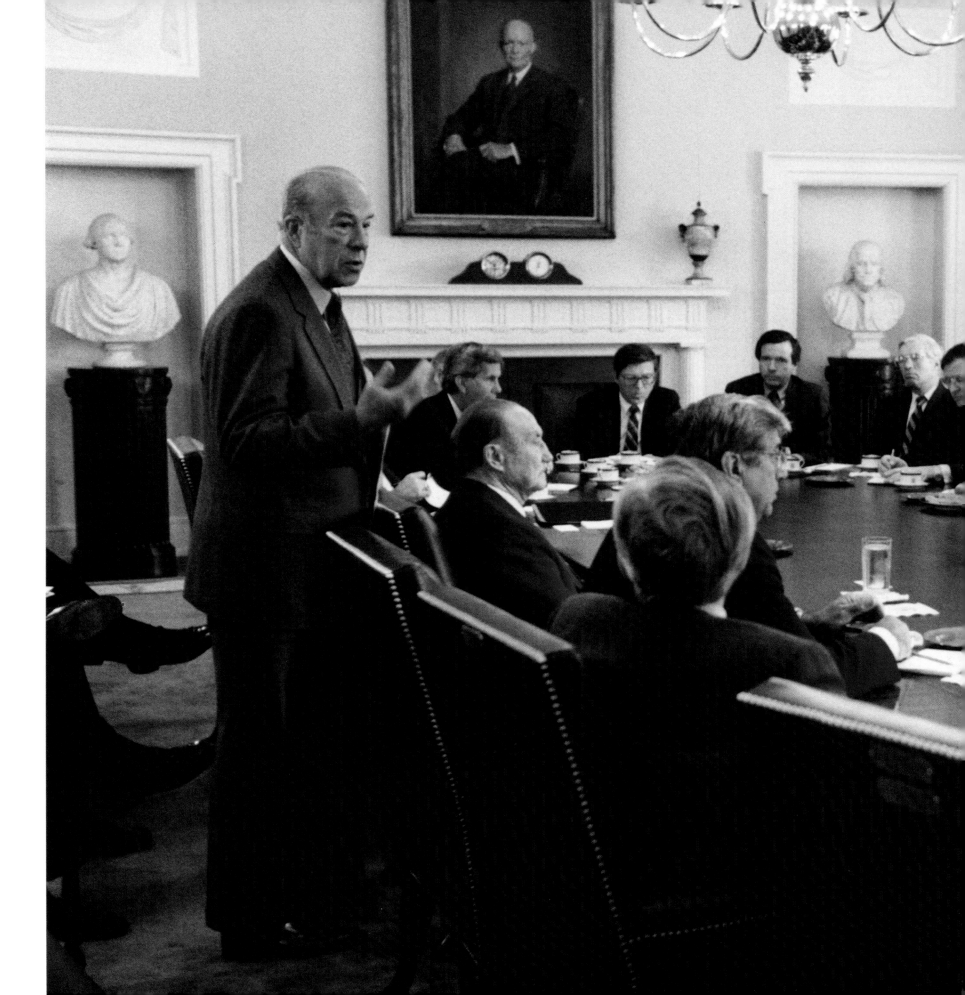

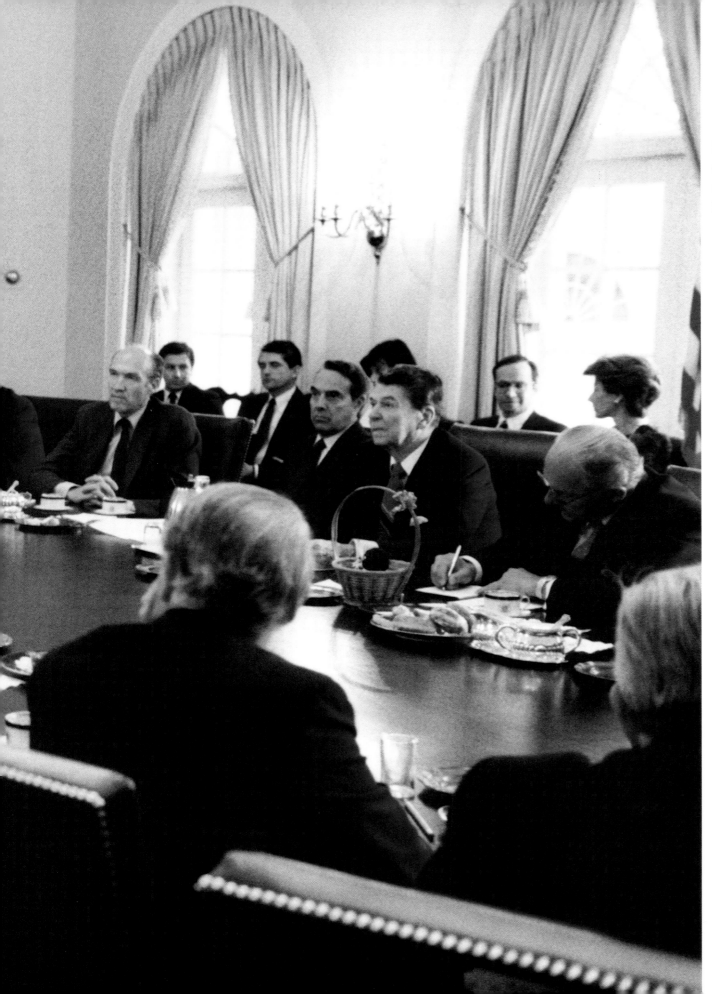

◄ Secretary of State George Shultz addresses a group of congressional leaders in the Cabinet Room of the White House.

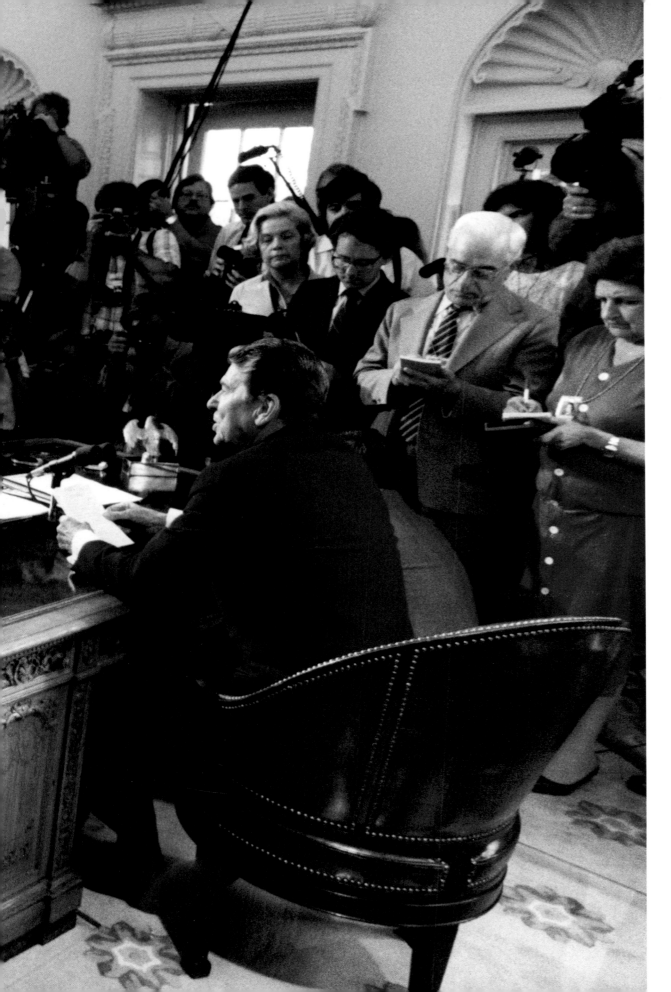

◄ The president speaks to the media during a mini press conference in the Oval Office in 1985. This was his first appearance before the press corps since having a small carcinoma removed from his nose. At the far right of the picture is legendary White House reporter Helen Thomas.

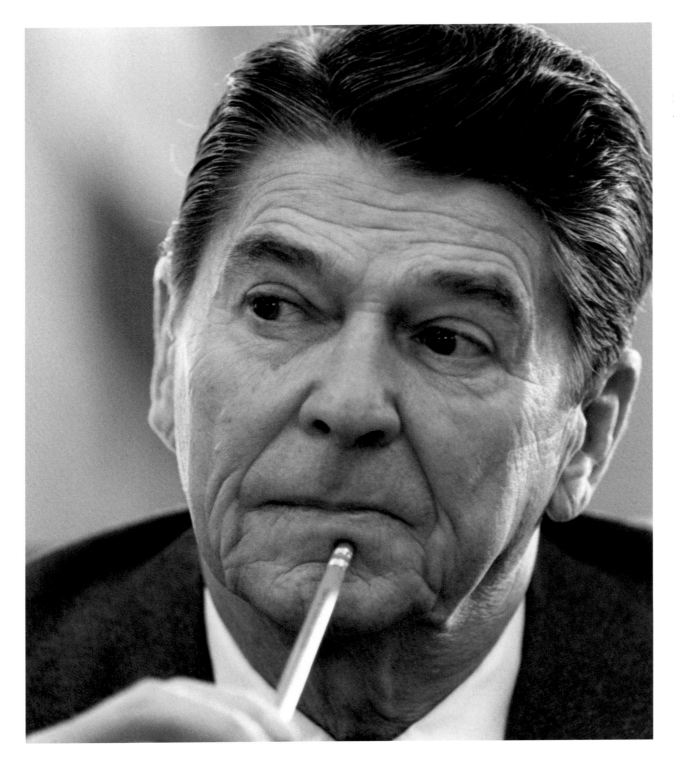

◄ The president listens intently during a meeting with his cabinet in 1983.

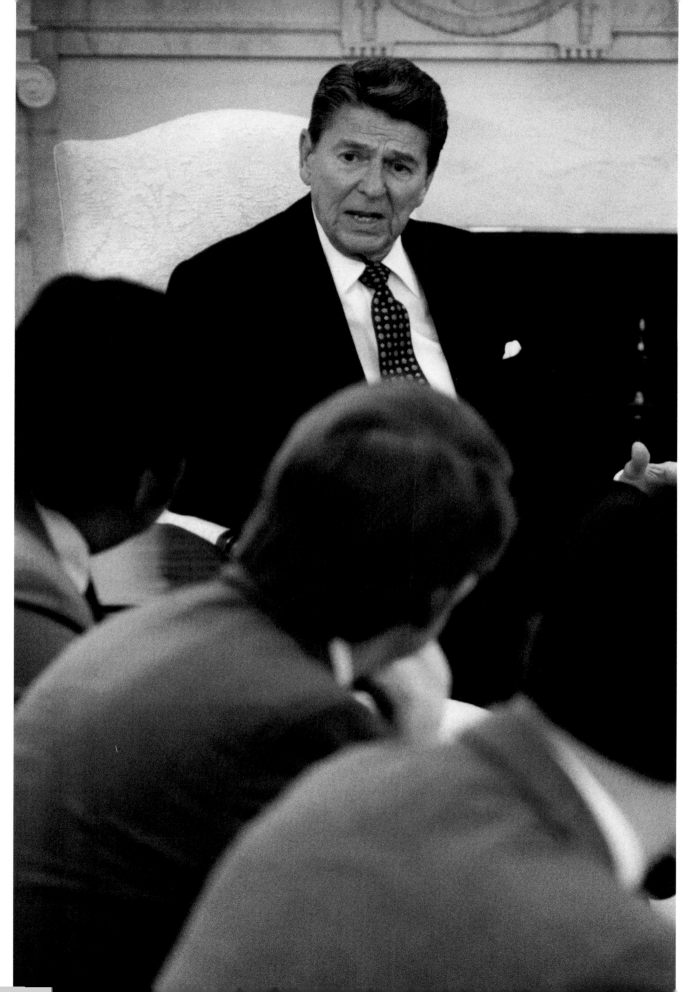

◄ The president lobbies congressmen in the Oval Office. Reagan was an affable person whom many underestimated as a politician. In this picture, he was certainly using his political muscle to try to persuade these congressmen to vote his way on a bill that was before Congress.

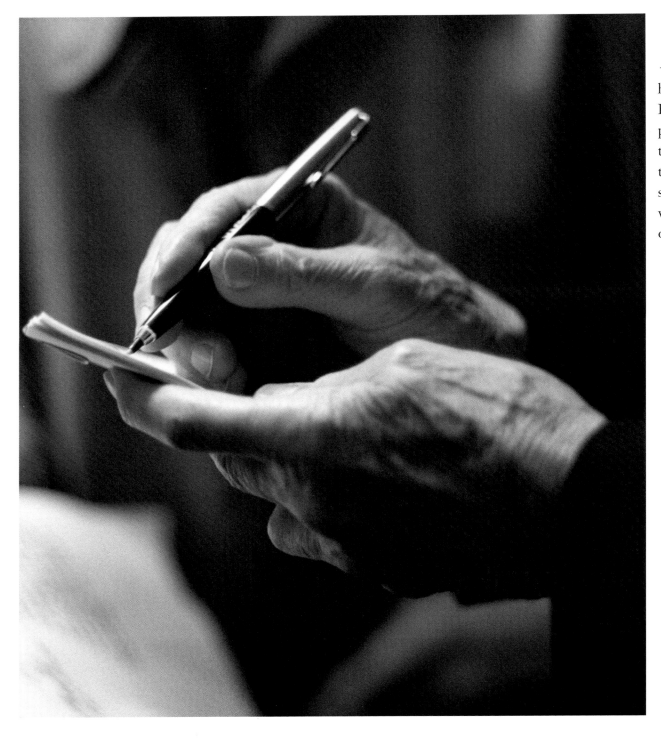

◄ A close-up of the president's hands as he copies some notes. He probably will be the last president to handwrite everything: letters, notes, speeches, thank-you cards, etcetera. His secretary might later type up what he wrote, but all of his originals were handwritten.

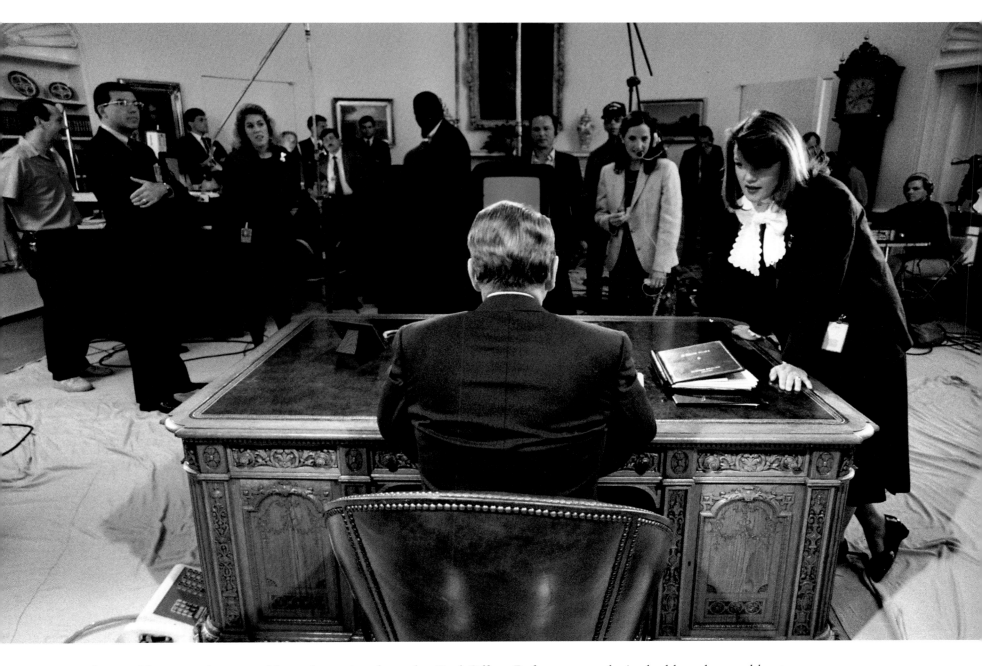

▲ The president was about to address the nation from the Oval Office. Before every televised address he would get kicked out of his own office for a few hours so it could be converted into a virtual television studio. He once complained to me that he wished there were two Oval Offices—one to work in and one to use for these types of events.

Sometimes before an address to the nation he would come in and sit at his desk earlier than was necessary. There would be so much commotion going on—people yelling into phones, technicians making last-minute adjustments. I was always amazed that he could totally concentrate on whatever he was reading, no matter what was going on in front of him. Although it's hidden in this picture, the president always kept a glass of hot water on his desk that he sipped to soothe his vocal chords before going on air.

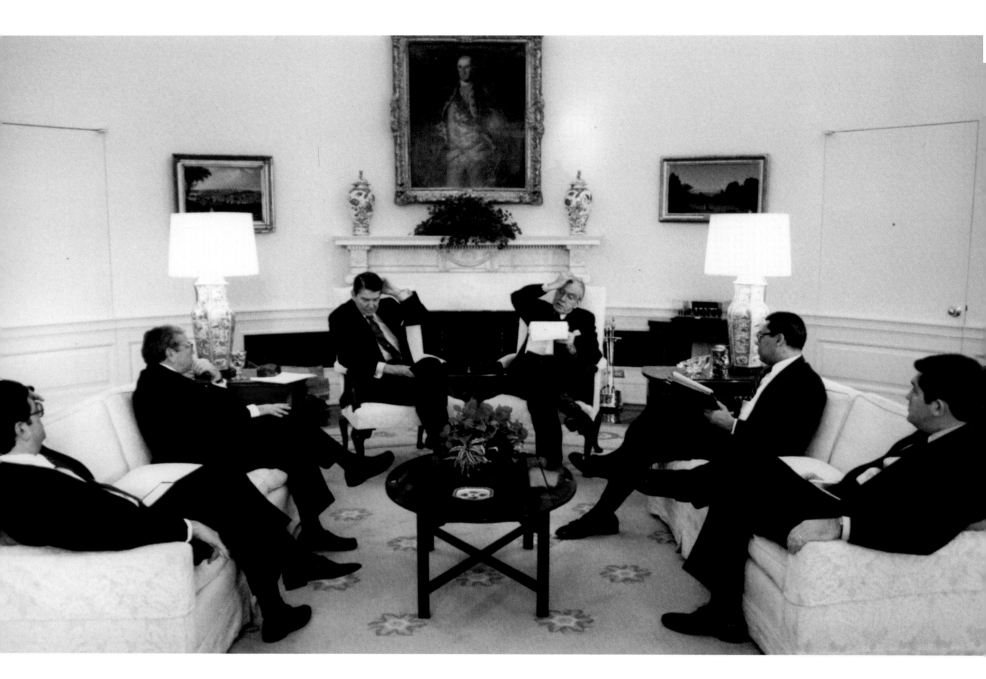

▲ The president listens to Democratic Speaker of the House Jim Wright, who was often at odds with the president about his policies. Reagan always sat in the chair at left, while Vice President George Bush, if in attendance, sat in the chair at right. If Vice President Bush wasn't there, then the guest of honor would sit in his chair, as Wright is doing here. On the left sofa are Deputy Chief of Staff Ken Duberstein, left, and Chief of Staff Howard Baker. On the right sofa are legislative aide Will Ball, right, and National Security Advisor Colin Powell.

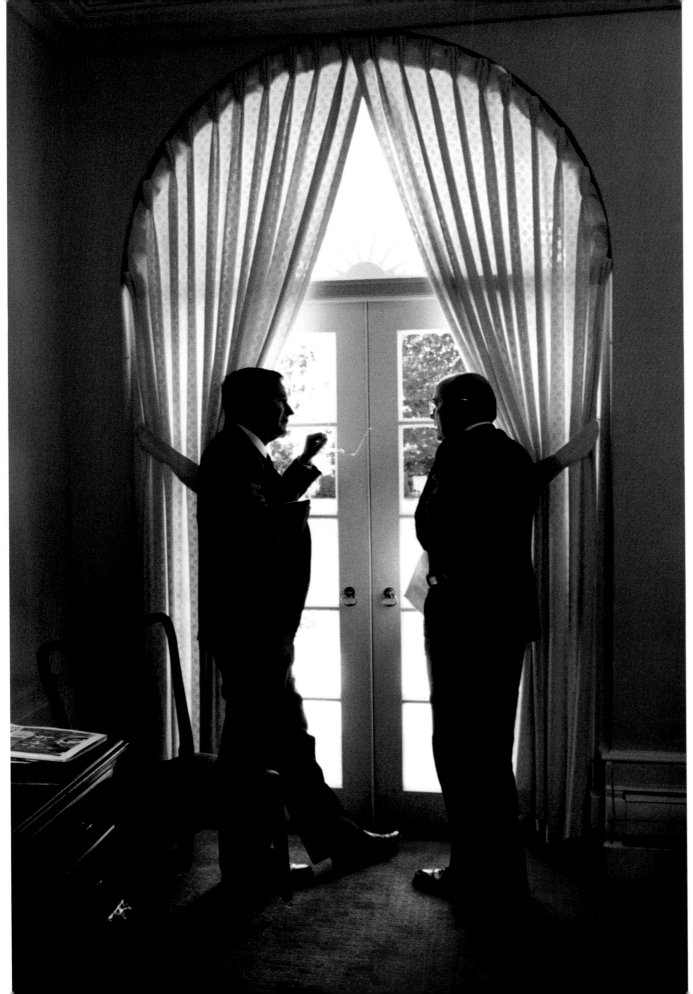

◄ Just outside the Oval Office, Vice President Bush talks with National Security Advisor John Poindexter before a meeting.

◄ After a 1984 meeting in the Cabinet Room, the president talks with a congressional group that had observed the recent election in El Salvador.

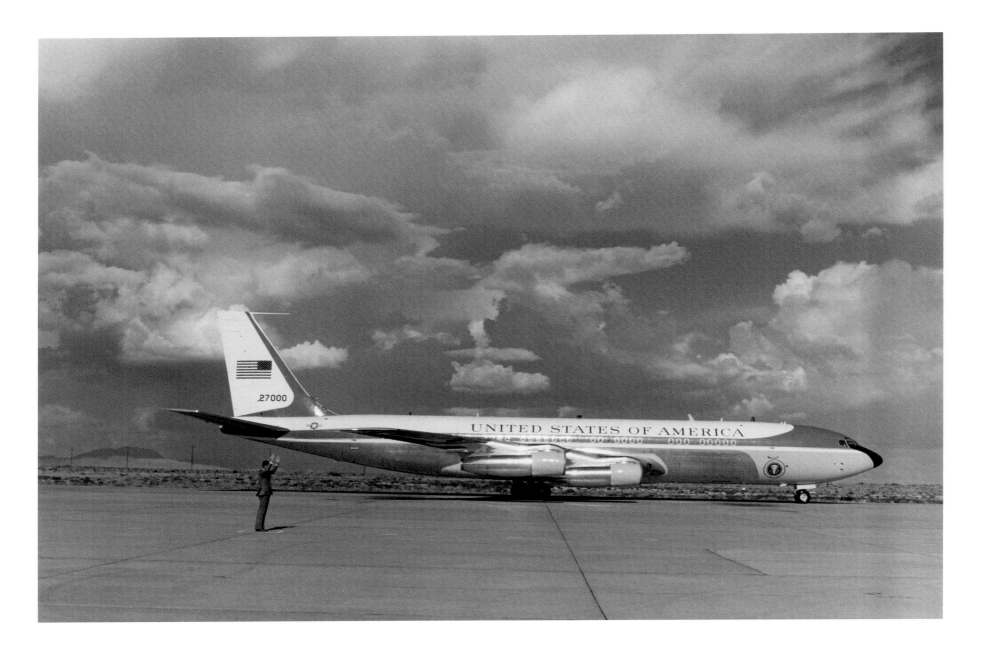

AIR FORCE ONE

◄ This is *Air Force One*, a modified Boeing 707 that flew President Reagan to all 50 states and many parts of the world during his presidency. (Officially, any plane on which the president of the United States is a passenger is called *Air Force One*.) This plane, which Reagan used 98 percent of the time, has since been replaced. Today, the president of the United States flies in a modified Boeing 747.

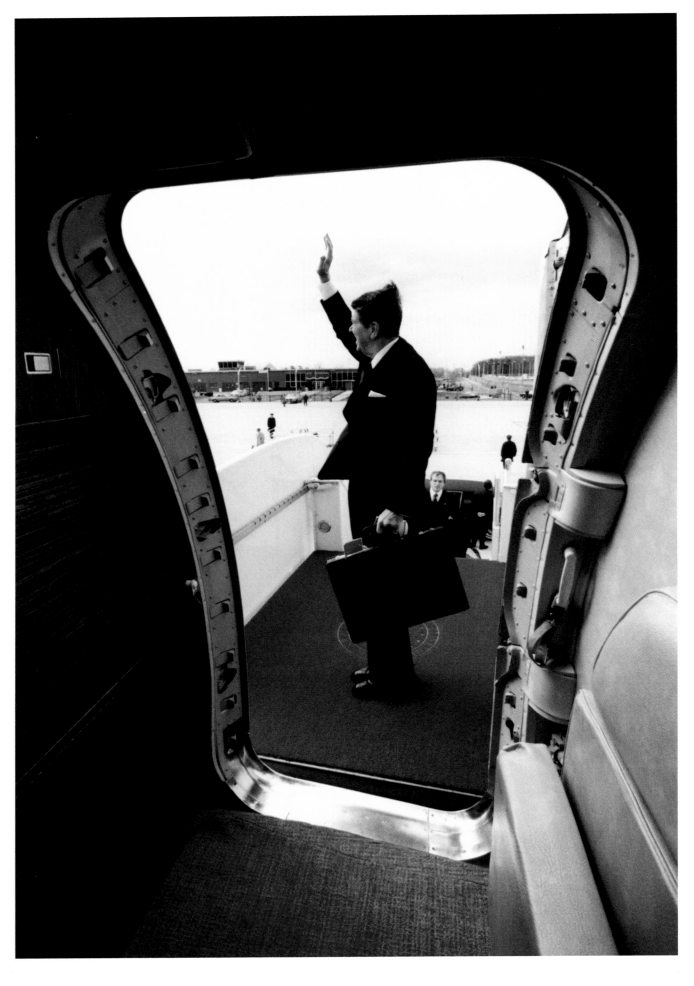

◄ The president boards *Air Force One* for a day trip to Iowa in 1984. It was a particularly windy day, as you can tell from the back of his hair.

One time at the White House the president had a similar cowlick. Usually his personal assistant would inform him of such things. But on this day, his personal assistant was out of the office at an appointment. Kathy Osborne, the president's personal secretary, told me about the cowlick when I arrived outside the Oval Office to cover the president's next event. She said she felt too embarrassed to tell him . . . which left it to me to inform the president that he needed to go into the bathroom to comb down the hair sticking up on the back of his head.

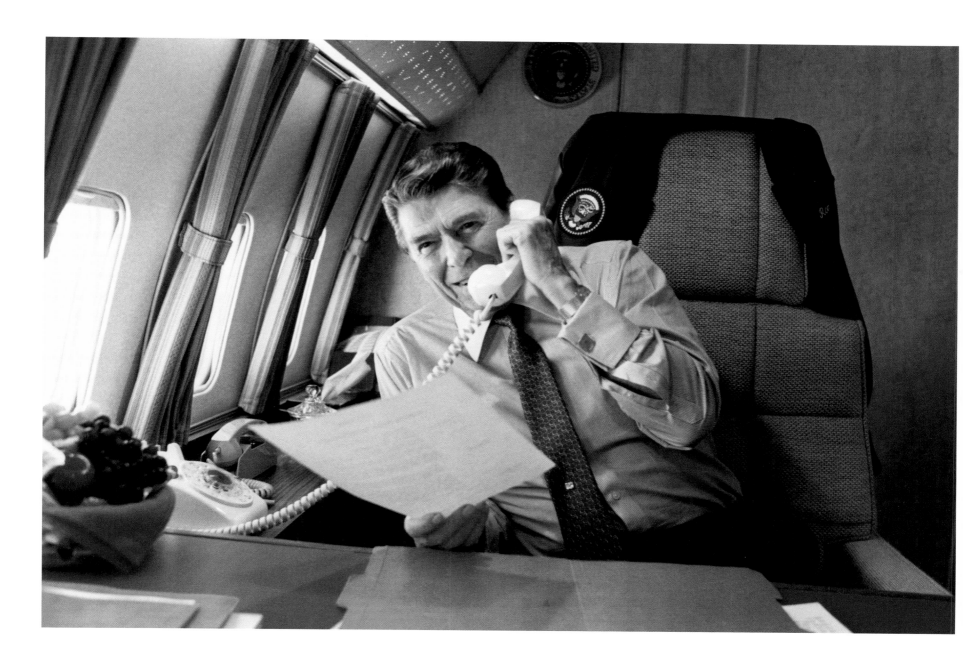

▲ The president makes a phone call from his private cabin aboard the plane.

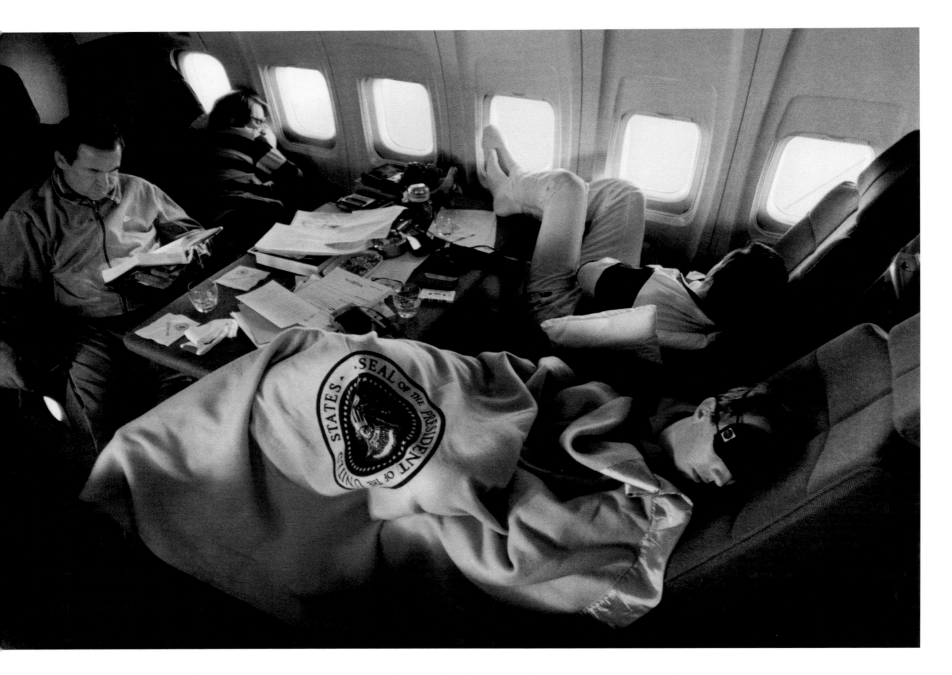

▲ We were aboard *Air Force One* returning home from a Far East trip. Almost everyone was asleep. I was talking quietly with fellow insomniac Jim Kuhn when the president, also unable to sleep, joined us from his private cabin. "You should get a picture of this," he said about the sleeping staff. Clockwise from left are Communications Director Pat Buchanan, Press Secretary Larry Speakes, Director of the White House Advance Office Bill Henkel, and Dennis Thomas, an assistant to Chief of Staff Don Regan.

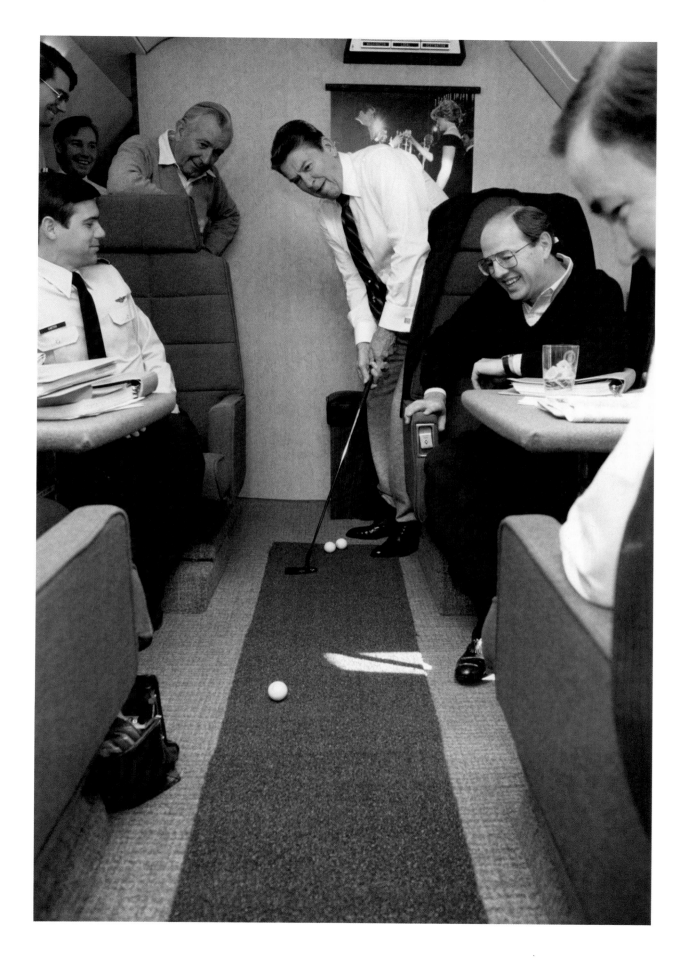

◄ The president tries out a putting green that someone brought aboard *Air Force One*. At left are one of his military aides, Tom Carter, seated, and Chief of Staff Don Regan. At right are Regan aide Dennis Thomas and Communications Director Pat Buchanan, foreground. On the wall is my picture of the president toasting Princess Diana.

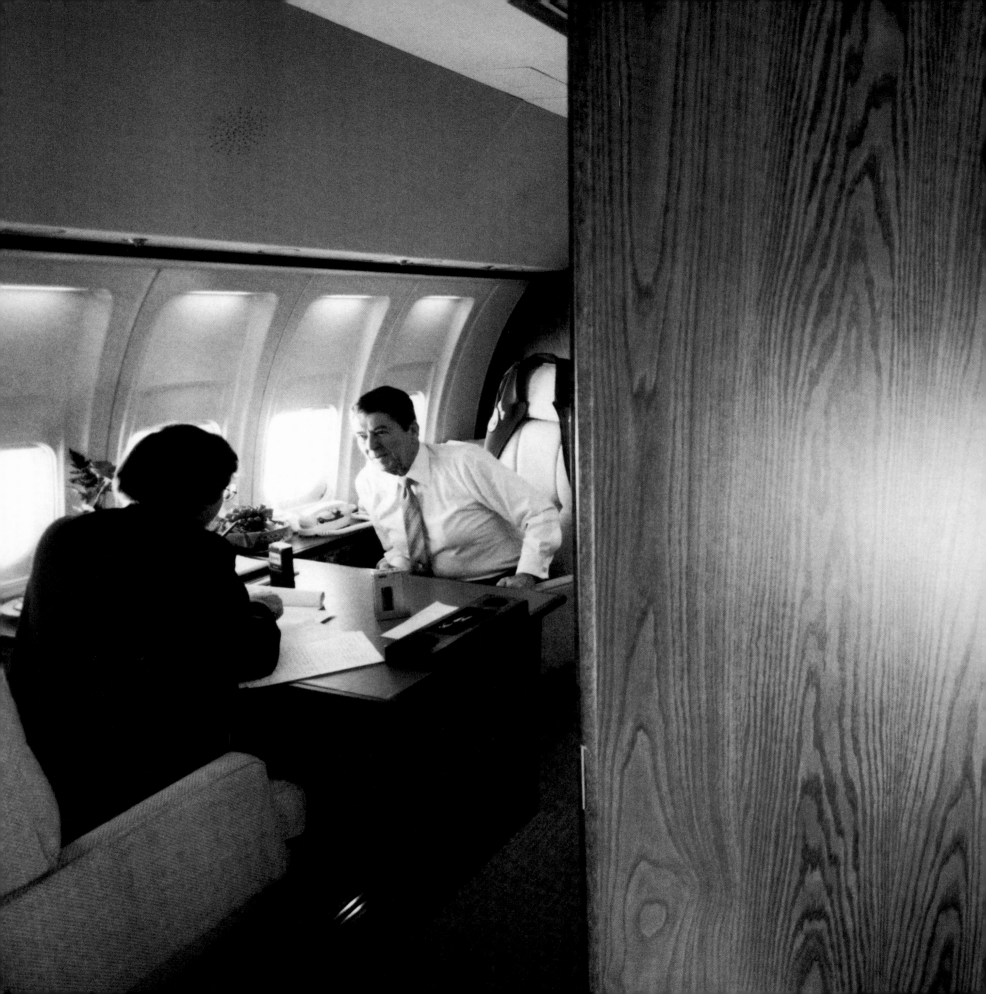

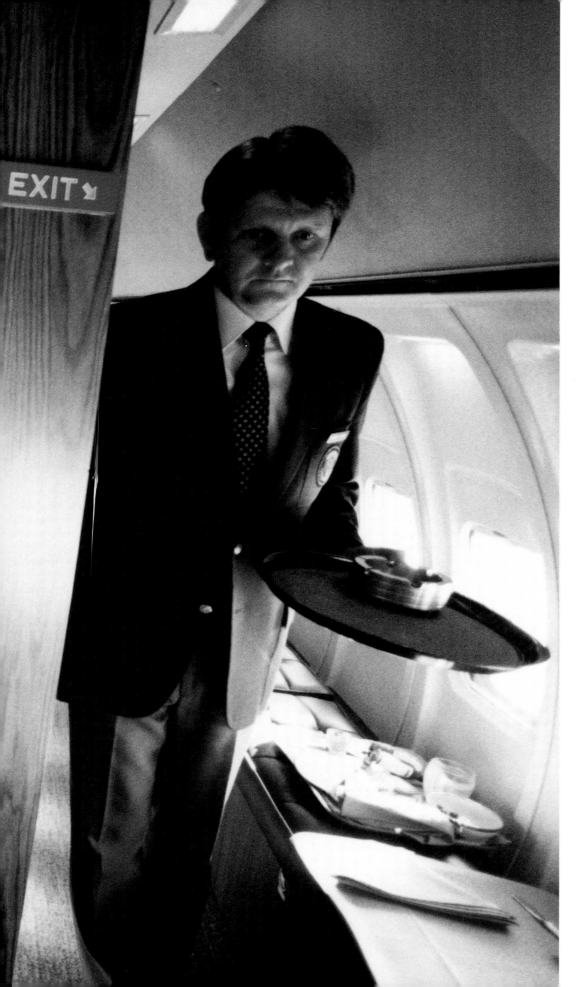

◂ The president responds during an interview with the door open as an *Air Force One* steward passes by on the right.

GORBACHEV

◄ The president waits for the arrival of Mikhail Gorbachev in November 1985. It was to be their very first meeting. (When asked why he hadn't met with his Soviet counterpart before this, Reagan joked, "They keep dying on me." In fact, Soviet leaders Brezhnev, Andropov, and Chernenko all had died while Reagan was in office.)

Inside the Villa Fleur d'Eau in Geneva, Switzerland, Reagan appeared anxious, but he was also excited and quite confident—he had been preparing for this meeting all his life. In this picture, he's still wearing his overcoat. He and his aides were trying to decide whether he should keep it on when he walked outside the villa to greet Gorbachev. His personal aide, Jim Kuhn, argued that Reagan would look silly if he walked outside wearing a coat only to find that Gorbachev wasn't.

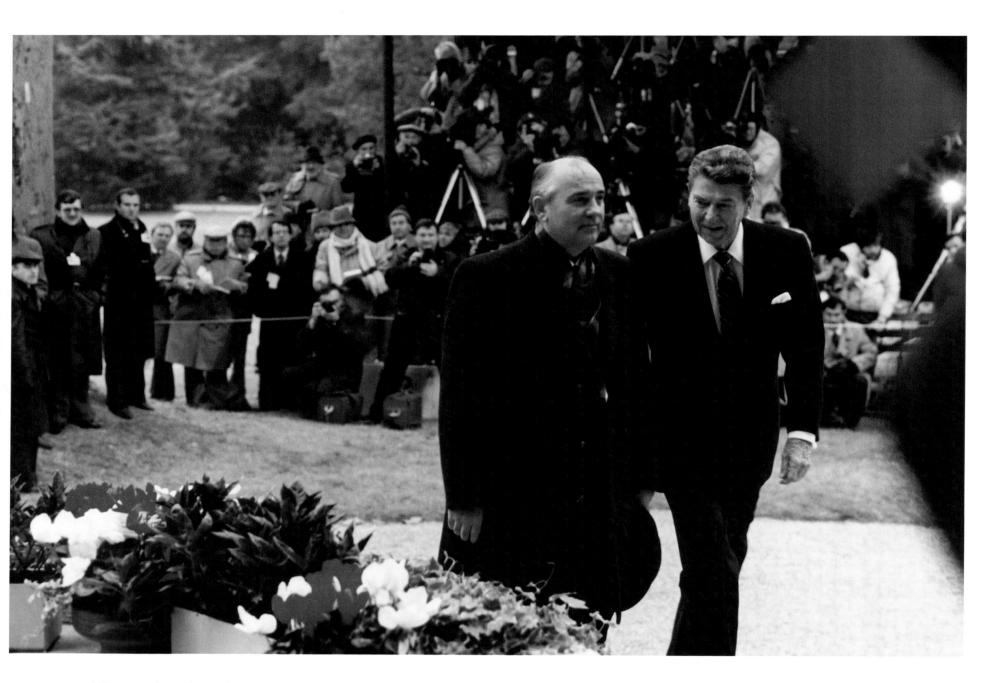

▲ The president decided to go coatless in the brisk, November cold and welcomed Gorbachev, who stepped out of his Zil limousine wearing an overcoat, scarf, and hat.

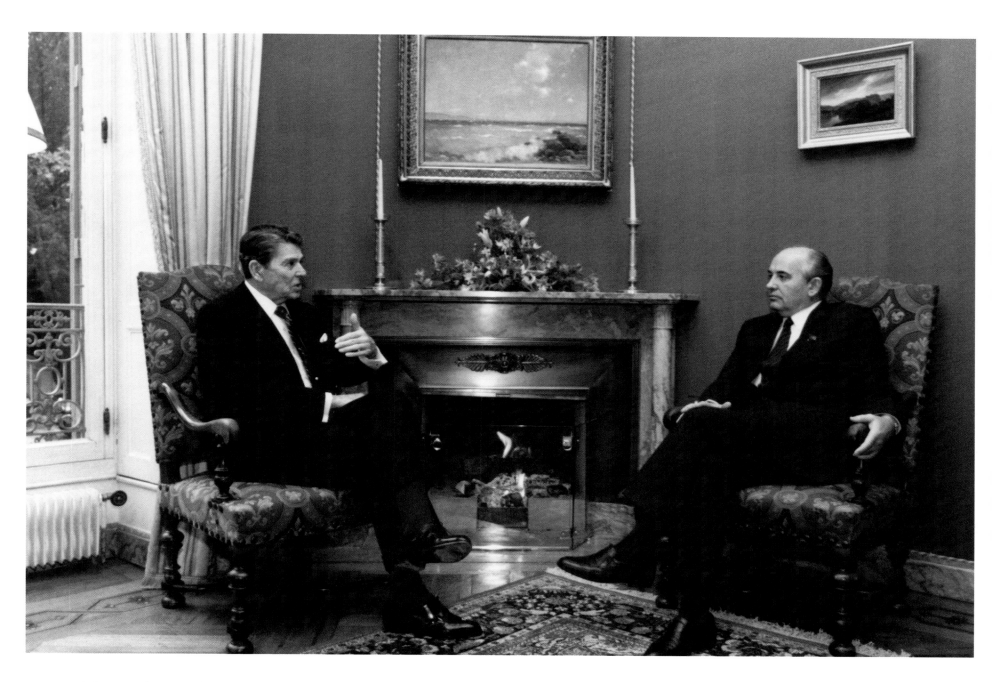

▲ The two then sat down for an extended one-on-one session with only the translators present.

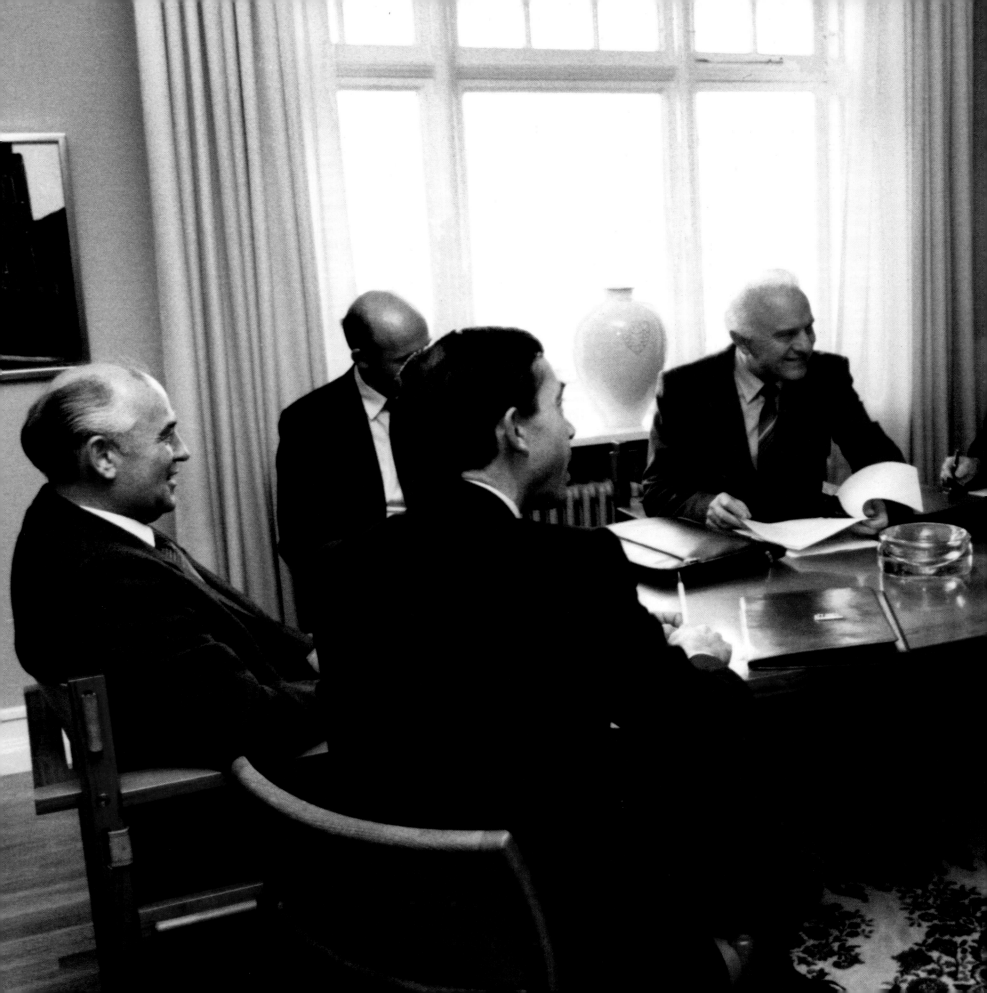

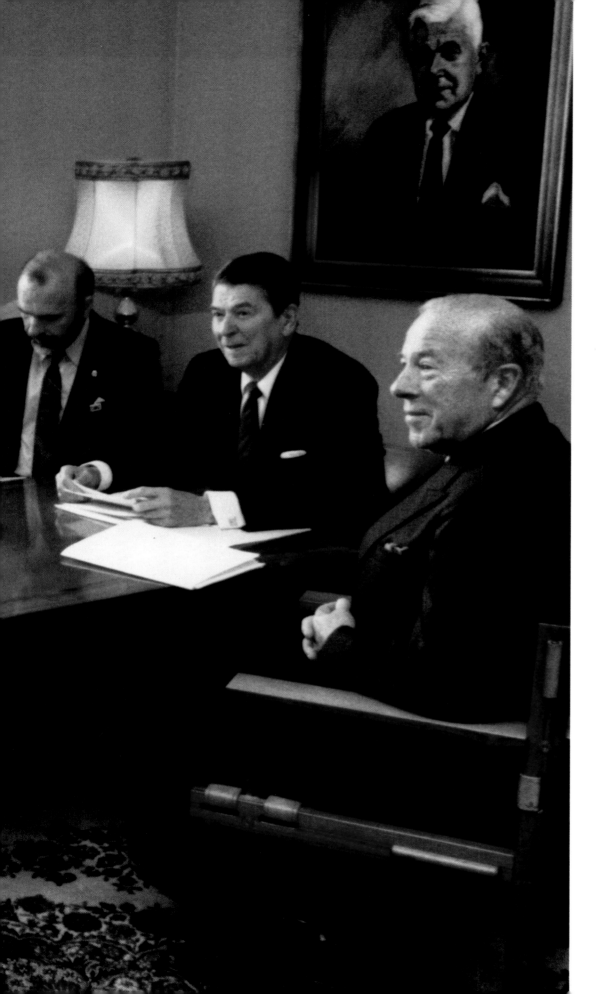

◄ Reagan and Gorbachev are all smiles at the start of the second summit meeting in Reykjavik, Iceland, in October 1986.

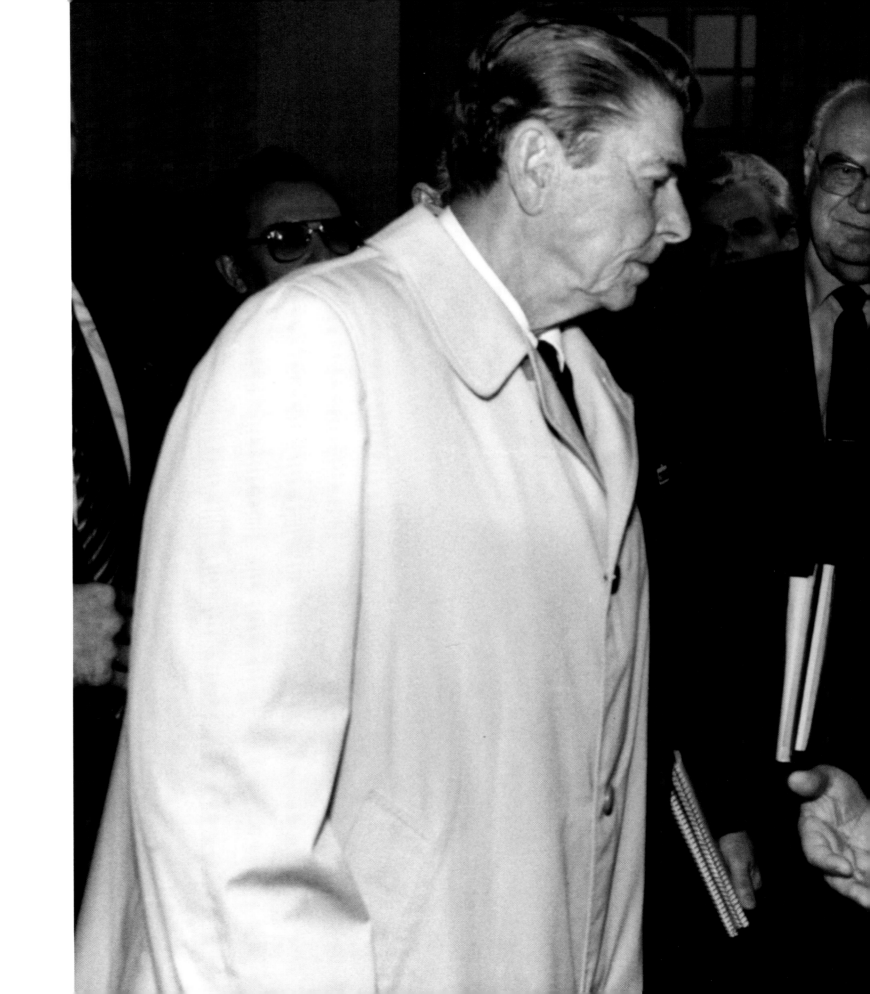

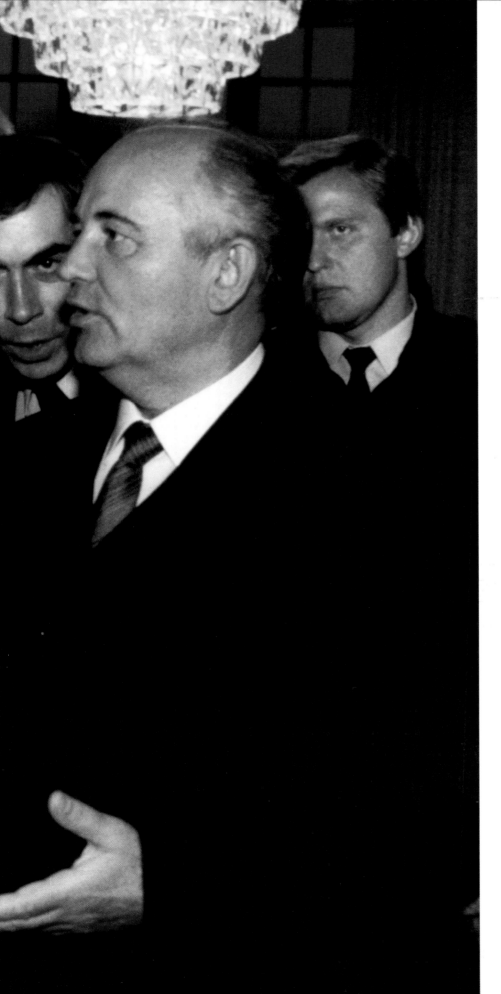

◄ The smiles disappeared after Reagan walked out on Gorbachev after the Reykjavik, Iceland, summit ended in a stalemate. Essentially, Gorbachev wanted Reagan to give up research on the Strategic Defense Initiative in exchange for nuclear arms reductions. Reagan said no way and told Gorbachev their meetings were over. You could feel the tension as the two leaders put on their overcoats in the foyer outside the meeting room.

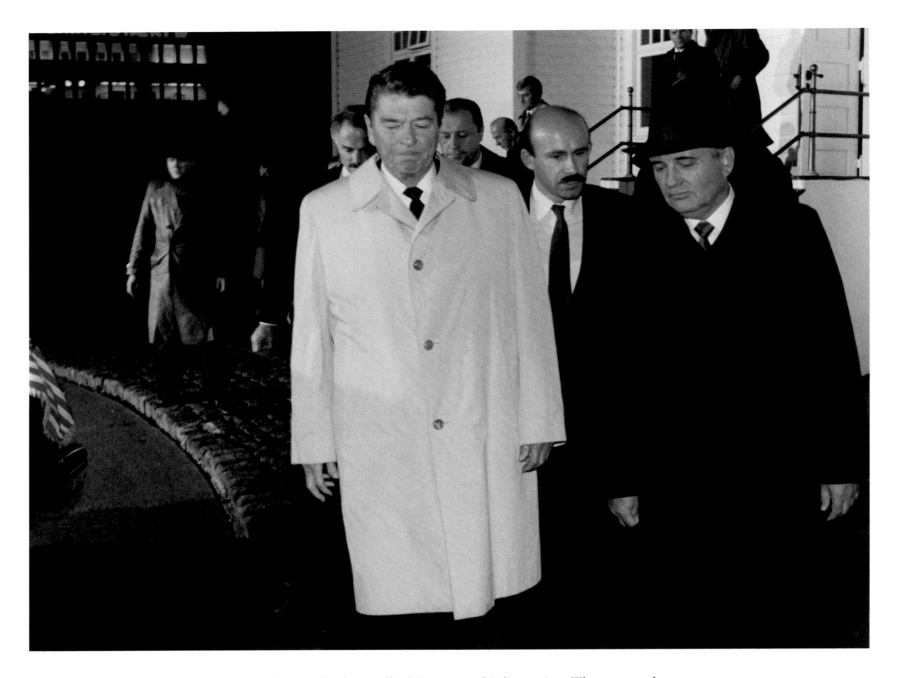

▲ Outside, their conversation continued as Gorbachev walked Reagan to his limousine. They stopped at the limo, and the two leaders had one final exchange. Gorbachev's bodyguard soon blocked my view, but I was able to listen in.

"I don't know what else I could have done," Gorbachev said through his interpreter.

"You could have said yes," Reagan replied curtly.

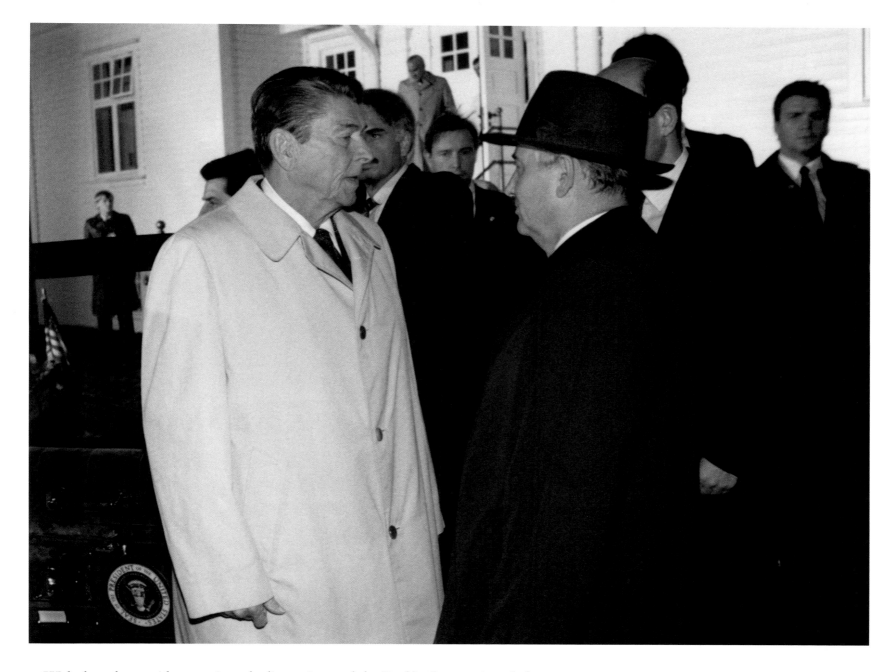

▲ With that, the president got into the limousine, and the Reykjavik summit ended on a sour note. When I got to my car in the motorcade, I told fellow passenger Pat Buchanan what I had overheard. "Write it down!" he practically ordered me. I took out my little notebook and wrote down the parts of the conversation I had heard. White House Press Secretary Larry Speakes later released my quotes verbatim to *Time* magazine to recap the summit.

Back at the ambassador's residence, where Reagan was staying, the president was still quite visibly upset. Chief of Staff Don Regan had gone to an adjacent room to plan post-summit strategy with the White House staff. I found myself alone with the president and a Secret Service agent. "I hope I didn't let people down," the president told us.

Jim Kuhn, Reagan's personal assistant, came to get the president and said that the embassy staff had assembled so Reagan could thank them. I could tell the president's heart wasn't really in it, but he shook hands and posed for pictures with every one of them. "I don't feel much like smiling," the president told them.

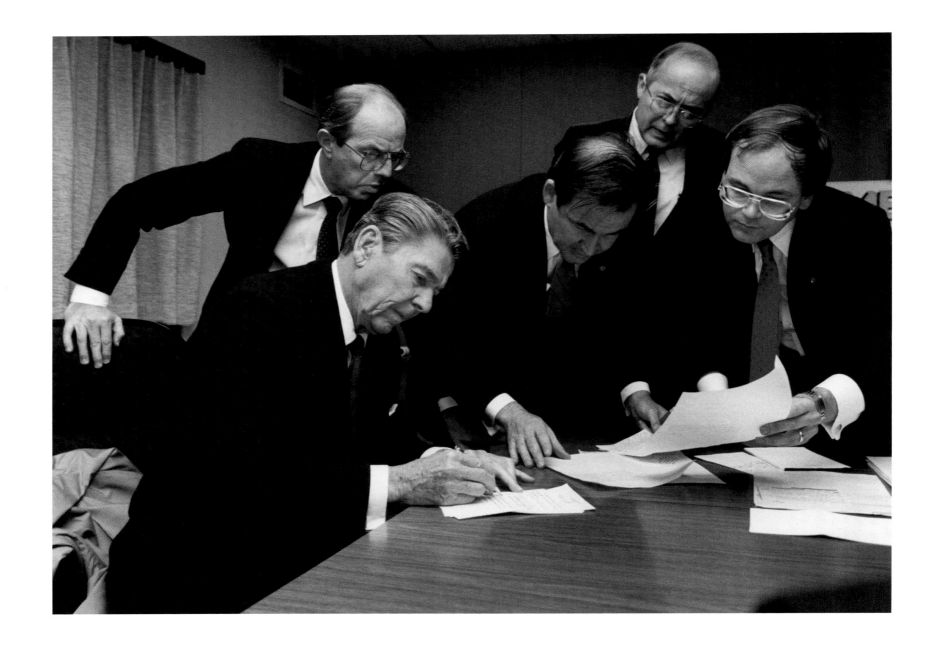

▲ The president hastily reworks his speech in a back room of the Keflavik, Iceland, military airport following the breakup of the summit meeting. The speech written earlier had to be scrapped, so aides rewrote the address in the motorcade during the ride to the airport. Reagan then did last-minute editing with, from left, Dennis Thomas, Pat Buchanan, Admiral John Poindexter, and White House Staff Secretary David Chew.

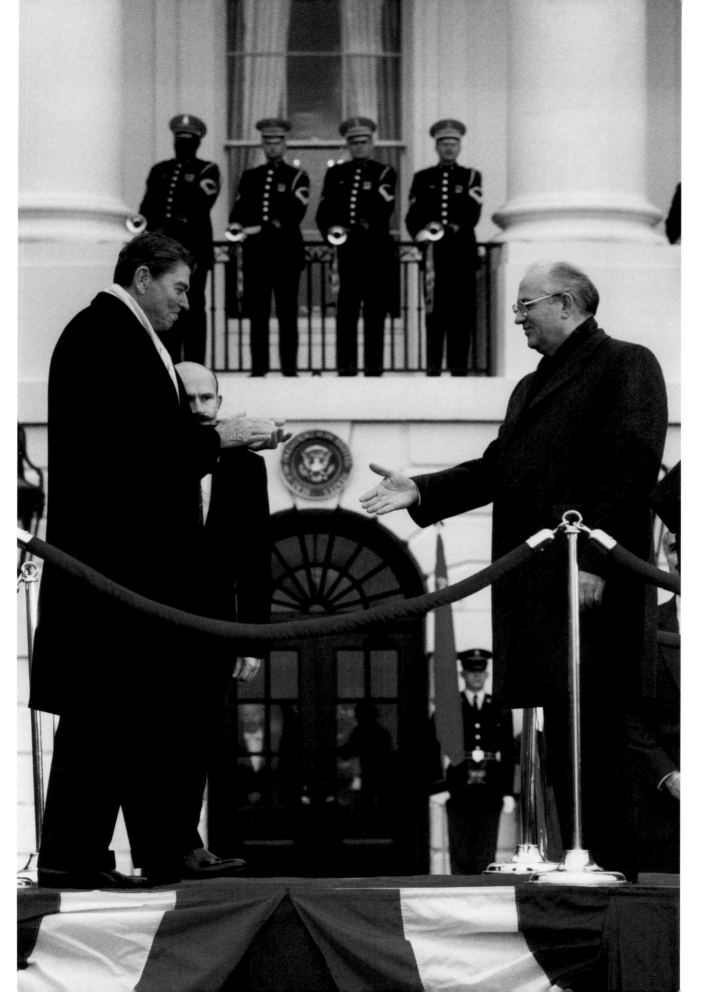

◄ Behind-the-scenes negotiations took place between the foreign ministers to bring the two leaders back together. Letters between the two principals were exchanged. An agreement was reached on the Intermediate-Range Nuclear Forces (INF) Treaty. The two agreed to meet first in Washington, then in Moscow. Here, 14 months after the breakup in Reykjavik, Iceland, Gorbachev extends his hand to Reagan during a formal state arrival at the White House in December 1987.

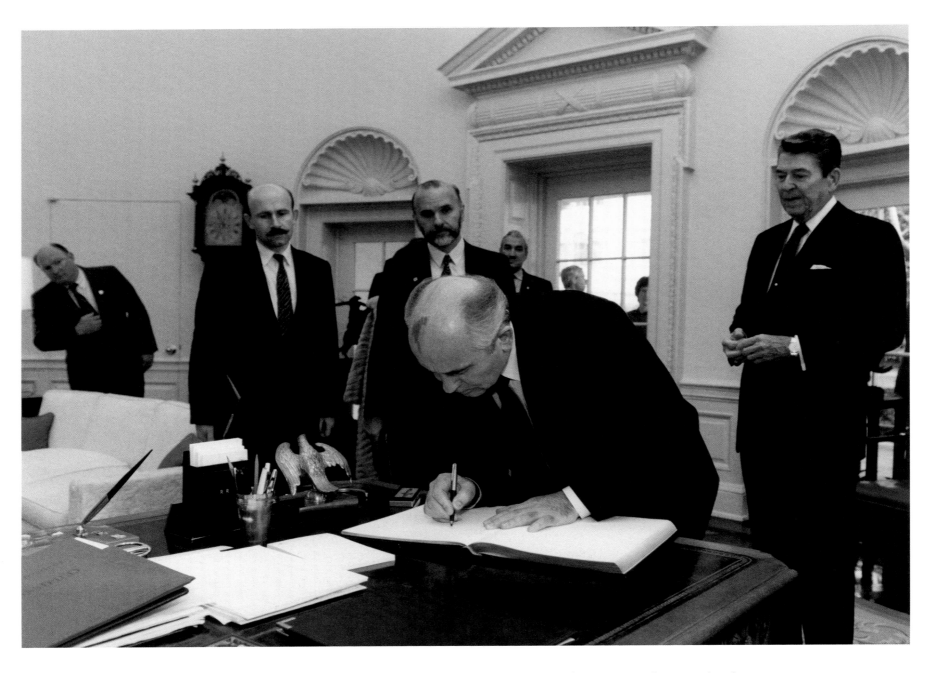

▲ In the Oval Office for the first time, Mikhail Gorbachev signs his name in the guest book as Reagan and the translators look on. Press Secretary Marlin Fitzwater is at far left.

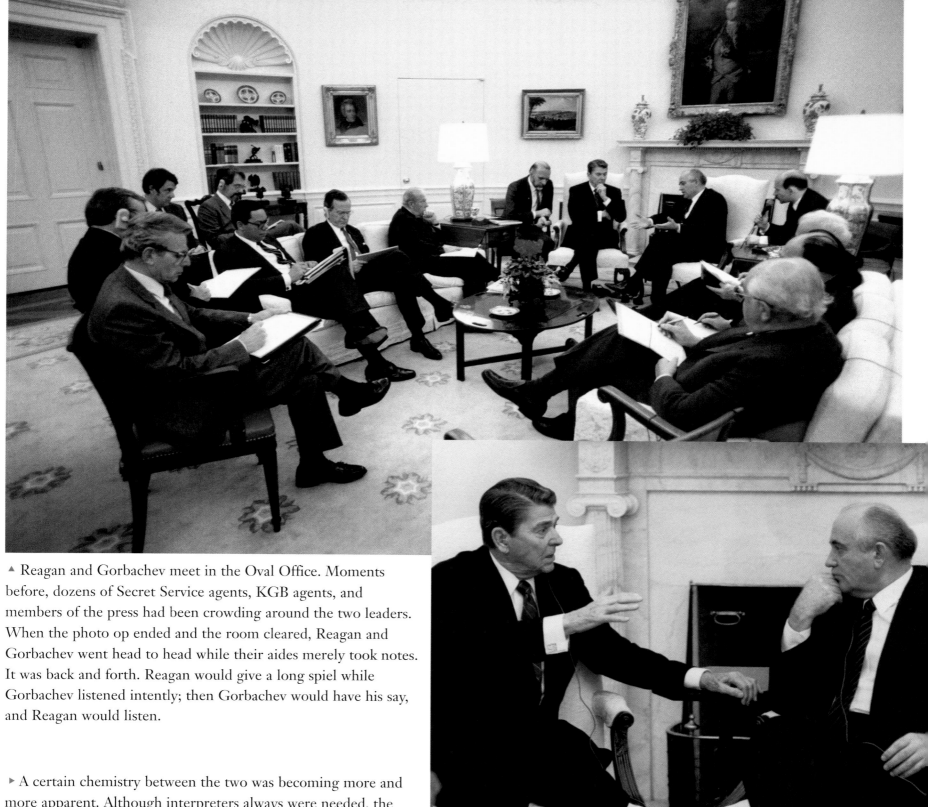

▲ Reagan and Gorbachev meet in the Oval Office. Moments before, dozens of Secret Service agents, KGB agents, and members of the press had been crowding around the two leaders. When the photo op ended and the room cleared, Reagan and Gorbachev went head to head while their aides merely took notes. It was back and forth. Reagan would give a long spiel while Gorbachev listened intently; then Gorbachev would have his say, and Reagan would listen.

▶ A certain chemistry between the two was becoming more and more apparent. Although interpreters always were needed, the two leaders' body language and eye contact gave me the impression that word-for-word translation wasn't completely necessary.

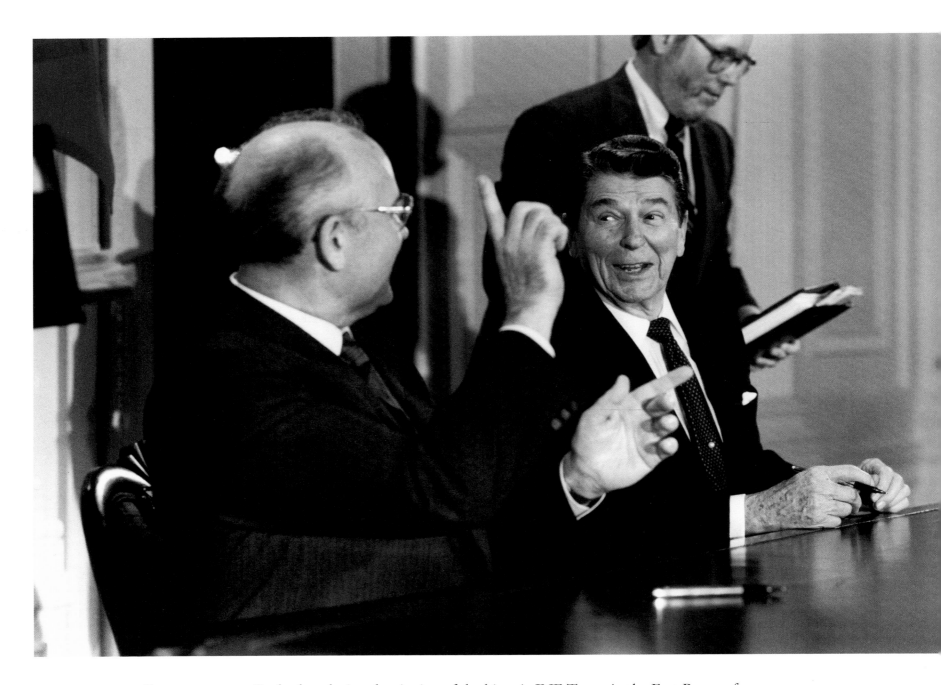

▲ Reagan reacts to Gorbachev during the signing of the historic INF Treaty in the East Room of the White House.

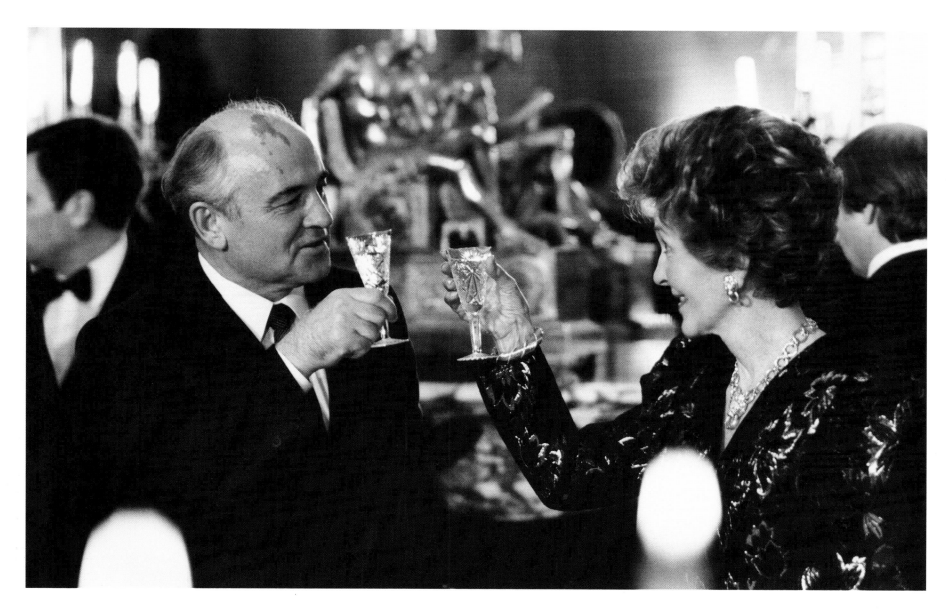

▲ Gorbachev toasts Mrs. Reagan during a dinner at the Soviet Embassy in Washington. In tight quarters, I stood next to one of the dinner tables directly behind Howard Baker, then Reagan's chief of staff. When it was time for the toasts, I knew everyone would stand in front of me, blocking me from getting any pictures. So I told Baker he couldn't stand up until I had gotten my picture. He complied, but then kept asking if he could stand up and join the toast so that no one thought he was being rude.

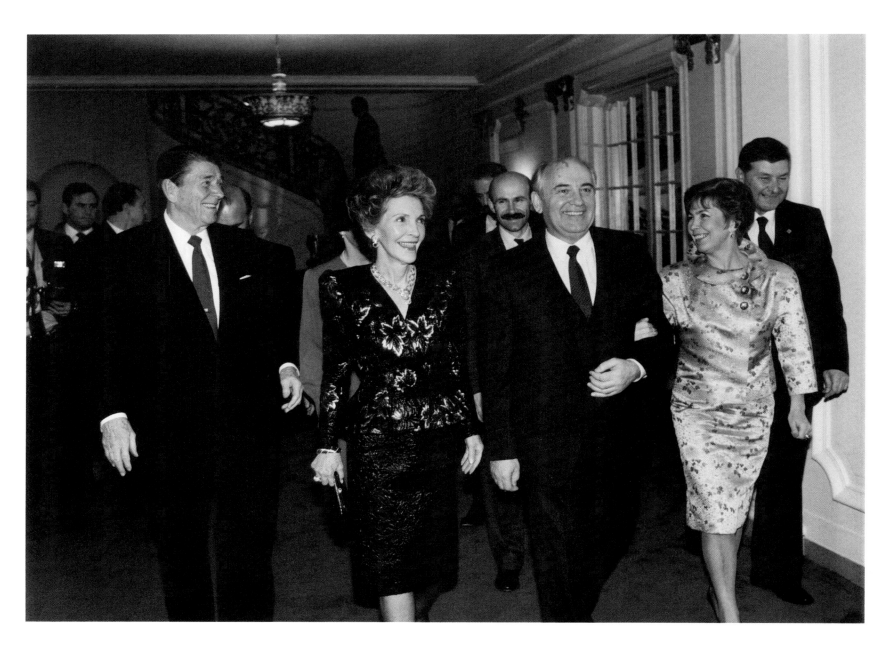

▲ The Reagans and Gorbachevs leave the Soviet Embassy.

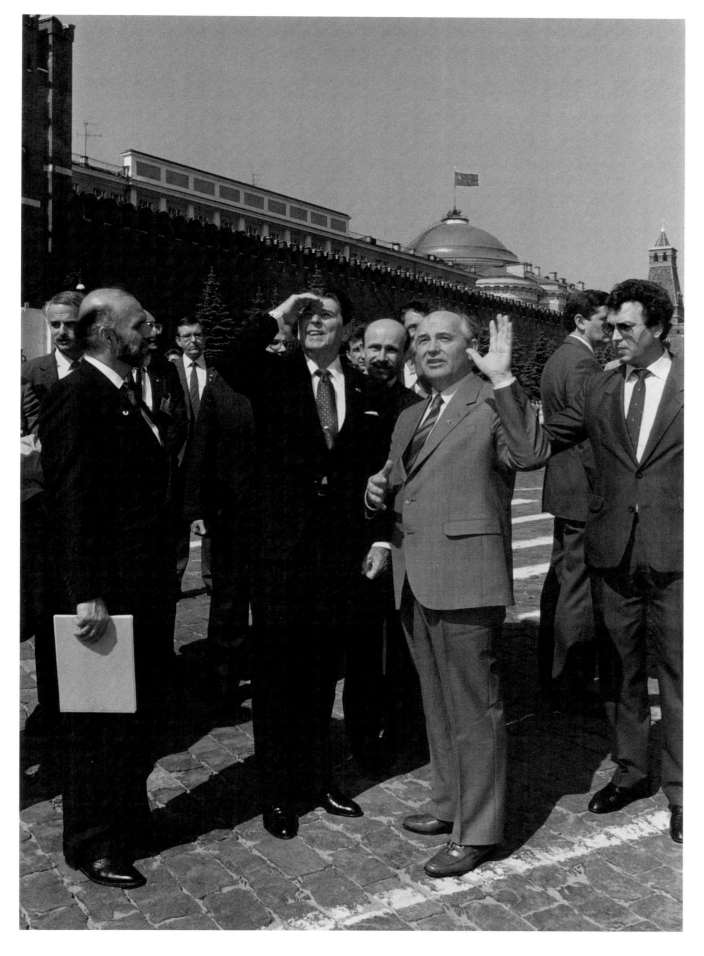

◄ Gorbachev gives Reagan a tour of Red Square in May 1988. You can see the walls of the Kremlin in the background. Lenin's mausoleum is also nearby.

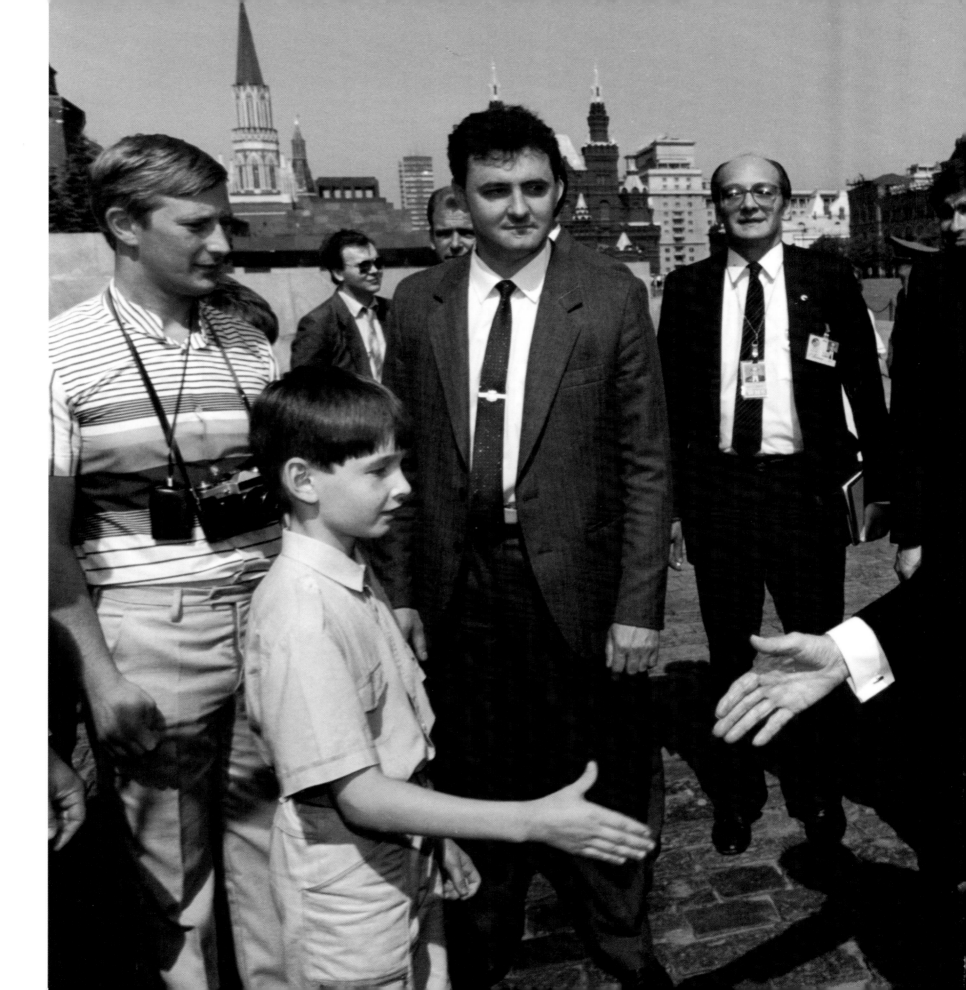

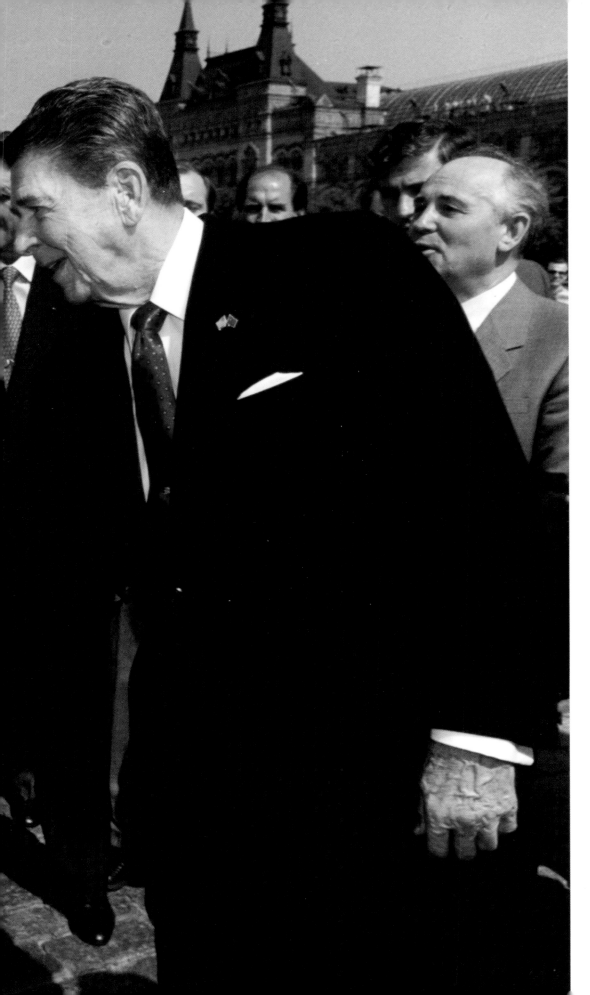

◄ Five or six groups of tourists were assembled in the square, and Gorbachev escorted Reagan from one group to the next. At each stop someone in the group asked the president a point-blank policy question. One tourist asked about the Strategic Defense Initiative (SDI), another about human rights in the United States, and so on. I thought it rather strange at the time that tourists in a nondemocratic society would ask such controversial questions. Later, a Secret Service agent said he was pretty sure that the "tourists" were really family members of KGB agents—they had been told what to ask.

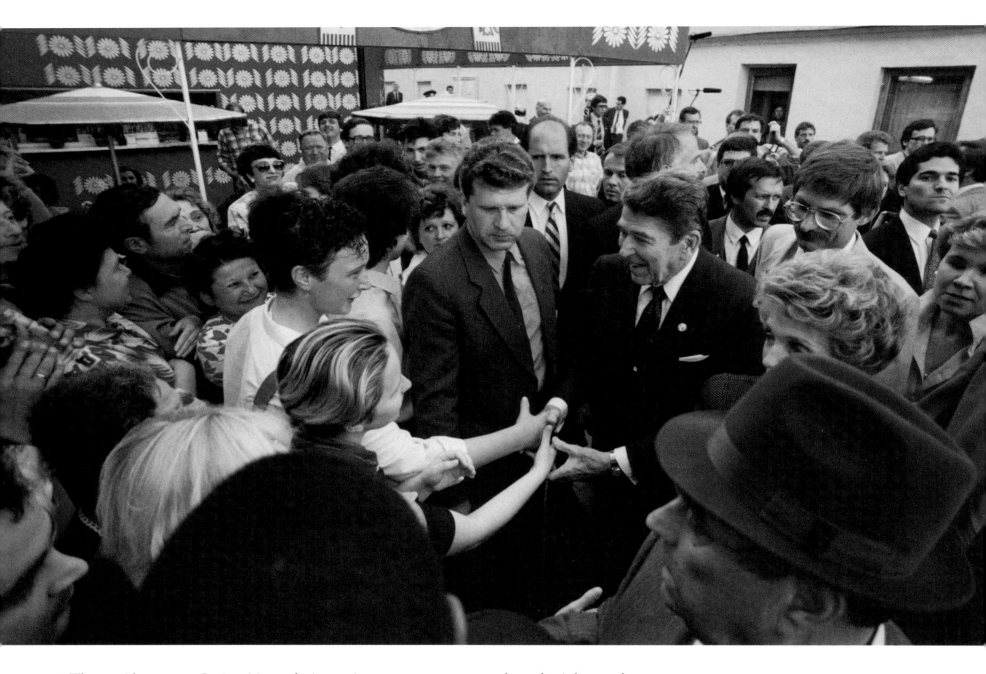

▲ The president greets Soviet citizens during an impromptu appearance along the Arbat outdoor shopping area. The staff had wanted Reagan to make this afternoon "stroll" on the Arbat; the Secret Service was opposed. Reagan ignored the Secret Service's advice. Chaos soon ensued as the crowds went crazy trying to reach out to Reagan, while KGB agents began manhandling the crowd in return. It grew somewhat out of control, and the Secret Service agents finally had to escort the Reagans out, clasping arms together and forming a ring around them. I was also manhandled by the crowds and KGB; they didn't distinguish me from anyone else. One of the Secret Service agents grabbed me and put me inside the security ring with the Reagans as they pushed their way to safety.

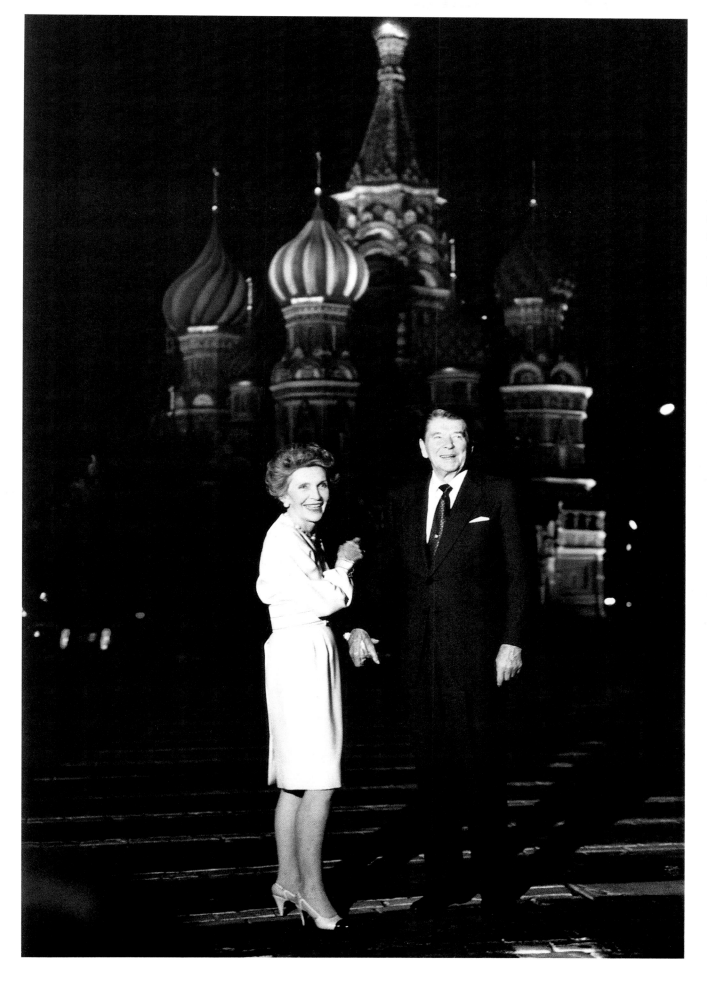

◄ On their last night in Moscow, the Reagans pose for a photo in front of St. Basil's Cathedral in Red Square. This was essentially an engineered photo op for the press.

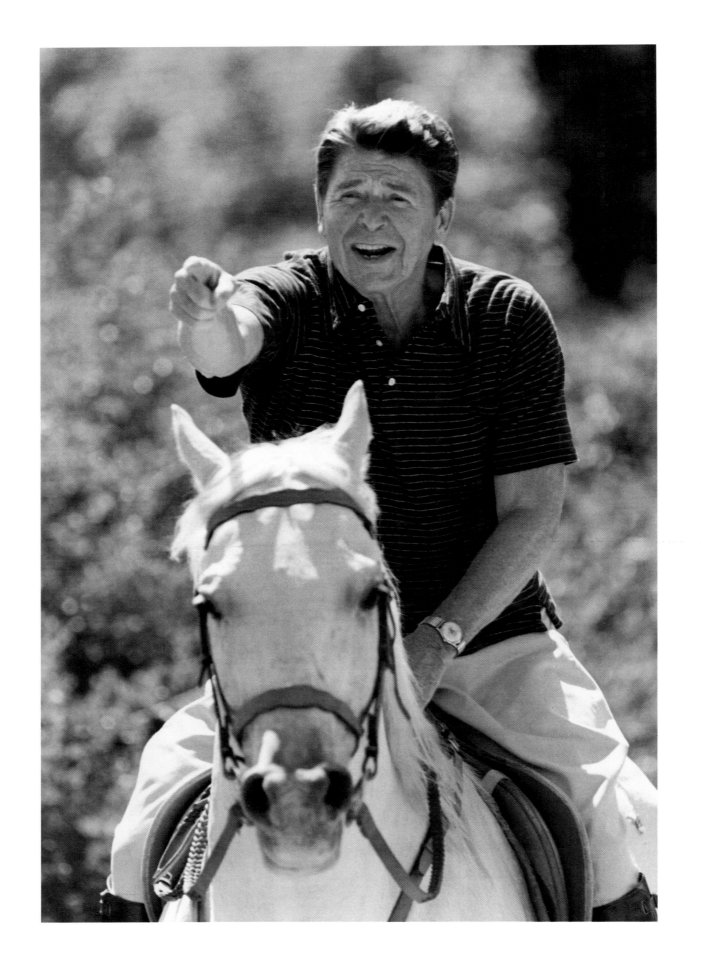

AT THE RANCH

◄ The president rides El Alamein at his ranch in California. He was riding along with some close friends, and when he spotted me taking pictures out on the trail, he yelled out, "Charge!" I think he was showing off for his friends. Rancho del Cielo ("ranch in the sky") was the one place where the president could come and go as he pleased. The 688-acre ranch sat atop the Santa Ynez Mountains, just north of Santa Barbara.

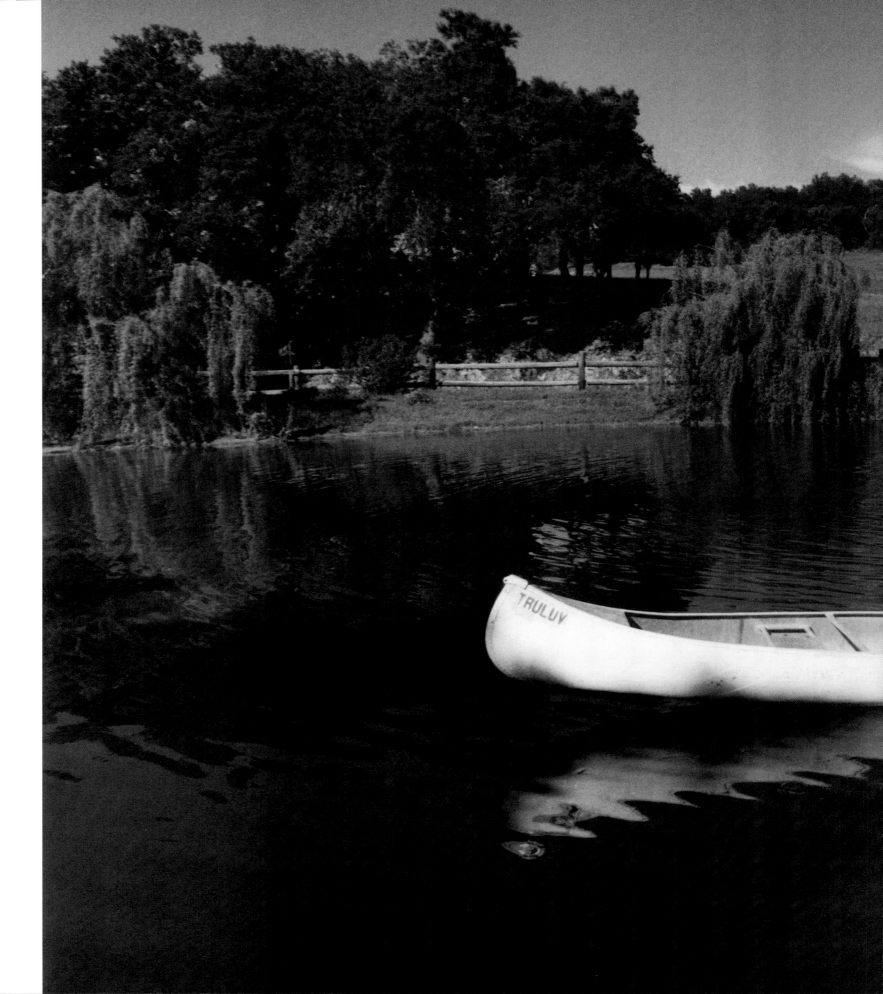

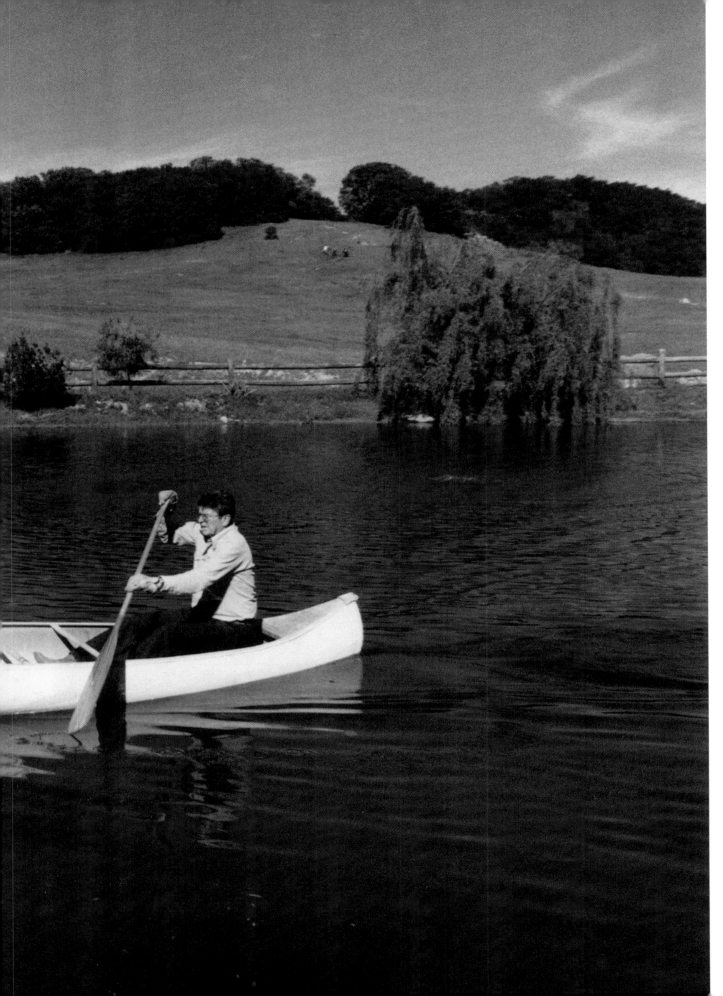

◄ The president paddles *Truluv* in the man-made pond alongside his ranch house. The president had been trimming tree branches that were dipping into the water. He was having difficulty getting to some of the branches from land, so he jumped into the canoe and eventually finished the chore from there.

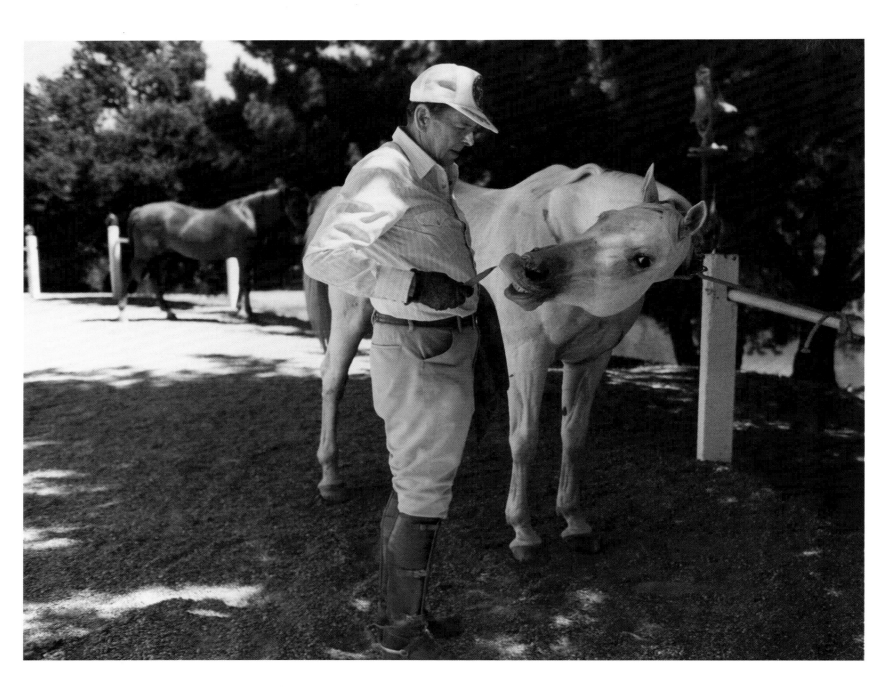

▲ Reagan feeds carrots to El Alamein after a morning ride. He is wearing zinc oxide on his nose for protection from the sun.

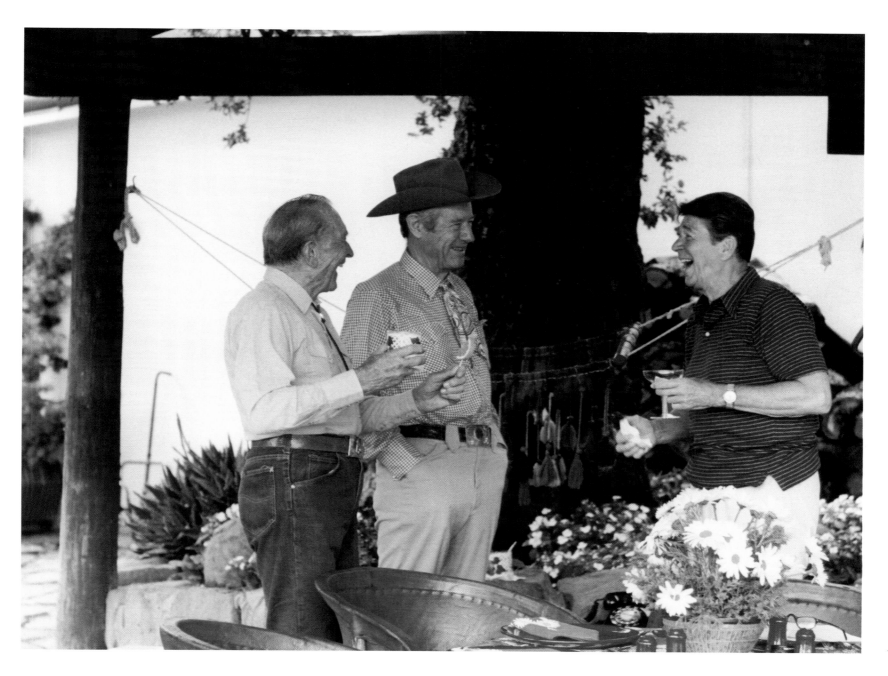

▲ The president entertains friends Earle Jorgensen, left, and Bill Wilson on the patio outside the two-bedroom adobe house that is more than 100 years old. Jorgensen and Wilson were both members of Reagan's original "kitchen cabinet"—a group of unofficial advisors who helped to launch Reagan's political career.

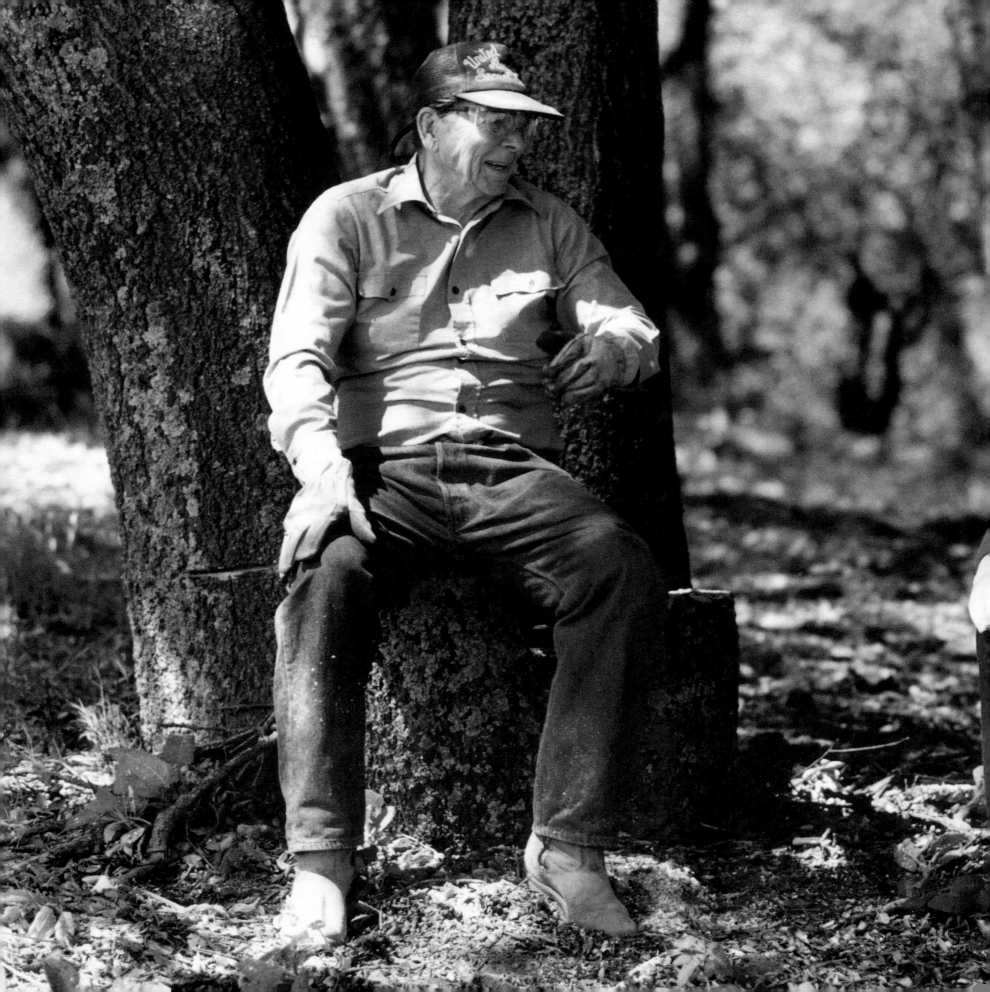

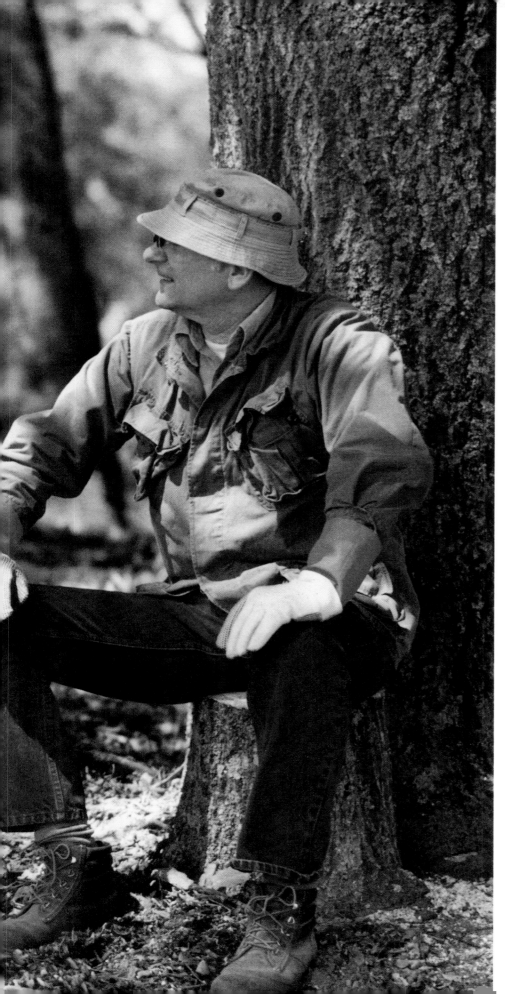

◄ Reagan shoots the bull with White House physician John Hutton at the ranch, where they had been cutting wood. The president gave me a slice of wood from the trunk he's sitting on and branded it with the Rancho del Cielo symbol. It's one of the few mementos from my time at the White House that I keep in my home office.

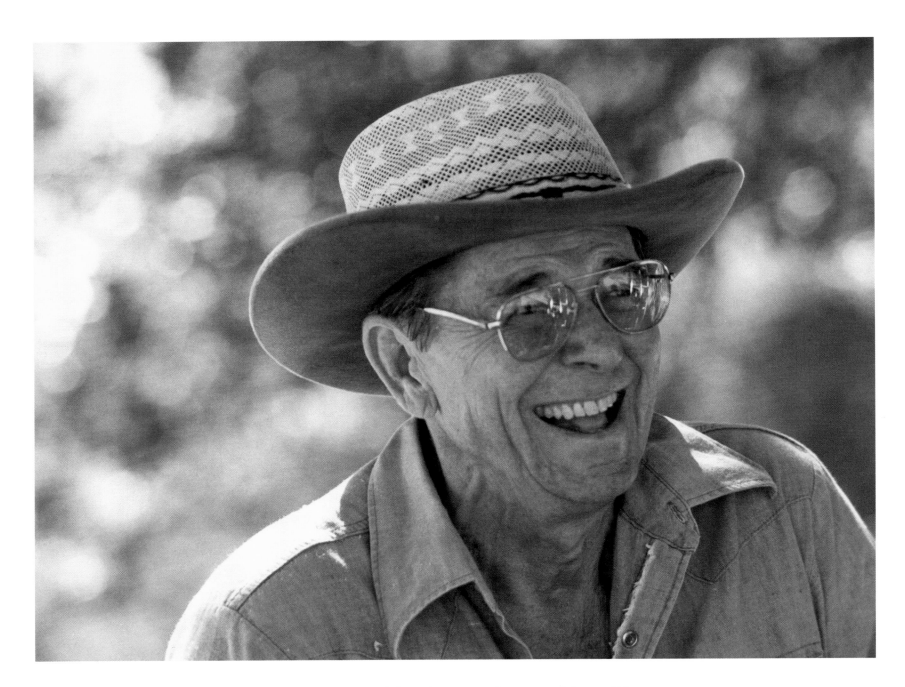

▲ The president laughs while swapping stories with the "fellas" during an afternoon of chores. The ranch was the one place where the proverbial bird was let out of his cage. He always insisted that his trips to the ranch weren't really vacations, but rather "a change of scenery." From what I observed, the ranch was certainly a place where he reinvigorated himself.

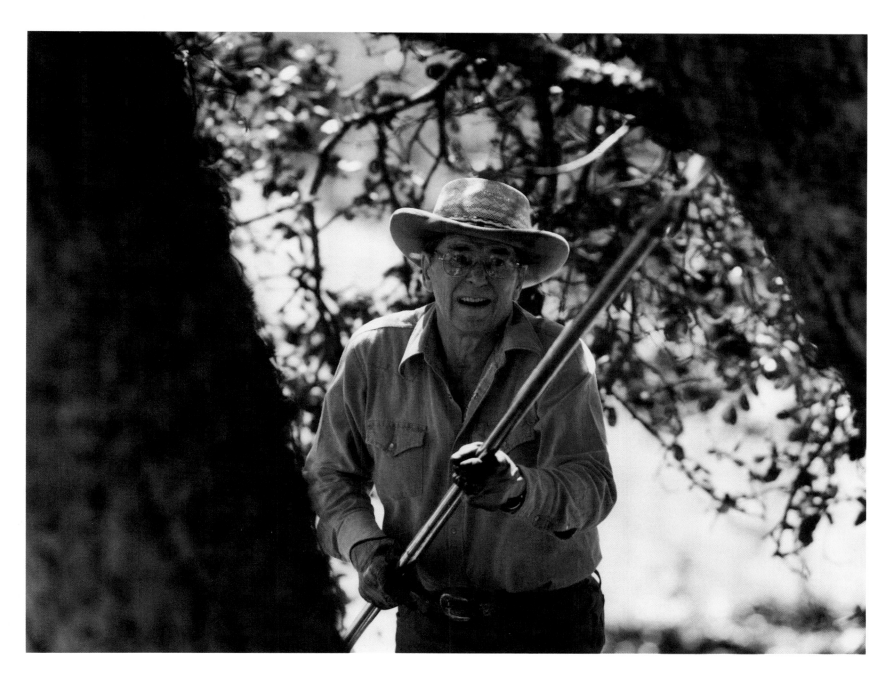

▲ The president saws a tree branch along a new horse trail.

▶ Reagan talks with a presidential aide from inside the tack barn, where old movie posters hang on the walls. While at the ranch, the president conducted most of his business via telephone. To allow him some privacy, the White House staff rarely made the 45-minute drive from Santa Barbara up to the ranch. Instead, paperwork usually flowed back and forth via White House couriers.

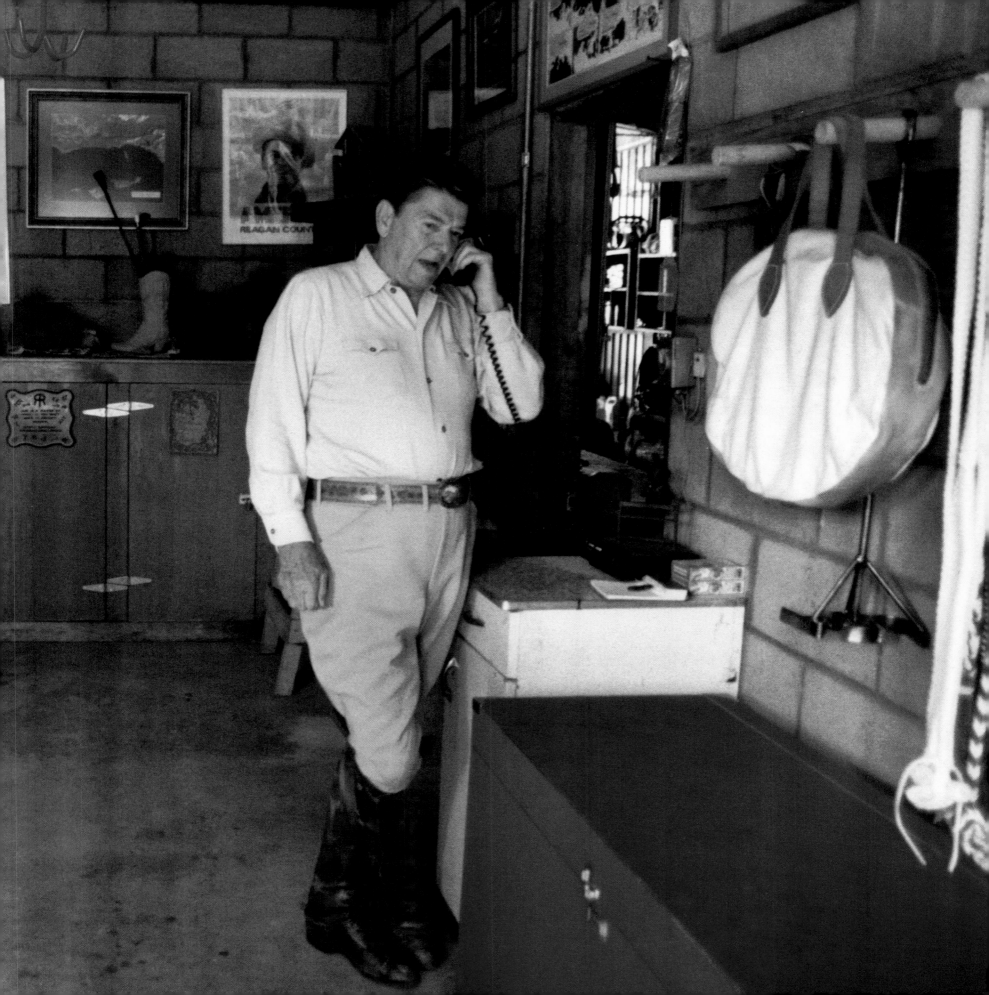

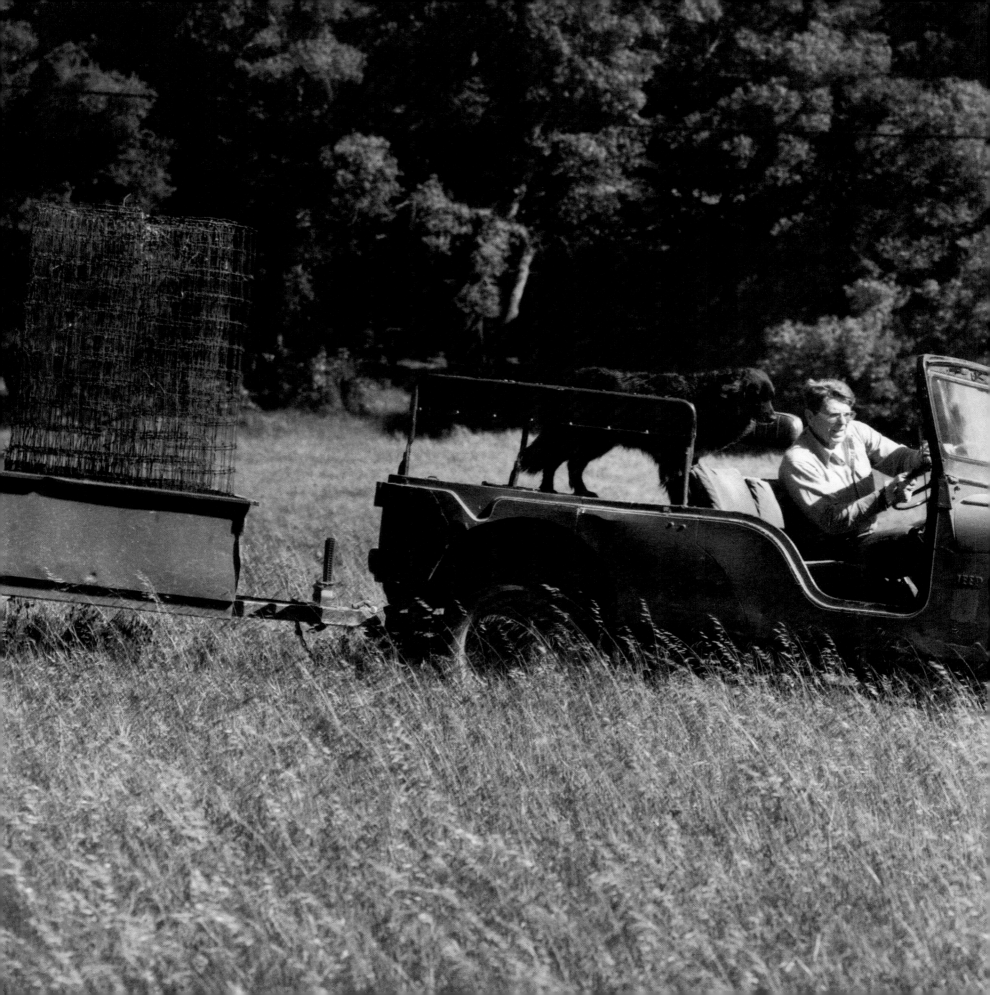

◄ The president drives his Jeep, with Millie aboard, during afternoon chores. The ranch was the only place where he had a chance to drive a vehicle himself. Occasionally, I'd hitch a ride in his Jeep and, inevitably, find myself and my cameras bouncing every which way.

One evening, when I returned to Santa Barbara after spending the day at the ranch, members of the White House press corps were talking about the earthquake tremor that had occurred that afternoon. I didn't remember feeling a tremor. Then I realized I must have been in the president's Jeep at the time and just didn't notice—every bump while he drove felt like a small earthquake.

▶ Reagan begins a morning ride followed by Freebo, left, and Victory, two of the four dogs that lived at the ranch.

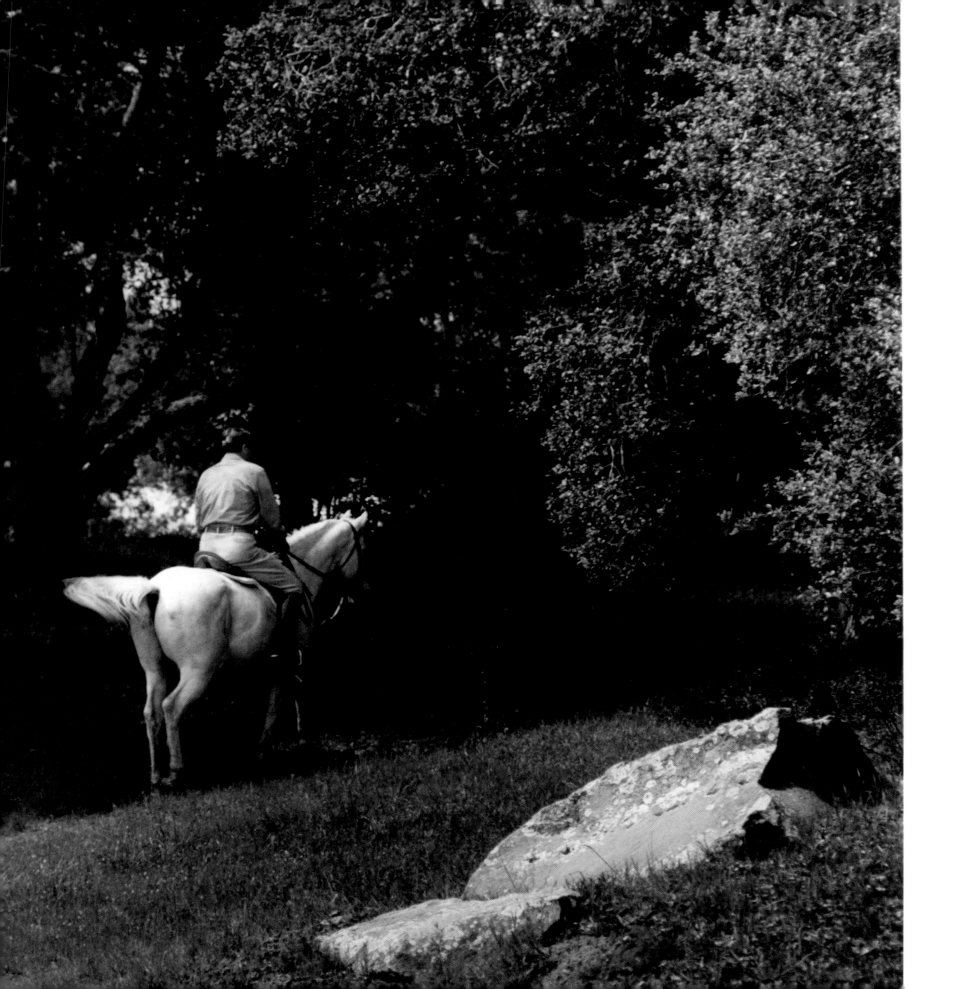

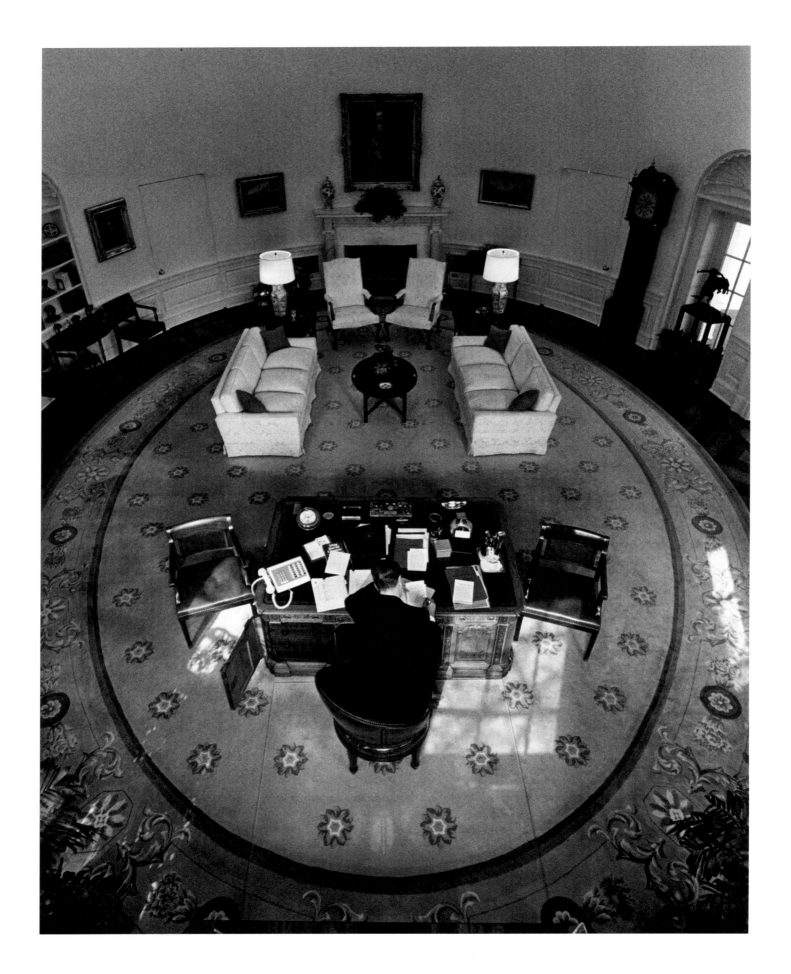

THE WORLD IN BLACK & WHITE

◄ The president writes a letter at his desk in the Oval Office. The pictures in this section were all taken on black-and-white film. The administration had made the decision from day one that official White House photographs would all be taken on color film. But I made an independent decision in 1985 to start shooting some in black and white. I took this picture from a camera I had mounted early that morning above the large windows behind the desk. The camera had a special back on it that allowed me to take 250 pictures without having to change the film. I triggered it with an infrared remote control while I hid in the room out of camera range. For this particular picture, I stood outside the Oval, peering through a peephole in the back door. (If you look closely at the upper right-hand corner of the picture, you can see the peephole centered at the top of the door.)

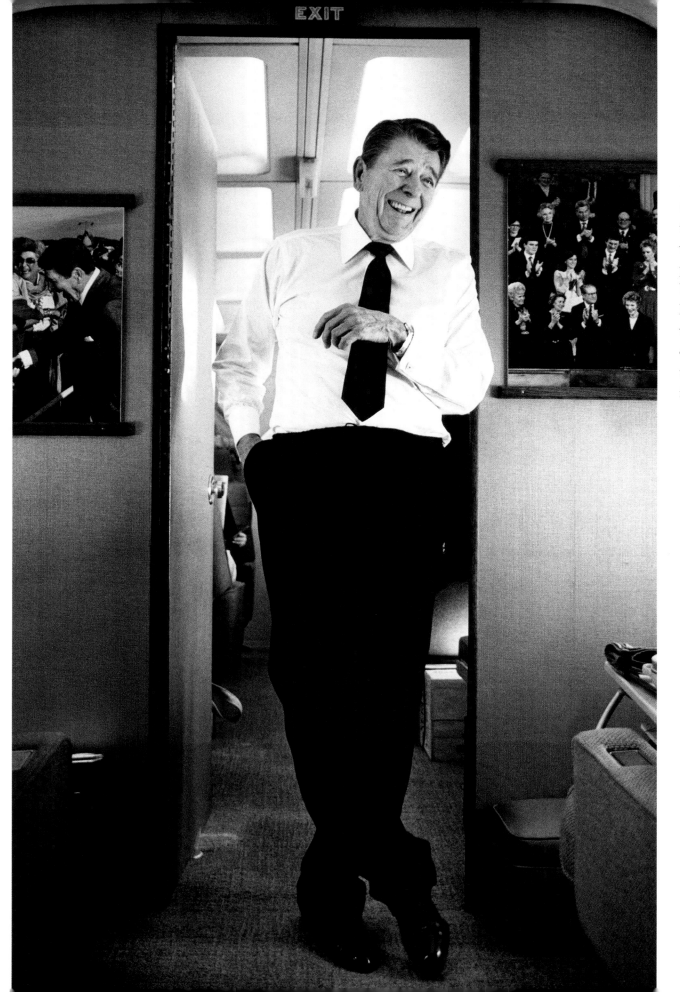

◄ Reagan, aboard *Air Force One*, laughs at the punch line to his own joke. He often wore sweatpants while on the plane, and he would venture back into the staff cabin to say hello to any new guests that were traveling. He always felt obliged to tell a story or two to make first-time passengers feel welcome.

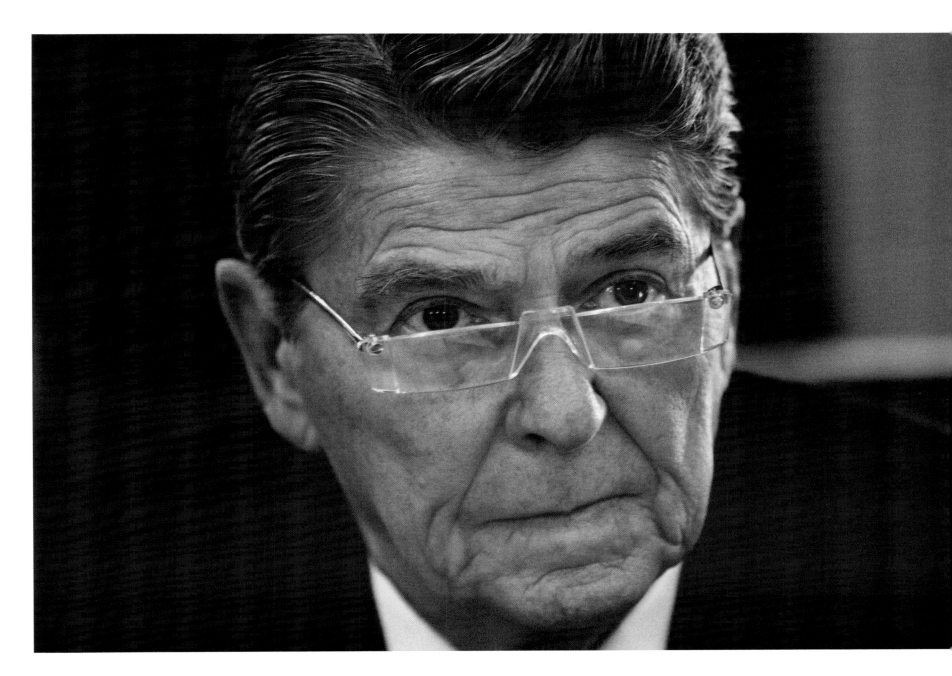

▲ The president listens intently during a cabinet meeting. He sometimes wore reading glasses in the
Cabinet Room and Oval Office.

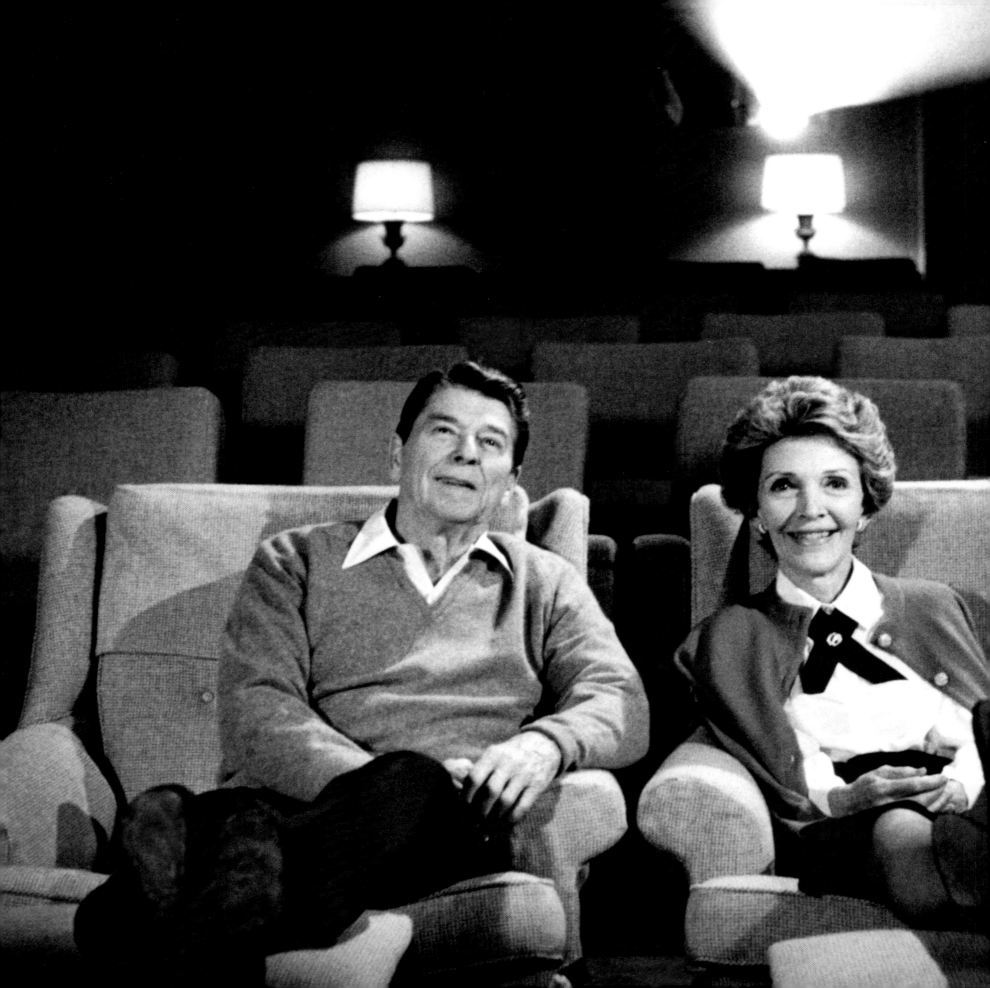

◄ The Reagans "watch" an old movie in the White House theater. In fact, they were only there so that *ABC News* could capture some B-roll video footage for an upcoming interview special with Barbara Walters. I was shooting some pictures while trying to stay out of the way of the ABC cameraman who was filming the Reagans. One of the producers instructed the Reagans to "please be looking at the movie." Mrs. Reagan replied, "But I can't see over Pete's head!" I think that was about the instant that I took this picture.

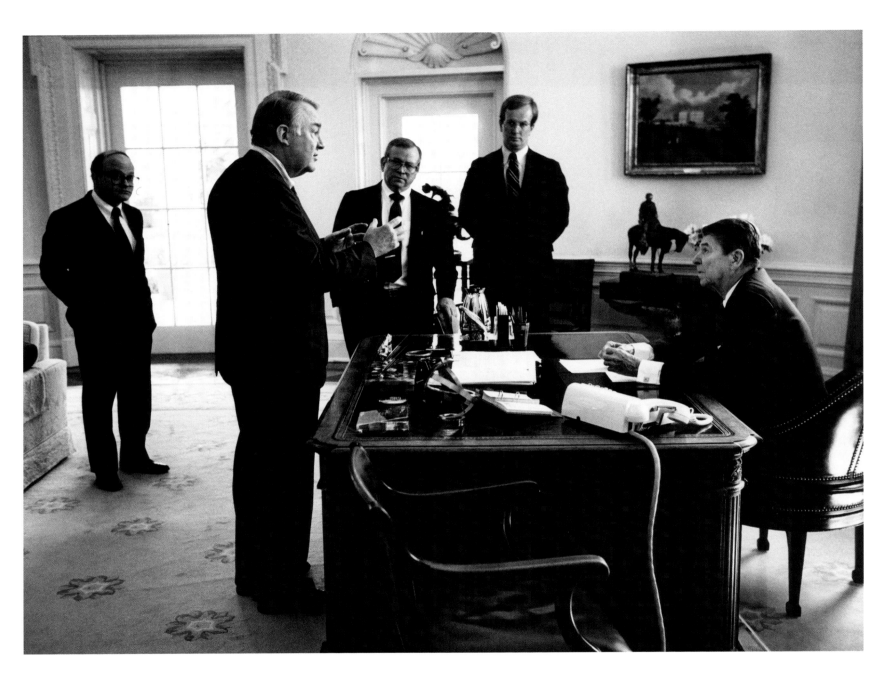

▲ Attorney General Ed Meese confers with President Reagan in the Oval Office. During the first term of the administration, Meese served as counselor to the president—one of the so-called "troika of power" along with Chief of Staff Jim Baker and Deputy Chief of Staff Mike Deaver. Behind Meese are, left to right, aide Ken Cribb, Howard Baker, and White House Counsel A. B. Culvahouse.

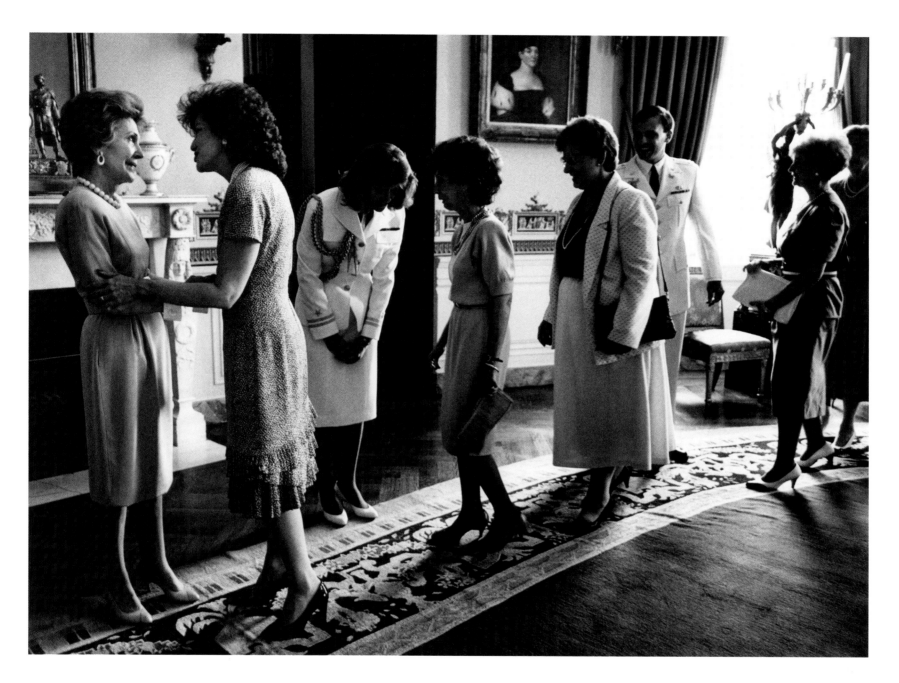

▲ Transportation Secretary Elizabeth Dole, the wife of Bob Dole and now a U.S. senator from North Carolina, greets First Lady Nancy Reagan during a receiving line in the Blue Room of the White House. At any White House social event, this was the setup for the receiving line, which usually took place before or after the event. This particular event was a women's luncheon hosted by Mrs. Reagan. To the right of Mrs. Dole, the next guest is giving her name to a military social aide, who will then introduce the guest to Mrs. Reagan.

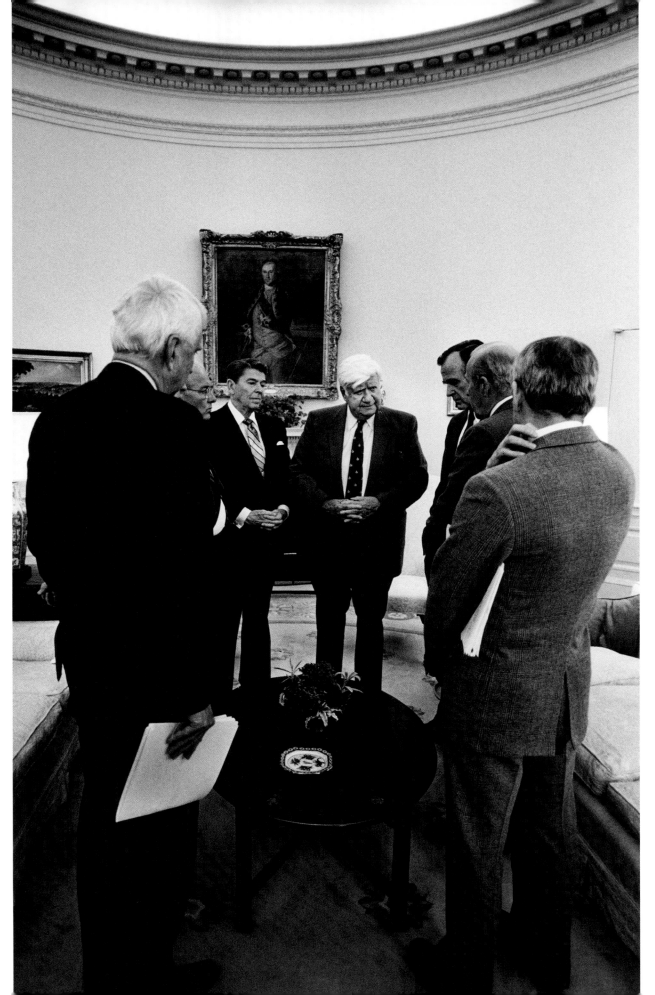

◄ Reagan and aides consult with congressional leaders after the conclusion of a meeting. I had taken pictures at the beginning of the meeting and then waited outside the Oval Office for the meeting to end. Looking through the peephole, I saw the president and the participants stand up, so I rushed back in. In a very serious tone, the discussion about the funding of the Contra rebels in Nicaragua continued. Democratic Representative Tip O'Neal, then Speaker of the House, is standing next to the president. On this day and in this instance, I was also escorting Bill Luster, a photographer from the Louisville *Courier-Journal*, who had gotten permission to tag along with me for a behind-the-scenes look at the presidency. When we finally walked out of the Oval, I turned to him and said, "Remember, you didn't hear anything."

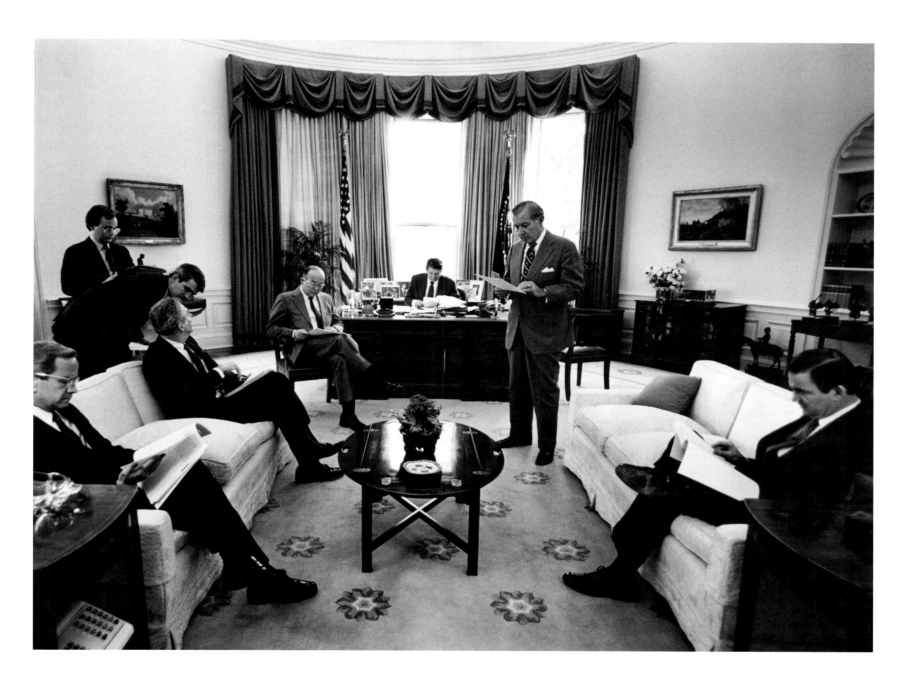

The president and staff read briefing material before the start of a meeting. This picture shows many of the principals involved in what later became known as the Iran-Contra scandal. This meeting took place before the scandal fully erupted. From left to right are Bud McFarlane (former national security advisor, who was then a special Middle East emissary), National Security Aide Oliver North, National Security Press Aide Bob Sims (seated), presidential aide David Chew (behind North), National Security Advisor John Poindexter, the president, Chief of Staff Don Regan, and White House Communications Director Pat Buchanan. This is only one of three or four times that I ever remember Oliver North being present in a meeting with Reagan.

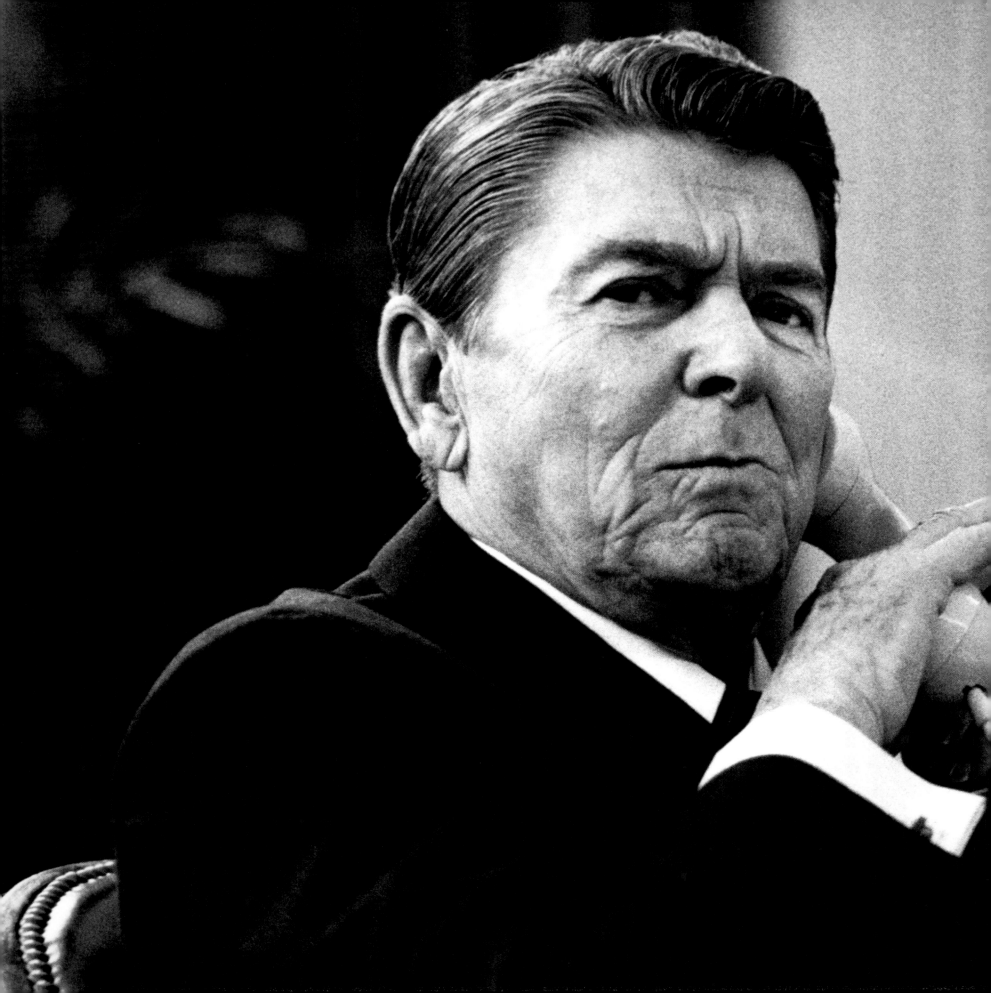

◂ The president interrupts a phone
conversation with Vice President Bush
to talk with an aide in the Oval Office.

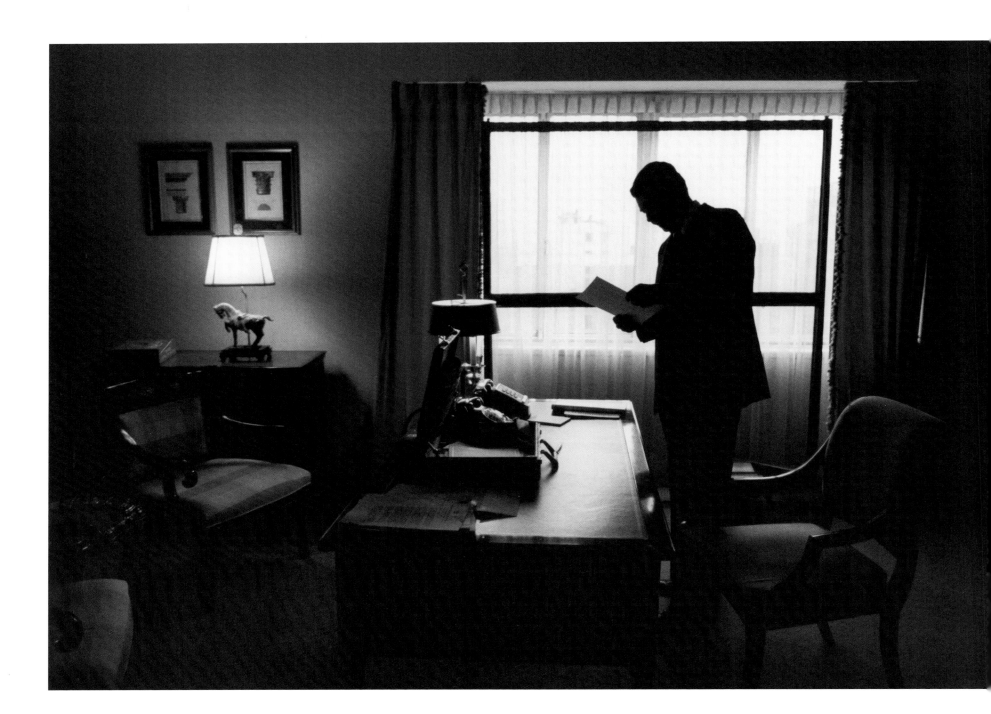

ON THE ROAD

◄ President Reagan reads a note in a hotel room in Chicago. On the road, I would notice added security measures wherever the president traveled. Here, bulletproof glass was set up in front of the hotel window.

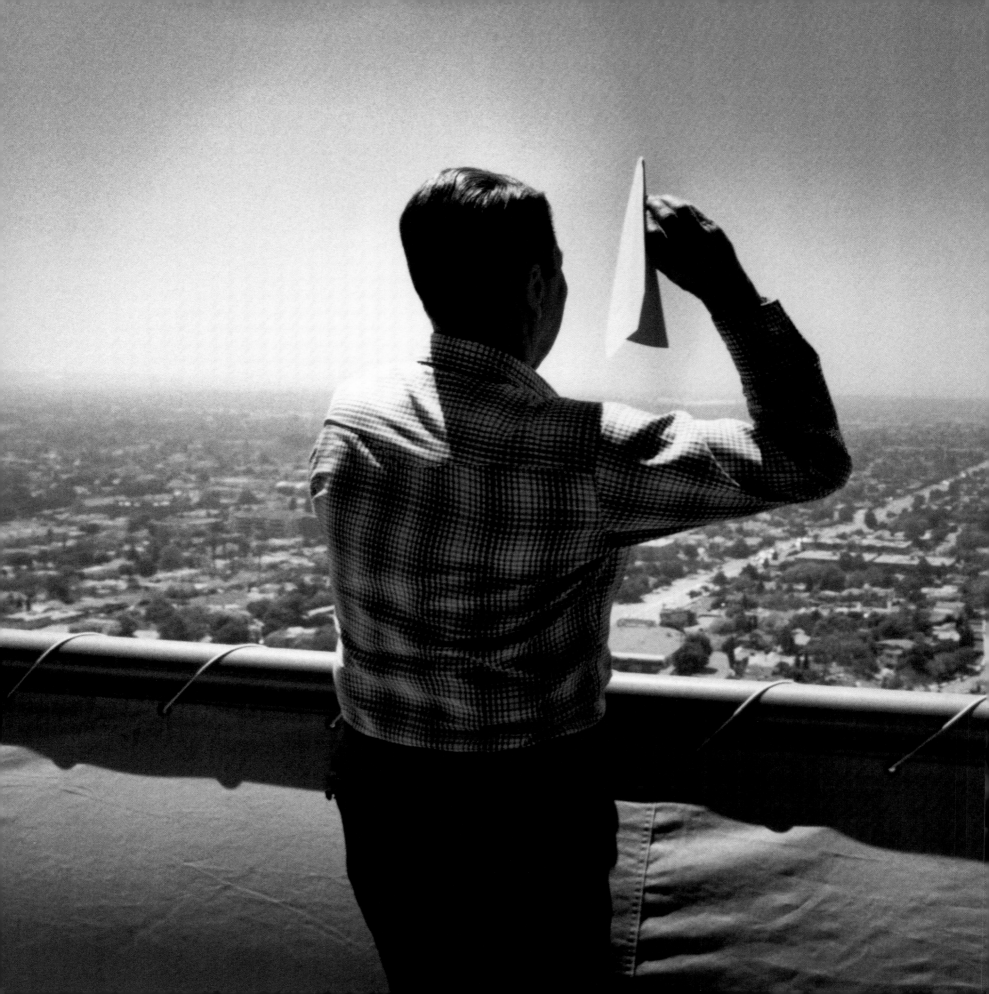

◄ President Reagan tosses a paper airplane from a Los Angeles hotel balcony in 1986. I had walked into the president's suite with speechwriter Ken Khachigian, who had a scheduled meeting with Reagan. Much to our amusement, the president was folding a piece of White House stationery into the shape of an airplane. He glanced up at us and said, "I'll be right with you, fellas." He proceeded to the balcony—I think it was on the 34th floor—and flicked the airplane into the afternoon sky. Ken and I then joined the president, hanging over the balcony, to track the craft's flight. The presidential paper airplane eventually landed on another balcony some 25 floors below.

The White House didn't want to release the photograph, and it wasn't published until Reagan's last month in office. When I showed Reagan the published picture in *U.S. News & World Report*, I could tell by the look on his face that he wasn't too thrilled. "Mr. President," I said, "it just shows there's a little bit of a kid in every one of us, even the president of the United States." He nodded his acknowledgment, and I later gave him a print and signed it, "Mr. President, bombs away!" Someone later told me they saw my signed picture on his office shelf in California near a signed picture from Queen Elizabeth II.

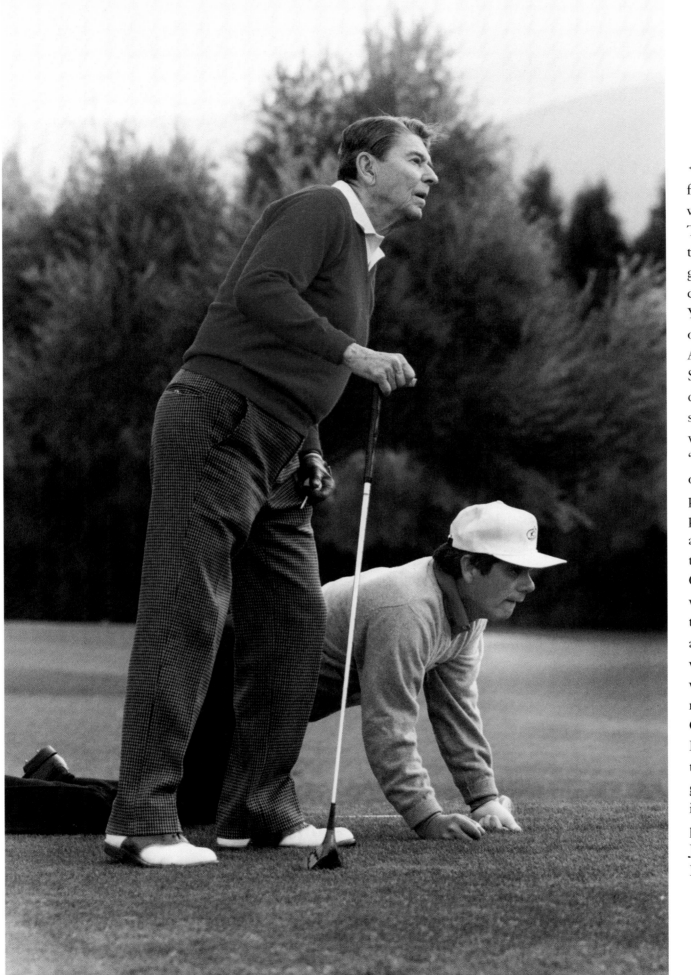

◄ The president watches the flight of his golf shot along with professional golfer Lee Trevino. To be quite honest, the president was a lousy golfer, but he played with good cheer. He spent every New Year's vacation with a group of old friends at the Walter Annenberg estate outside Palm Springs. He'd play golf every day for three or four days and shoot the bull along the way with the "fellas." The wives, "the girls," sometimes came out to watch their husbands play a hole or two. One year, professional golf stars Trevino and Tom Watson played with the president, Annenberg, George Shultz, and others. It was kind of amusing to watch the two pros hit perfect shot after perfect shot, seemingly without effort, and then to watch everyone else struggle not to slice a shot into a tree. One year, Ambassador Charles Price insisted on taking a picture of me with Reagan on the golf course after they had finished their round. Later, the president signed it, "Dear Pete, Just don't tell anyone my score. Best regards, Ronald Reagan."

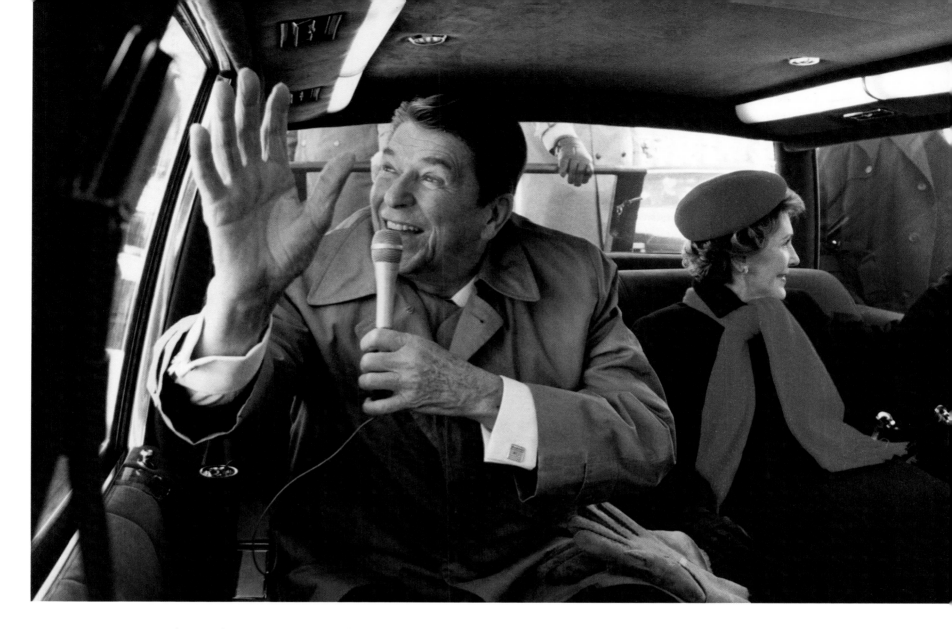

▲ President and Mrs. Reagan wave from their limousine during a 1984 parade celebrating the president's birthday in his hometown of Dixon, Illinois. I had mounted a camera with a suction-cup attachment onto a window in the limousine. The camera was triggered with a remote cord from the front seat by Secret Service Agent Bob DeProspero, who pushed the button about 26 times, thereby giving us 26 pictures, including this one. I had flown into Dixon the day before to make final arrangements with the Secret Service, and I set up the remote camera early on the morning of the parade. The night before, as a test, I mounted the camera with the suction cup onto the mirror in my hotel room. About 3:00 A.M., I was startled awake by the noise of the camera falling off the mirror when the suction-cup mount came undone. I slept little after that, my head filled with visions of the camera falling in the limousine, breaking one of the president's toes. So when I mounted the camera in the limousine the next morning, I made sure I put extra saliva onto the suction cup. I guess that did the trick because after the parade, White House photo editor Carol Greenawalt (now Carol McKay) had to get help from a Secret Service agent to pry the mounted camera from the window.

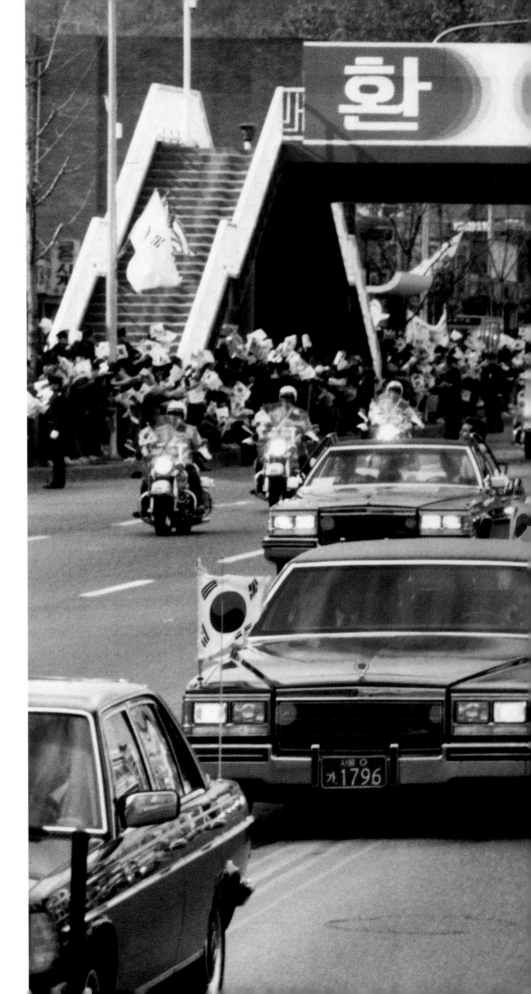

▶The presidential motorcade heads into Seoul, Korea, during a state visit in 1983. I especially like the second banner sign: "We all like Ron and Nancy."

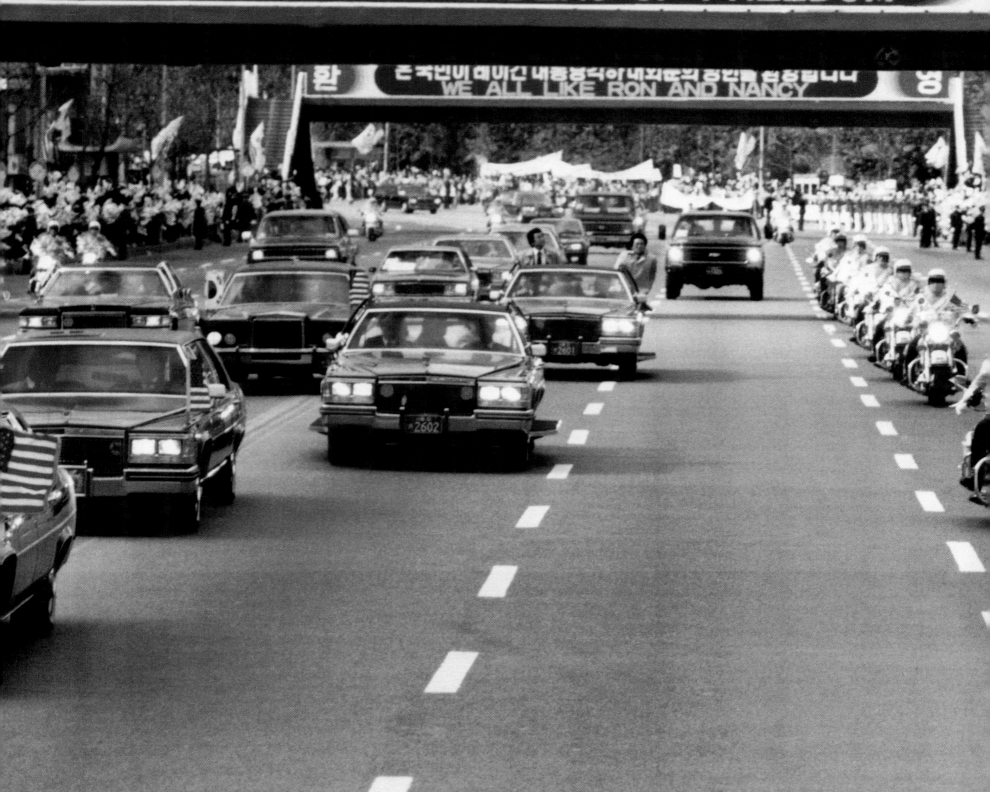

자유의 수호자, 한국과 미국
US AND KOREA: DEFENDERS OF FREEDOM

환 WE ALL LIKE RON AND NANCY 영

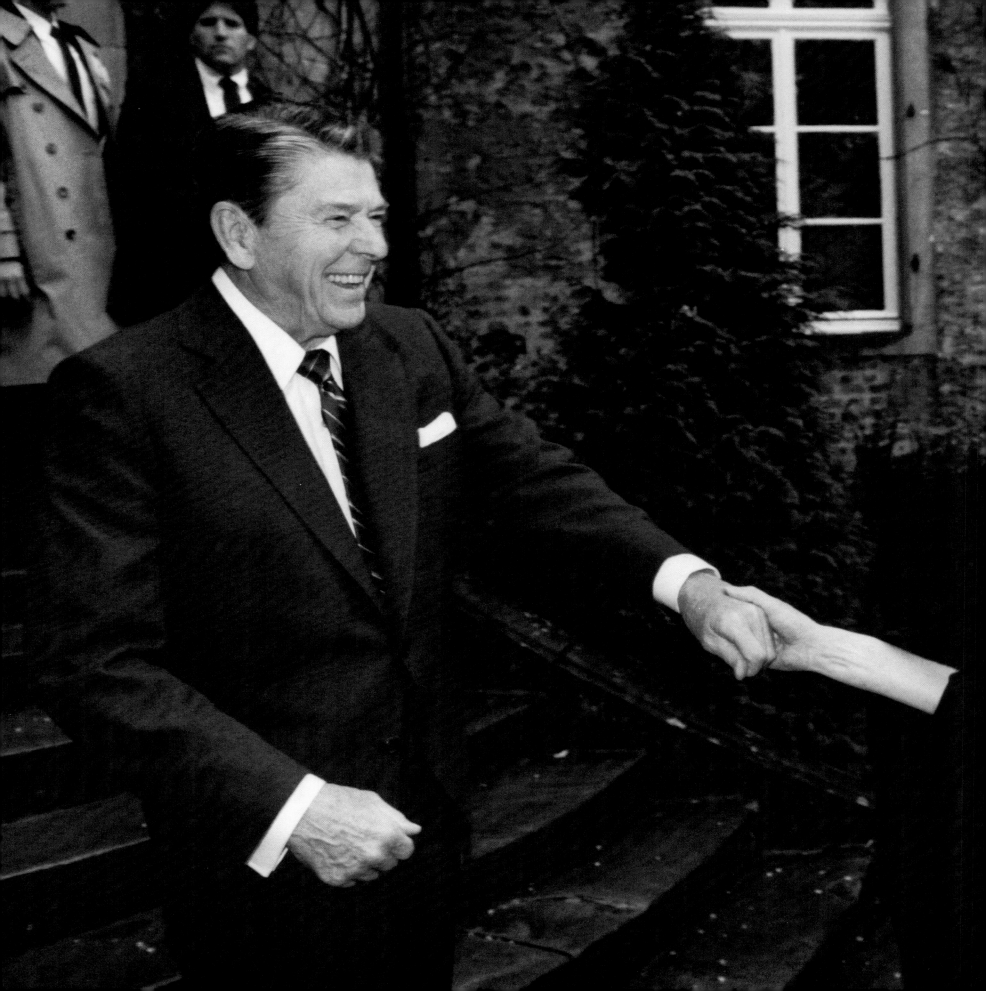

◄ The president bids farewell to British Prime Minister Margaret Thatcher after a meeting in Bonn, West Germany. Thatcher and Reagan were usually aligned politically, and they became good friends. Reagan also admired the fact that a woman had risen to become a prime minister in Great Britain. The two conversed frequently, both in person and on the phone. One time, I was in the Oval Office when the president happened to be talking to Thatcher on the telephone. He had the phone to his ear for a long time, and he was trying unsuccessfully to interrupt the caller. I could tell he was frustrated as he leaned back in his chair. When he finally hung up, he turned to me and said, "That Maggie!" and lamented that he sometimes couldn't get in a word when something was on her mind.

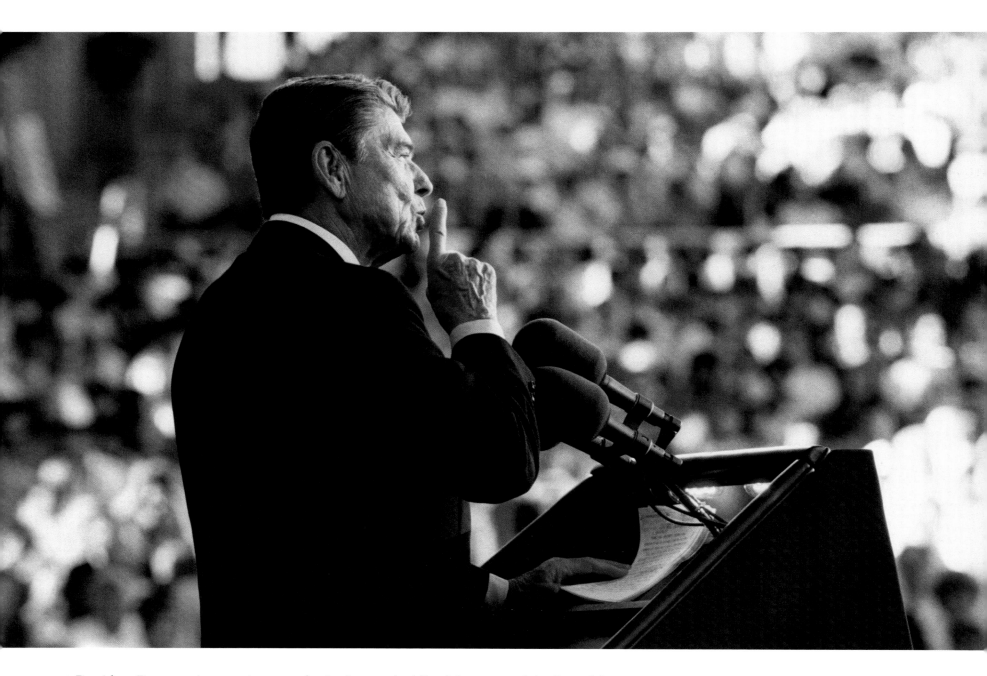

▲ President Reagan tries to quiet an enthusiastic crowd while giving a speech in Costa Mesa, California. The crowd kept interrupting the beginning of his speech with applause, and he was shushing them so he could continue.

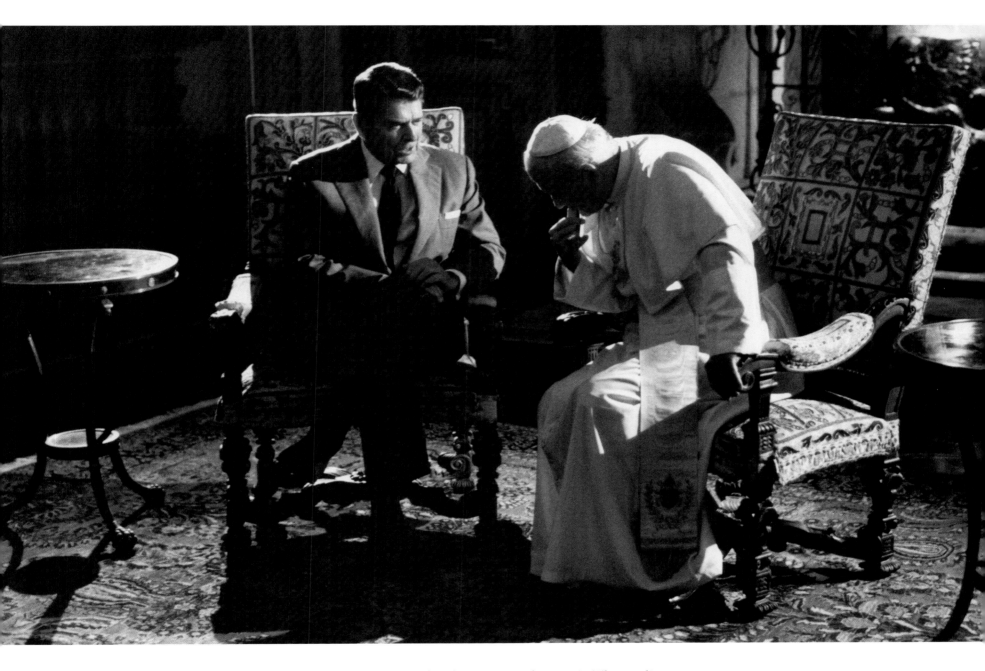

▲ The president meets with Pope John Paul II in Miami, Florida, in September 1987. The media photo op had just ended; a press aide turned off all the TV lights except for the hair light. The lighting was thus unintentionally dramatic as the pope leaned forward to listen to Reagan.

▸Reagan talks on the telephone to activist Gino Casanova before a black-tie dinner at a New York City hotel. He was trying to convince Casanova to end his hunger strike on behalf of POWs and MIAs. Casanova, a former marine, lost 43 pounds in 51 days. According to news reports, he fasted while "crammed in a seven-foot bamboo cage on a snow-covered cow pasture," in Kent, Washington. When the press reported that Casanova's health was quickly deteriorating, the president called him and convinced him to end the strike.

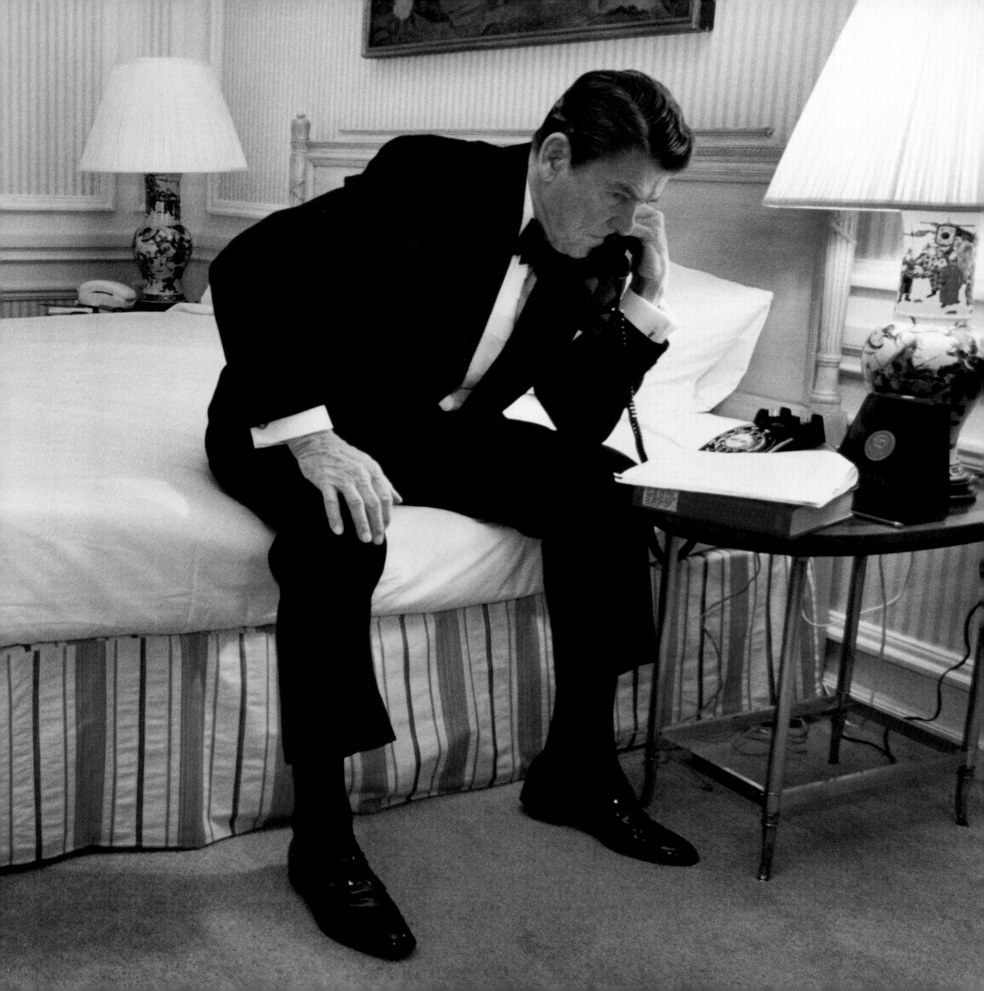

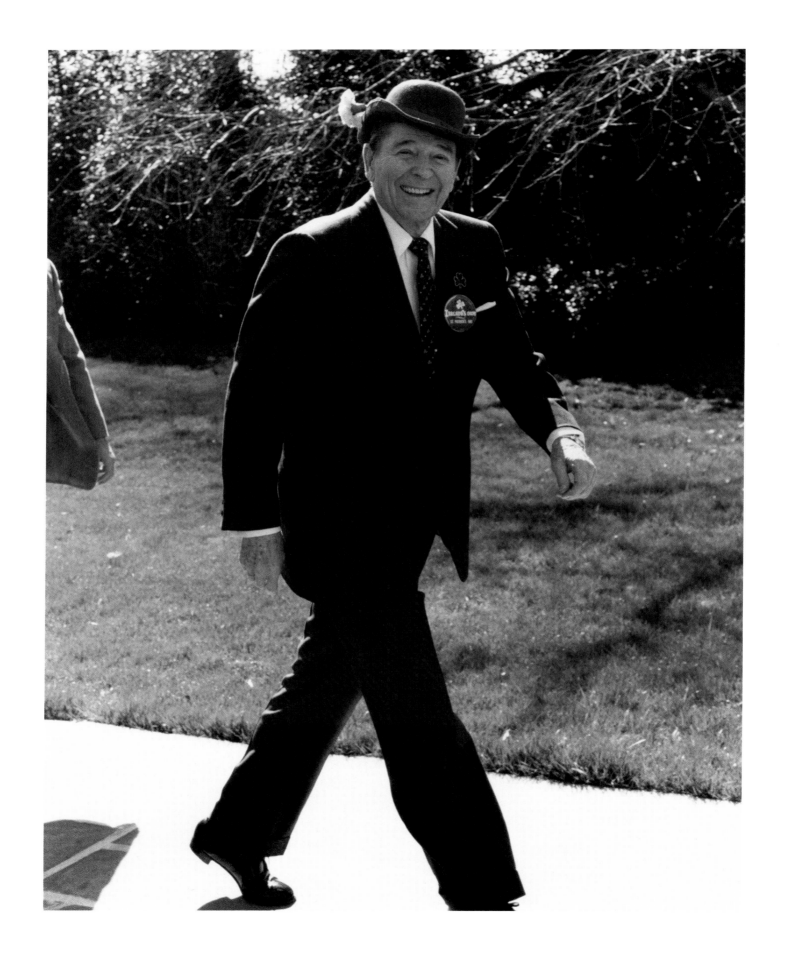

THE LIGHTER SIDE

◄ The president walks toward the Oval Office from his motorcade after visiting an Irish pub on St. Patrick's Day in nearby Alexandria, Virginia. This event had been what the staff referred to as an "OTR"—an off-the-record stop that wasn't on the president's schedule. In fact, the visit had been set up by a White House advance man and approved by the Secret Service. Reagan ate lunch and sipped a beer at the pub amidst the cheering customers. When he arrived back at the White House and stepped out of his limousine, the president was wearing this Derby cap that someone had given him. I sprinted from my car in the motorcade to catch up to him, and he let out this spontaneous laugh when he spotted me taking a picture.

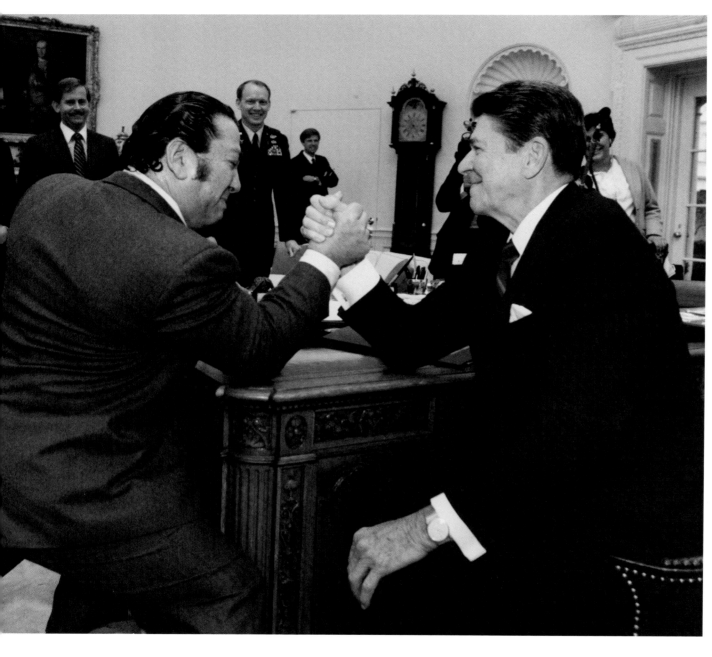

◄ Dan Lurie, editor of *Muscle Training Illustrated*, arm wrestles Reagan in the Oval Office in 1984. Lurie had just presented Reagan with a plaque for being the "most physically fit president of all time." As Lurie later told *New York Times* columnist Ira Berkow:

> I said, "Now that you have the title, I would like to challenge you to an arm wrestling contest." Just like that.
>
> I guess that's my crazy sense of humor. I thought he'd say, "No, bring on the next character, and get this guy outta here."
>
> But he said, "Sure."
>
> We sat down and plunk! He flattens me in about 30 seconds. I wasn't ready for him to be so strong. I screamed for a rematch. He puts me down again, this time in about 40 seconds.

Lurie saved the best moment for last. As he was bidding him farewell, he asked the president if he could kiss him, saying, "'Cause I'm a kissin' kind of guy." He then bussed Reagan smack on the cheek.

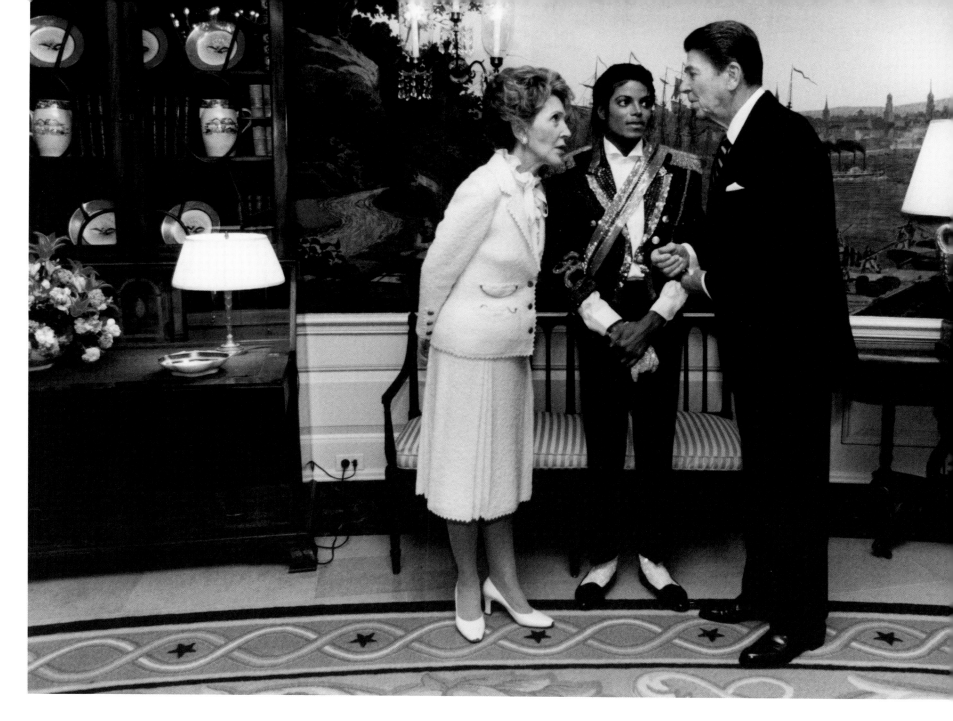

▲ Pop singer Michael Jackson becomes a momentary bystander as the Reagans engage in a private conversation in the Diplomatic Reception Room. Later, on the South Lawn of the White House, Jackson joined the Reagans for a ceremony honoring a campaign for drunk-driving awareness. Prior to the visit, the White House administrative office circulated a memo to all staff instructing them not to bring their children to the event so that Jackson would not be overwhelmed by his fans.

But when Jackson showed up in the Diplomatic Reception Room, he was immediately surrounded by—you guessed it—members of the White House staff and their children. Jackson sought refuge in a men's room in the White House library until the Reagans appeared. In 200 years, how will a historian explain this picture? Who is this man with the funny suit listening in on a private conversation between the president and his wife?

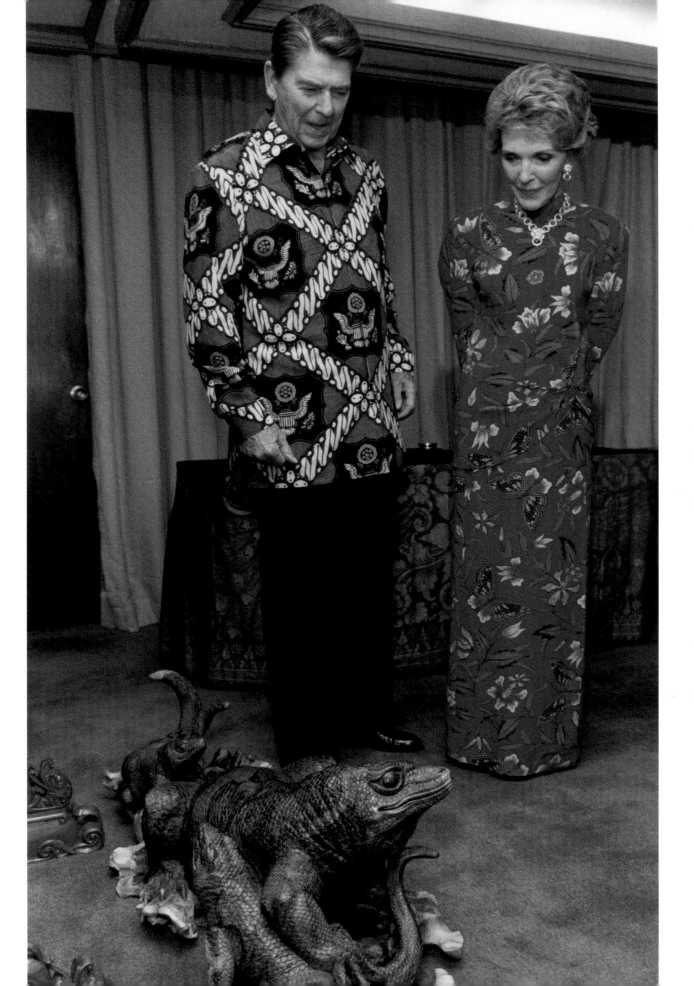

◄ The Reagans view their official gift from the president of Indonesia. I still chuckle every time I look at this picture. We were in a holding room prior to a formal state dinner in Bali, and the Reagans had just been presented with this gift. The president later used this picture as part of a slide show he gave at the White House News Photographers' Association's annual dinner in 1988. "On another trip," he joked to the audience, "the government of Indonesia gave us these gifts . . . and they're our friends. Actually, I love this shirt. I finally found something louder than Sam Donaldson." (Donaldson, the ABC news correspondent, had gained infamy for always shouting questions to Reagan.)

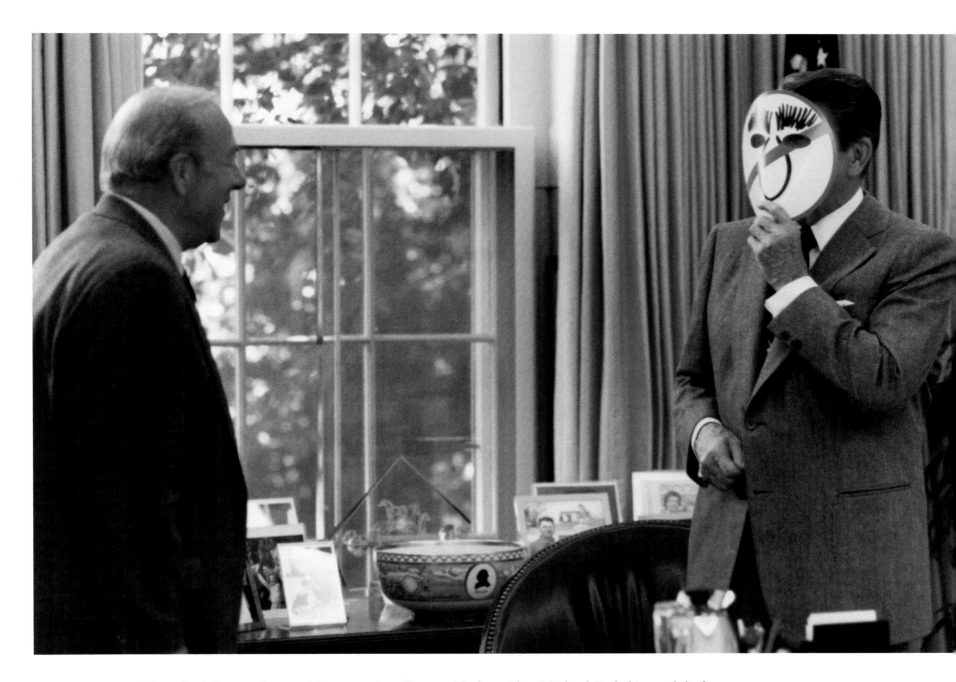

▲ Ever the jokester, the president surprises George Shultz with a Michael Dukakis mask before their scheduled meeting. Dukakis was the Democratic nominee for president in 1988 and was running against Vice President George Bush. Reagan loved to hear the latest campaign jokes, even if they were sometimes in bad taste.

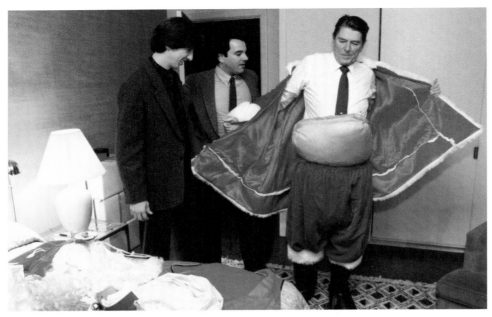

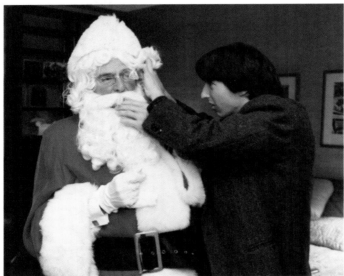

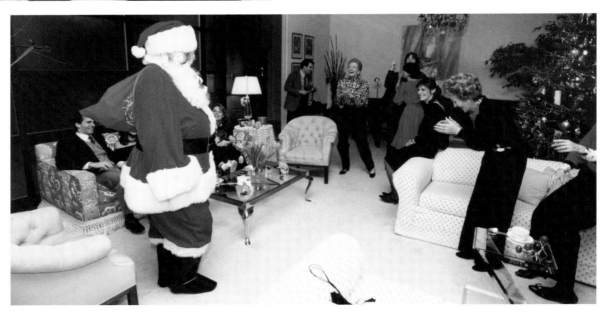

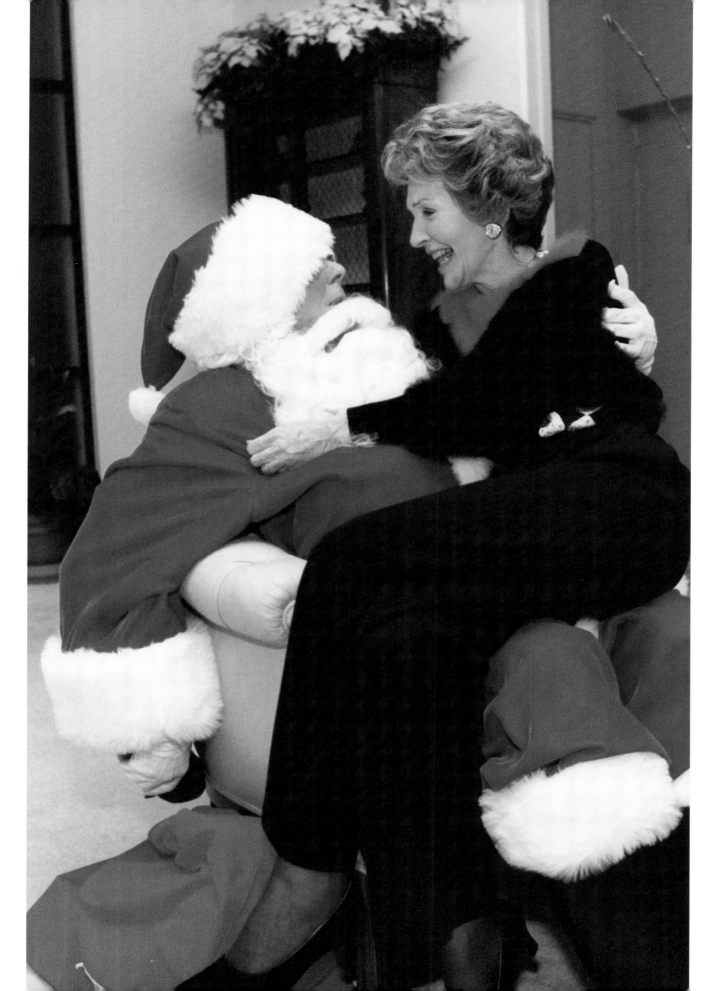

◄ The president plays Santa Claus. Every year the Reagans got together for Christmas Eve with Charles Wick and his family. I presumed that I would be spending the occasion watching TV with the military aide in one of the Wick bedrooms. But Mrs. Wick soon came to find me. "It's our tradition for someone to dress up like Santa Claus," she said. "And this year, it's the president's turn." Ooh, I thought, this could be interesting. The president's son, Ronald Prescott Reagan, helped him put on the Santa outfit in one of the bedrooms. Everyone laughed as Santa Reagan appeared in the Wick's living room. One by one, they all sat on his lap and he gave them each a gift.

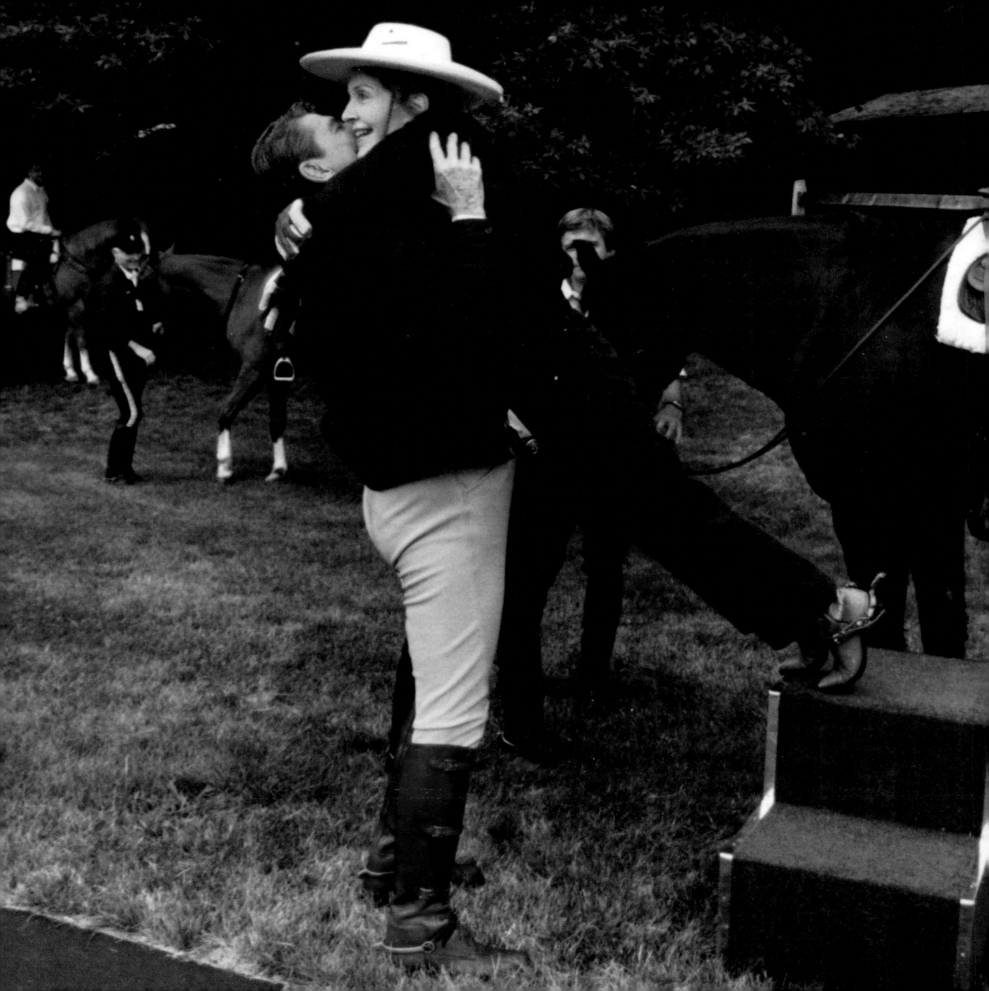

◄ The president helps Mrs. Reagan from her horse following a weekend ride at Camp David.

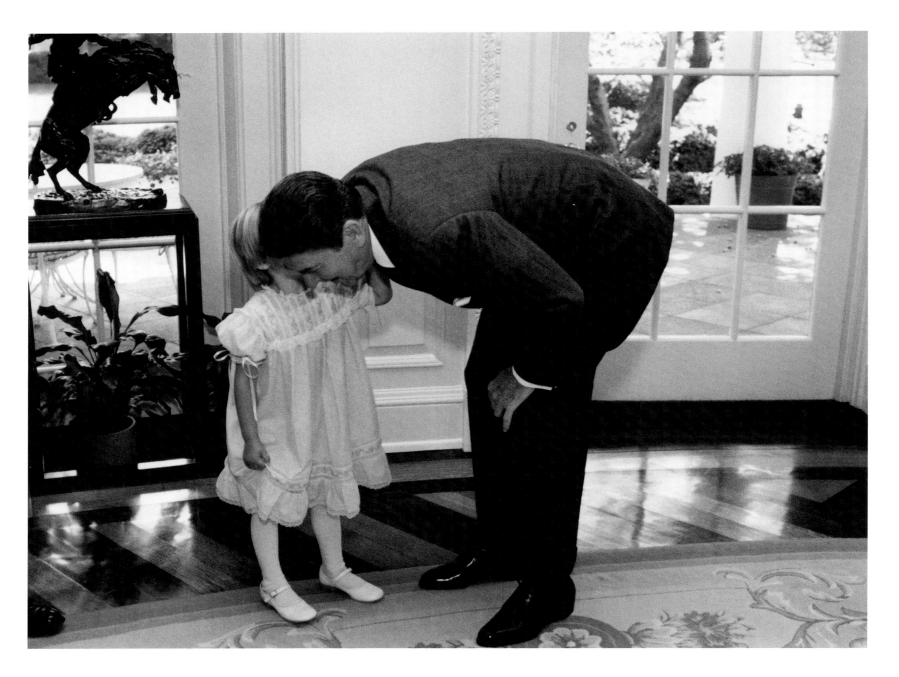

▲ Three-year-old Lucy Tutwiler whispers her name to Reagan. She is the niece of Margaret Tutwiler, then an aide to Chief of Staff Jim Baker. Upon entering the Oval Office, Lucy eyed the president and asked, "What's your name?" He replied, "Ronald Reagan; what's yours?" That's when Lucy insisted on whispering her answer in the president's ear.

◄ President Reagan and Vice President Bush stand mischievously in front of the fireplace in the Oval Office. They were waiting for Chief of Staff Don Regan, who was late for their 9:00 meeting. The president was a very punctual man; 9:00 meant 9:00. The president's personal aide, Jim Kuhn, called Regan's office to tell him that the president and vice president were waiting. You can almost envision Regan then running down the hallway. The president motioned Bush over to the fireplace just as the back door to the Oval Office opened. Don Regan rushed in. He first glanced toward the president's desk, but no one was there. He then peered around the door to see Reagan and Bush standing with their backs to the roaring fire. "Just warming our buns," the president, with a burst of laughter, told his chief of staff.

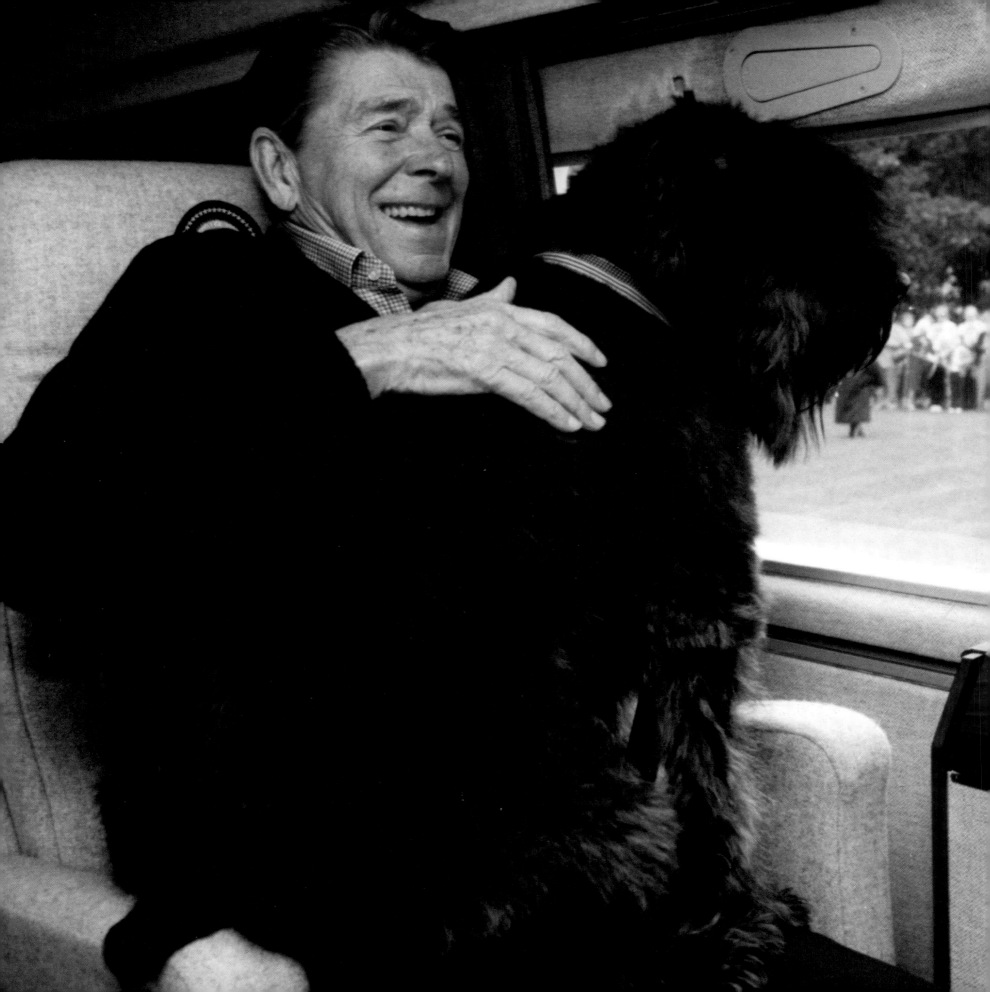

◄ Lucky the dog sits on the president's lap. We were headed to Camp David for the weekend. Lucky, who had been such a cute puppy, had now grown quite big. She hopped up on the president's lap as the helicopter lifted off from the South Lawn of the White House. Reagan roared with laughter. It wasn't too much later that Lucky was sent packing to California. "Banished to the ranch," some said. I suspect, though, that she was a heck of a lot happier running around the hundreds of acres in California than she would have been living confined at the White House.

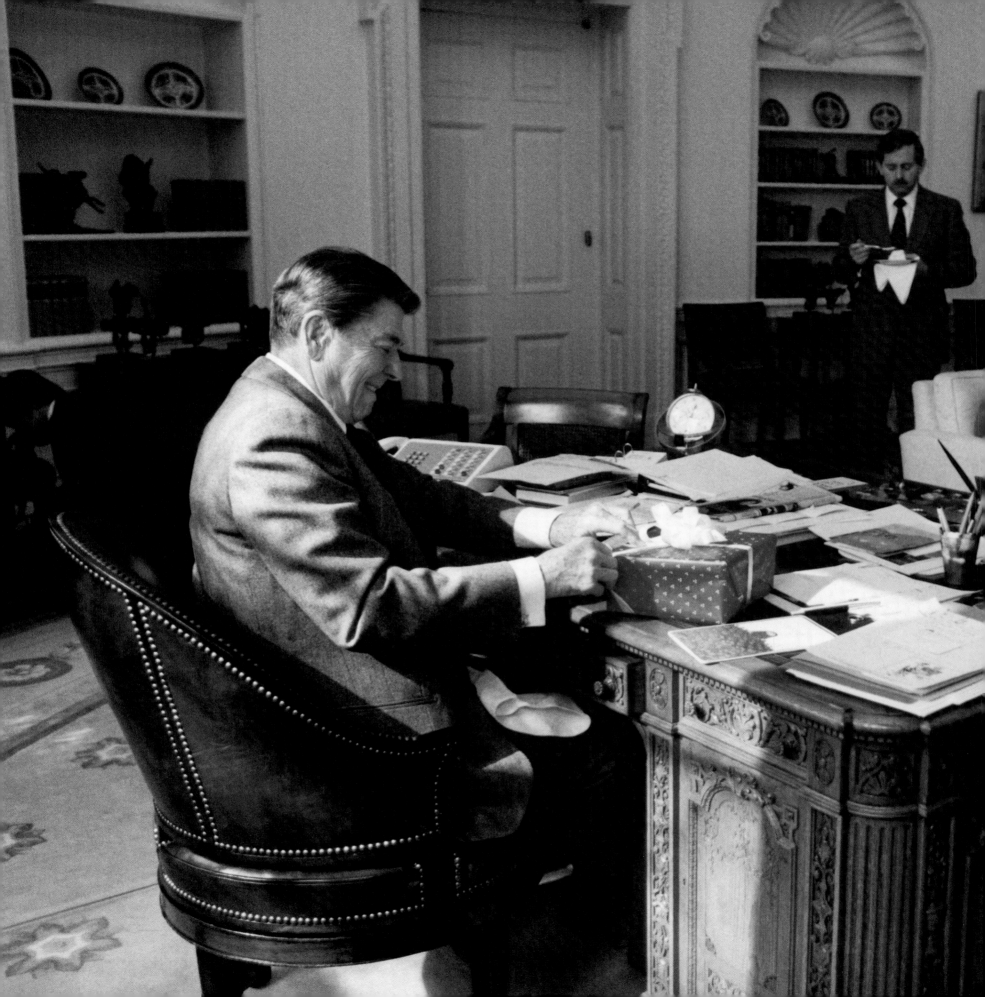

◄ President Reagan opens a birthday present in the Oval Office in 1985. Eating birthday cake in the background are his first-term personal assistant David Fischer and personal secretary Kathy Osborne. The president exhibited the excitement of a little kid tearing open his birthday gifts.

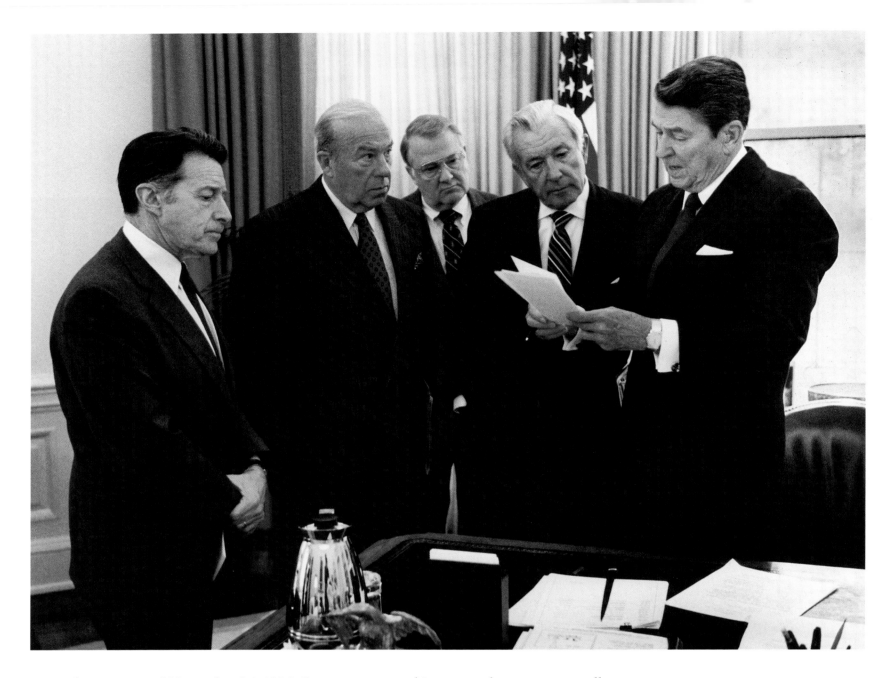

▲ On the morning of November 26, 1986, Reagan goes over his notes as he prepares to tell congressional leaders about the latest development in the scandal. Reagan had ordered Attorney General Ed Meese to conduct an internal administration investigation into the Iran initiative. To make the scandal even worse, Meese discovered that the Iranians were being overcharged for the arms sales and that National Security Aide Oliver North was diverting those profits to help fund the Contra rebels in Nicaragua. (Reagan called the Contras "freedom fighters" because they were attempting to overthrow a communist dictator in that Central American country. Congress had gone back and forth on funding the Contras.) The tension and concern in the room was evident on everyone's faces minutes before the president told congressional leaders, and then the nation, about the diversion of funds. The two-fold scandal now became known as the "Iran-Contra" affair. From left are Defense Secretary Caspar Weinberger, George Shultz, Meese, and Don Regan.

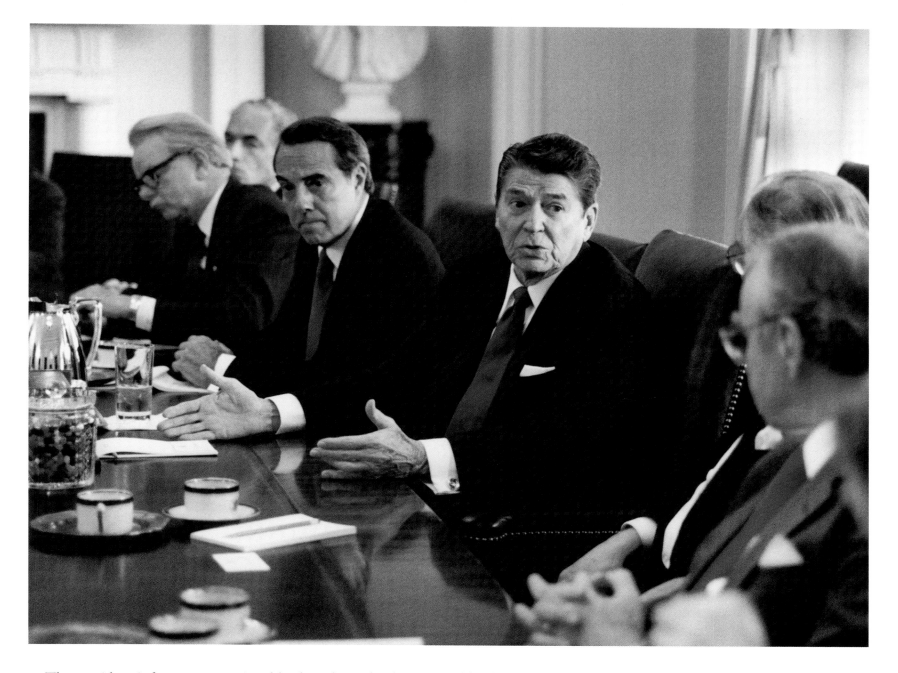

▲ The president informs congressional leaders about the diversion of funds to the Contras from the arms sale to Iran. He also told them that he had fired Oliver North and that National Security Advisor John Poindexter had just resigned. Later, in testimony before Congress, Poindexter said he had approved North's diversion of funds and "made a very deliberate decision not to ask the president so that I could insulate him from the decision and provide some future deniability for the president if it ever leaked out." He said Reagan did not know about the diversion of funds. "The buck stops here with me," he testified. A jury convicted Poindexter in 1990 on five felony counts of misleading Congress and making false statements, but an appeals court overturned the verdict because Congress had given him immunity for his testimony.

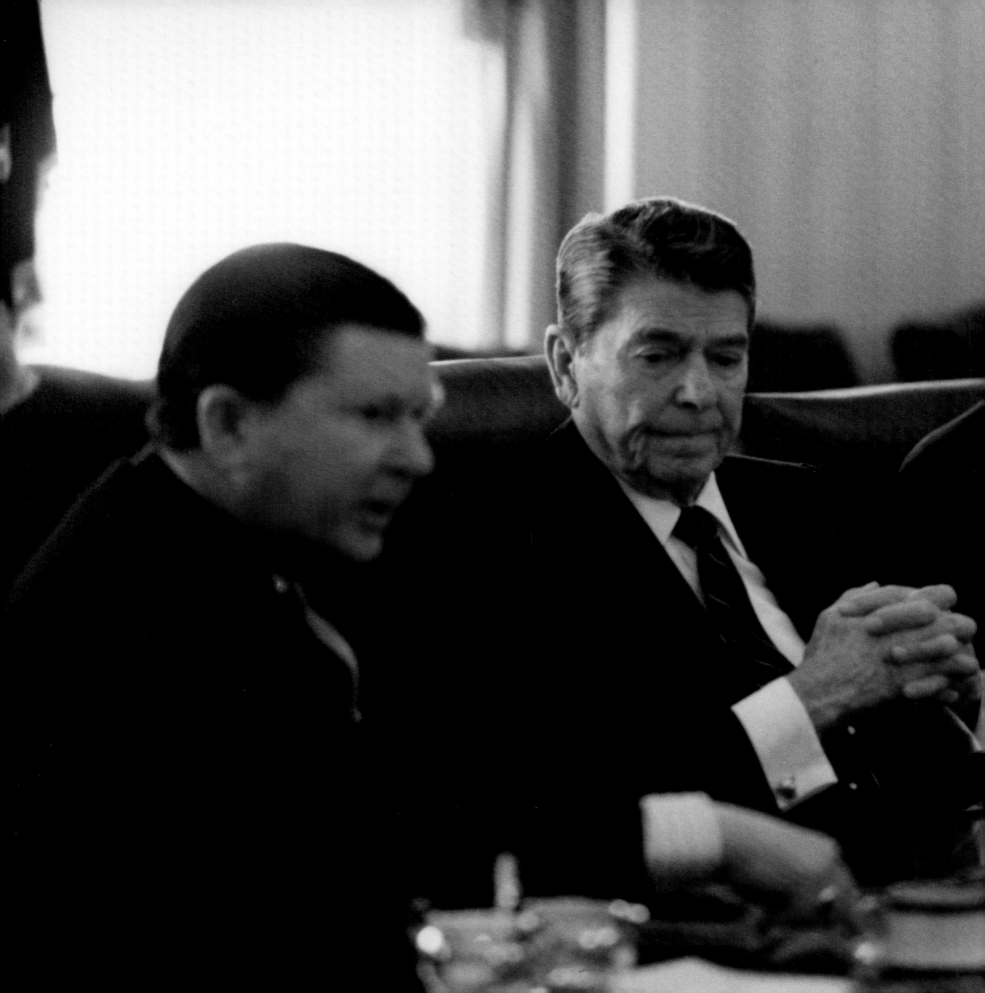

◄ Former Senator John Tower presents his report to Reagan in February 1987. Reagan had appointed the Tower Commission to investigate the Iran-Contra affair. Tower headed the commission. The atmosphere in the Cabinet Room was extremely tense when Tower gave his report. Only a handful of aides were present. I had staked a good vantage point for pictures and stayed put throughout the entire meeting because I wanted to minimize my presence so I wouldn't get kicked out of the room. This picture was taken at the exact moment that Tower shared his commission's conclusion that the administration indeed had traded "arms for hostages." The look on Reagan's face shows how he felt.

Despite admitting that he had made mistakes, Reagan felt he had done the right thing. In his autobiography, he wrote that the Iranian initiative "was made to *look* like an arms-for-hostage deal. . . . We never had any contacts with the kidnappers, had seen to it that the defensive weapons that went to Iran never got into the hands of the people who held our hostages."

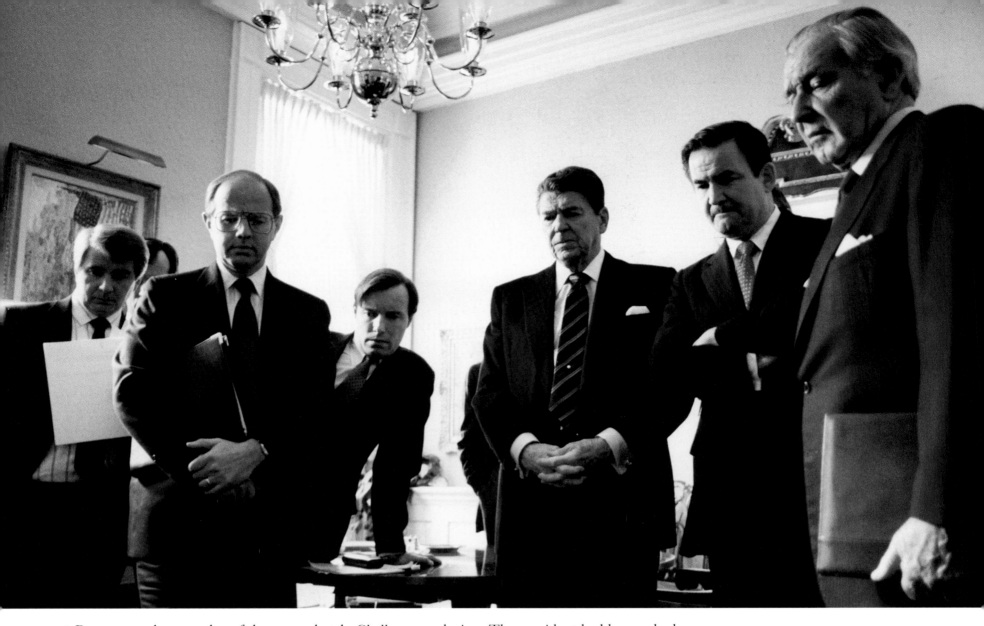

▲ Reagan watches a replay of the space shuttle *Challenger* explosion. The president had been scheduled to meet with the network news anchors the morning of January 28, 1986, as a prelude to his State of the Union address that night. I was in the Roosevelt Room with Dan Rather, Peter Jennings, Tom Brokaw, and Bernard Shaw awaiting the president's arrival; Reagan and his aides were in the Oval in a prebriefing. Via pager, the news anchors began receiving word that the *Challenger* had exploded; they informed the White House press aide that they had to leave. I headed to the Oval Office and passed by the president's secretary, Kathy Osborne, who said, "They're in the study." I walked through the Oval into the adjacent private study and found President Reagan and his aides watching a television replay of the explosion. At one point, the president closed his eyes for a few seconds, apparently in prayer. As a tribute to the astronauts, he postponed his State of the Union address and, that afternoon, gave a moving speech to the nation. He concluded his speech with the words: "We will never forget them, nor the last time we saw them, this morning, as they prepared for their journey and waved good-bye, and slipped the surly bonds of Earth to touch the face of God."

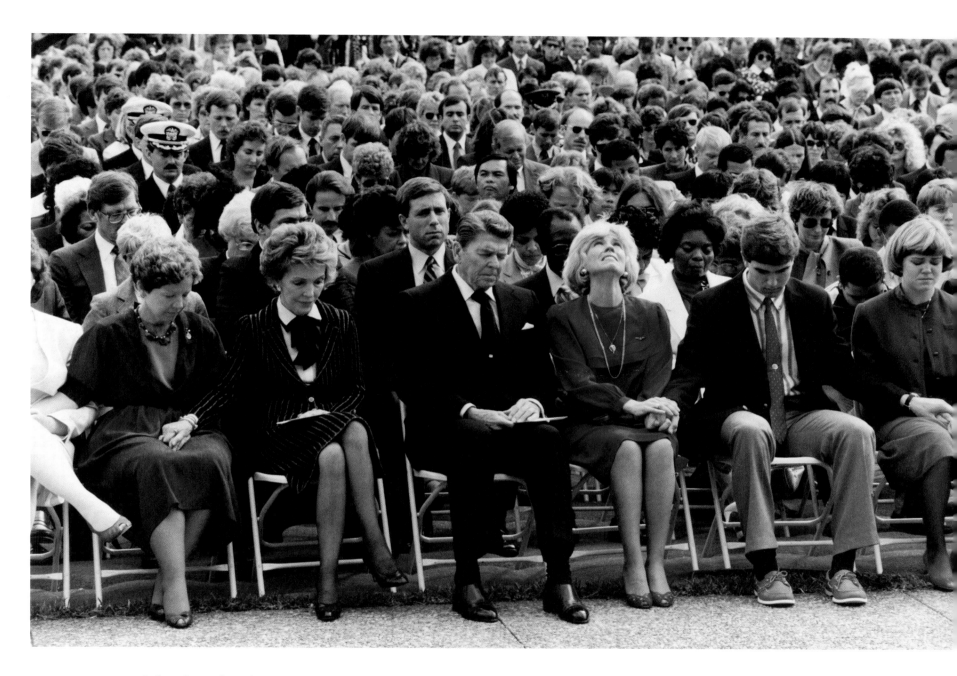

▲ A few days after the *Challenger* explosion, the president and Mrs. Reagan attended a memorial service at Johnson Space Center in Houston, Texas. The Reagans sat next to the astronauts' families during the moving ceremony. It was customary following any event that the president would retreat to a holding room backstage, where he'd wait for the staff and press to board the motorcade. In the holding room after this memorial service, we could hear the wrenching shouts and cries of emotion from the families.

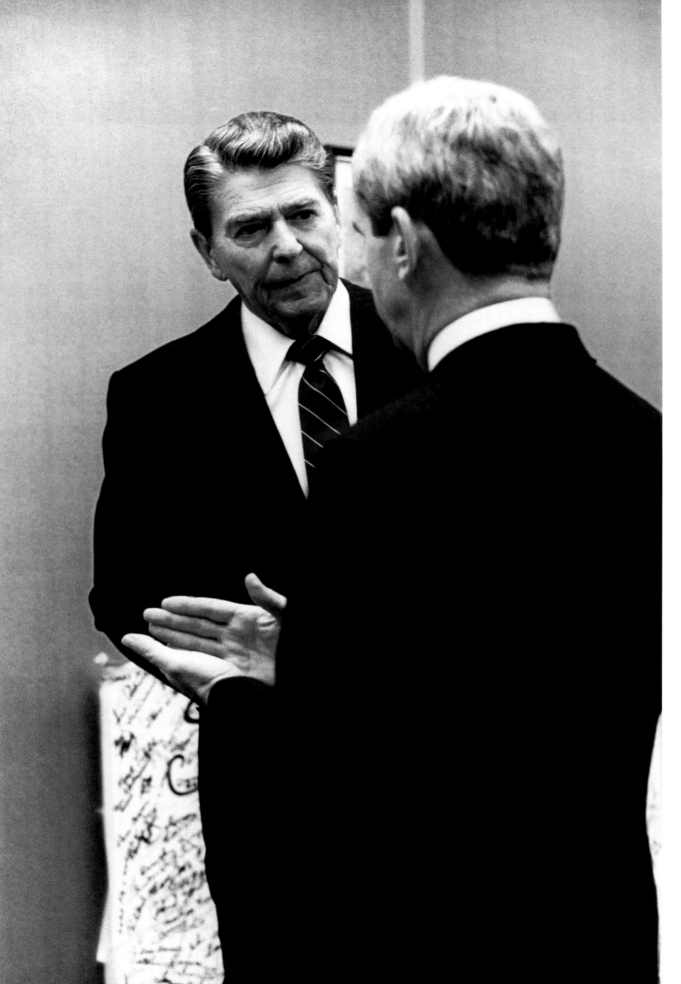

◄ National Security Advisor Bud McFarlane confers with President Reagan in the holding room at Sara Lee headquarters outside of Chicago. McFarlane reported that the hijackers of the Italian cruise ship *Achille Lauro* had just been spotted through intelligence means and were about to board an Egyptian airliner to Tunisia. McFarlane then inquired whether Reagan wanted American fighter pilots to intercept the hijackers. Without hesitation, Reagan replied in a soft, but authoritative voice, "Yes, OK, go ahead."

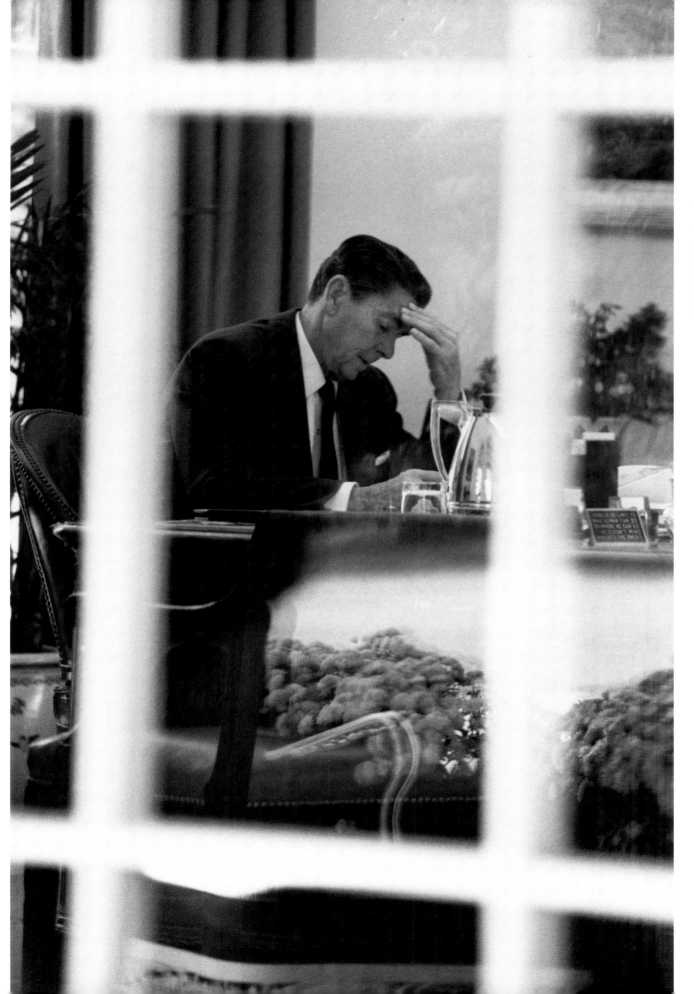

◄ Seen through an Oval Office window, the president works on his address to the nation regarding the terrorist bombing of the U.S. Marine barracks in Beirut, Lebanon, that killed 263 marines in 1983.

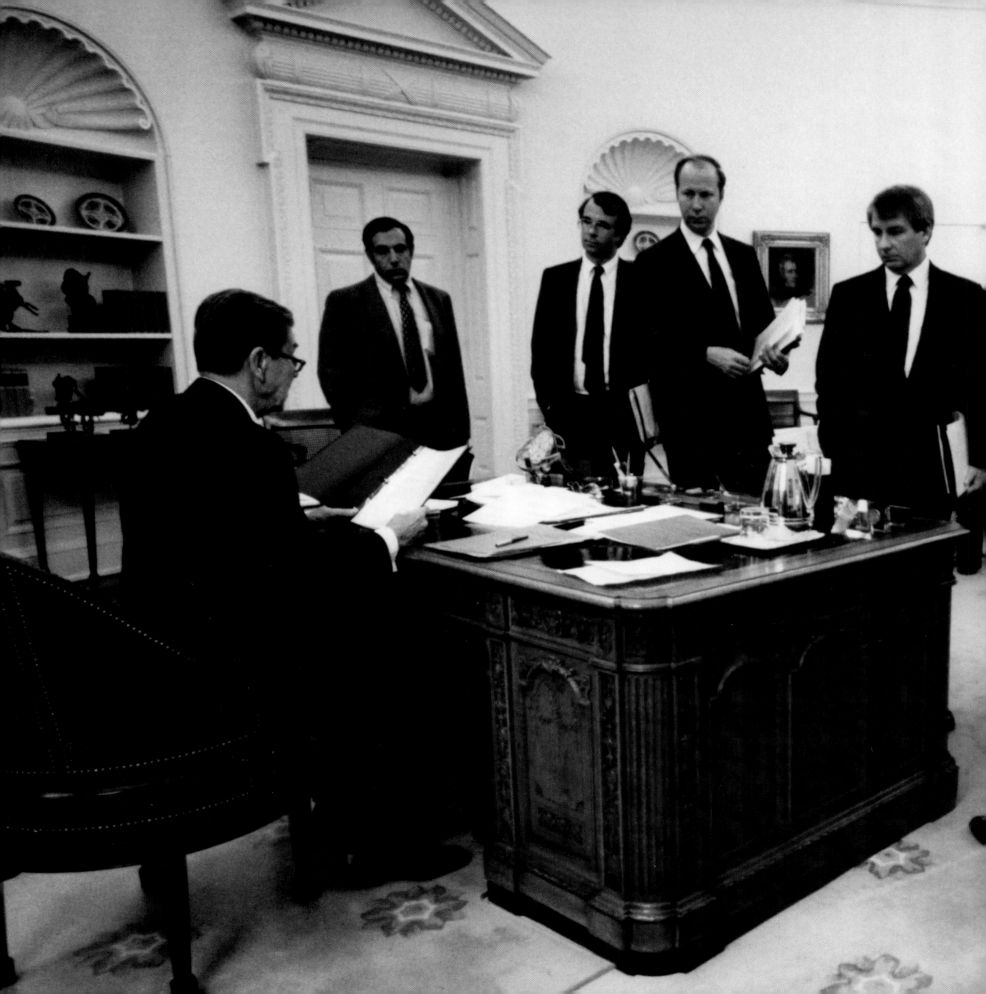

◄ The president reads a letter from the mother of a U.S. Marine killed during the barracks bombing in Beirut. He took letters like this very seriously and made an effort to personally reply to families who had lost loved ones who were serving in the military.

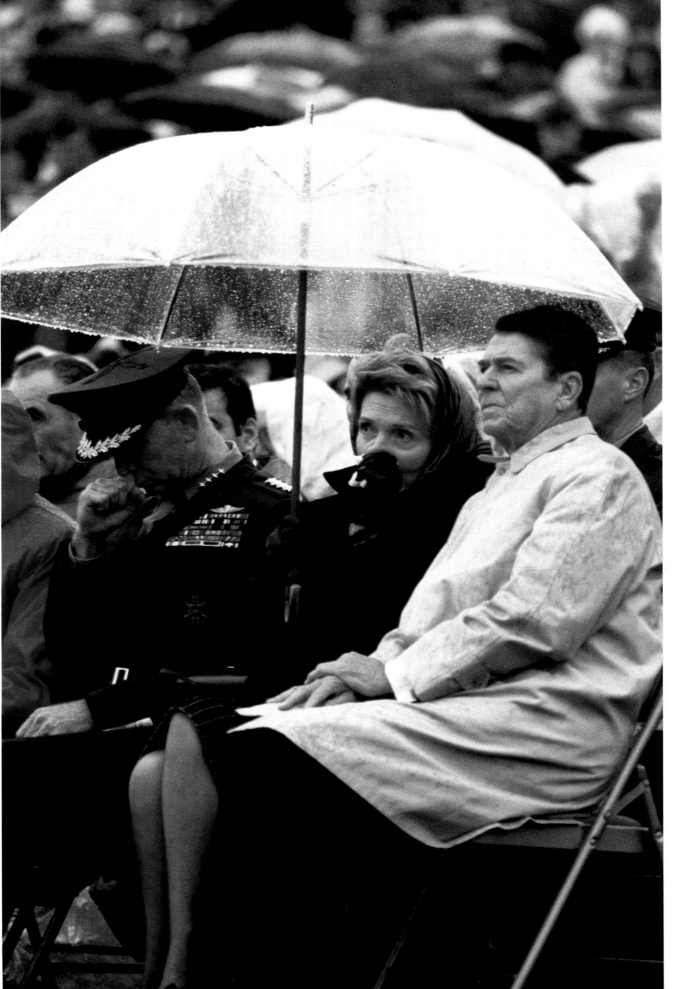

◀ The Reagans attend a memorial service at Camp Lejeune, North Carolina, for the marines killed and injured in the Beirut bombing. It was a very solemn occasion on a very rainy day

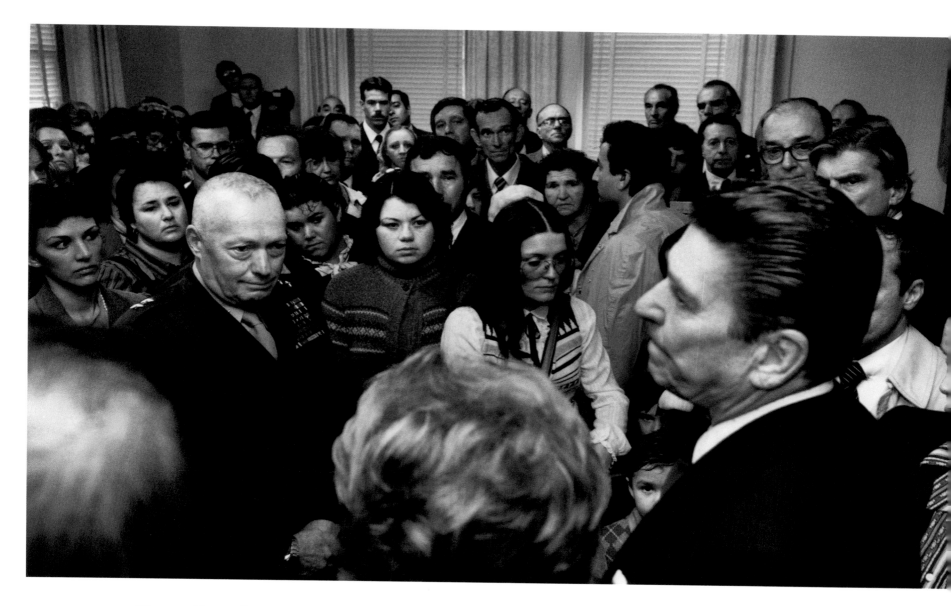

▲ The president talks privately with family members following the memorial service at Camp Lejeune. The room was packed, both with people and with emotion.

▶ During a meeting in the White House Situation Room, the president asks a question of General Robert T. Herres, vice chairman of the Joint Chiefs of Staff, following the 1987 Iraqi bombing of the USS *Stark* in the Persian Gulf. Caspar Weinberger is seated at left.

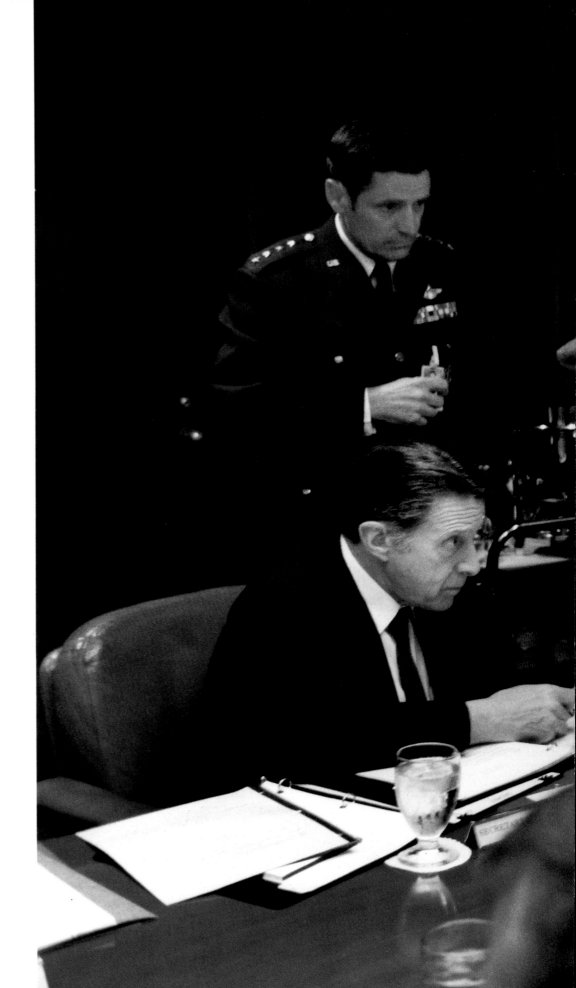

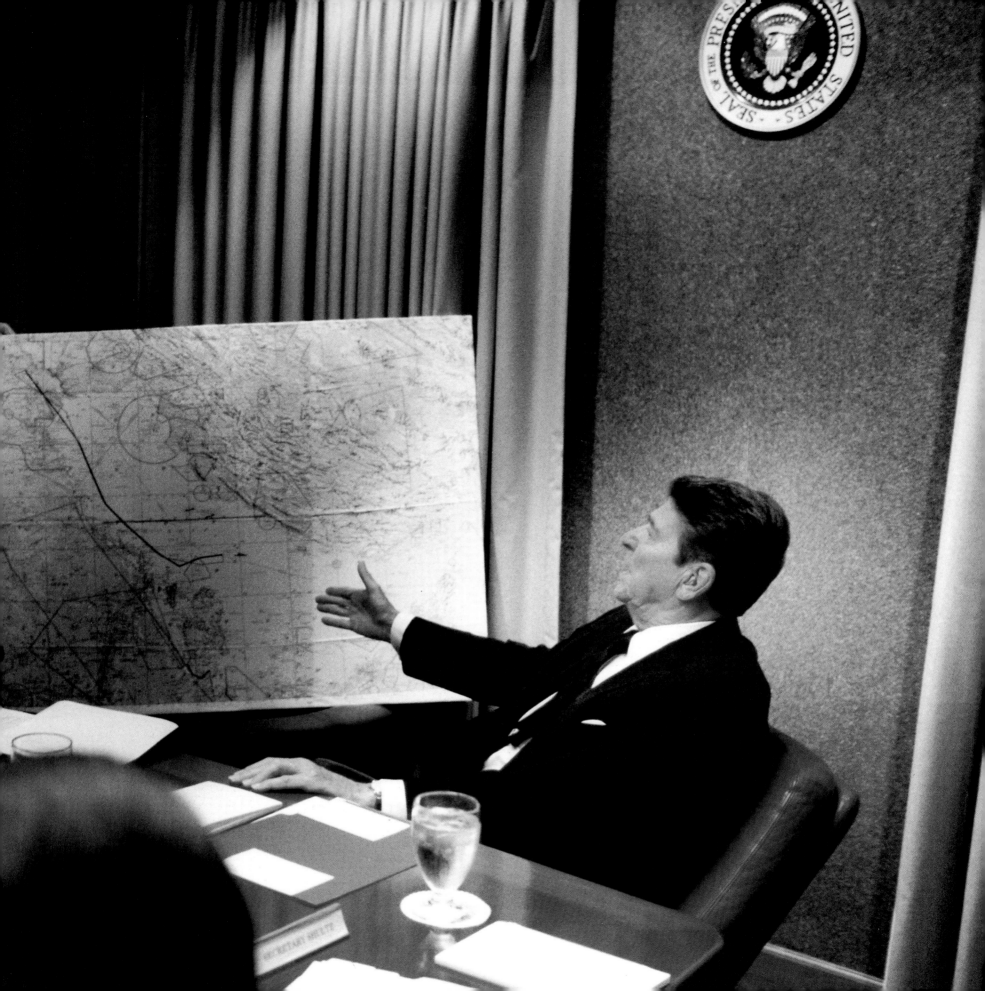

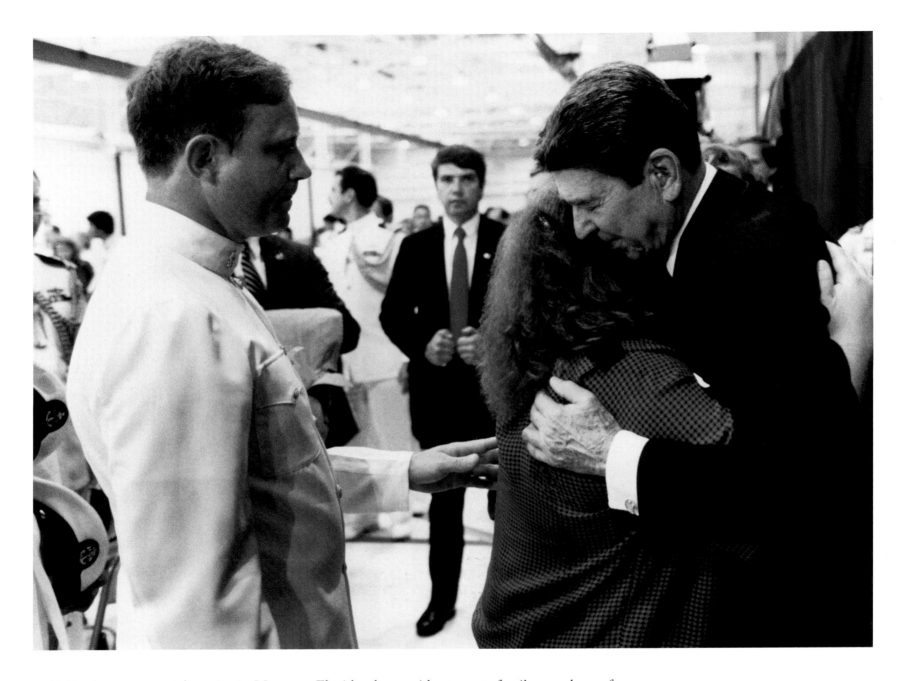

▲ Following a memorial service in Mayport, Florida, the president greets family members of servicemen killed in the USS *Stark* bombing. I often wondered how moments like this weighed on his mind. In his role as commander in chief, he makes a military decision based on what he thinks is best for the country. The Congress concurs with his decision, and the latest poll shows the American people rallying behind him.

▲ But when tragedy results, he is alone. The president is the one who, personally, has to face the blame. He is the one who has to look the grieving widow in the eye. He is the one who sees family members' tears and feels their embraces. During discussions about military decisions, most of his advisors would talk about potential casualties as numbers. To the president, it was much more personal.

▸ Chief of Staff Don Regan briefs the president at Bethesda Naval Hospital a few days after the president underwent major surgery to remove a cancerous growth near his colon.

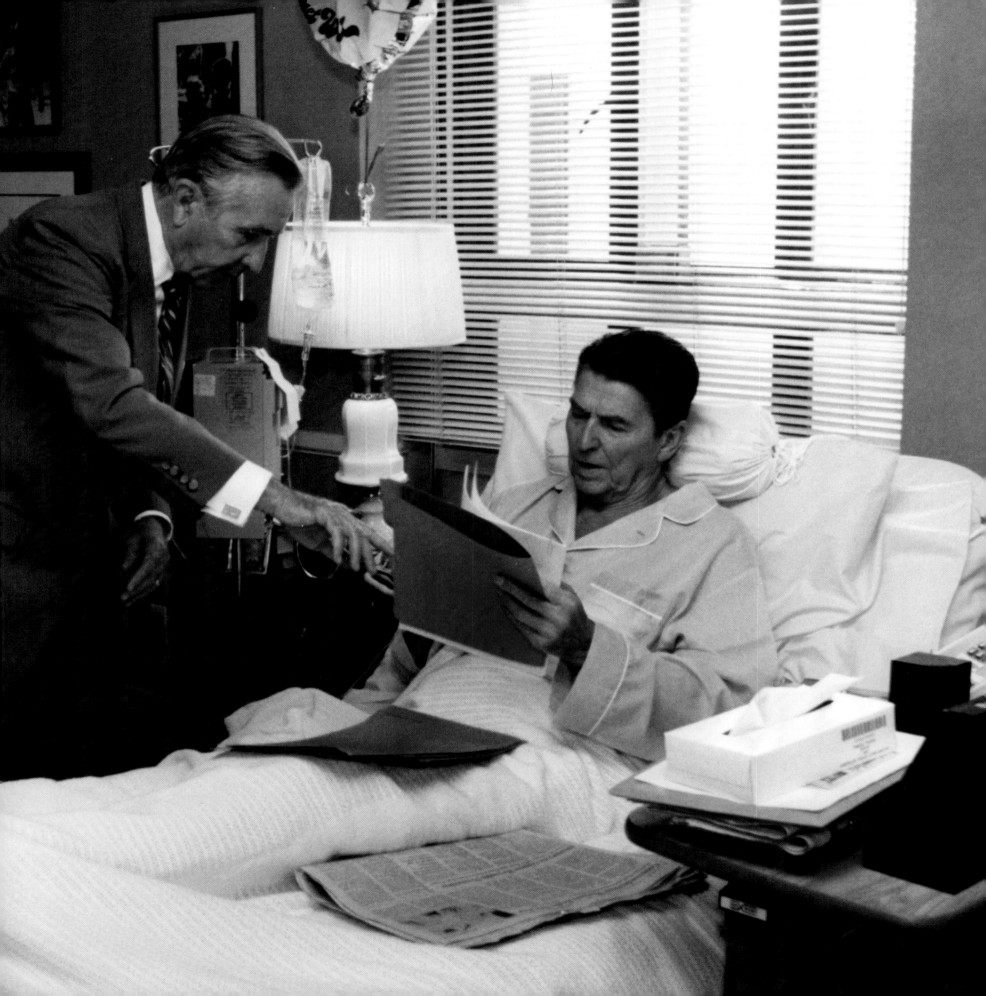

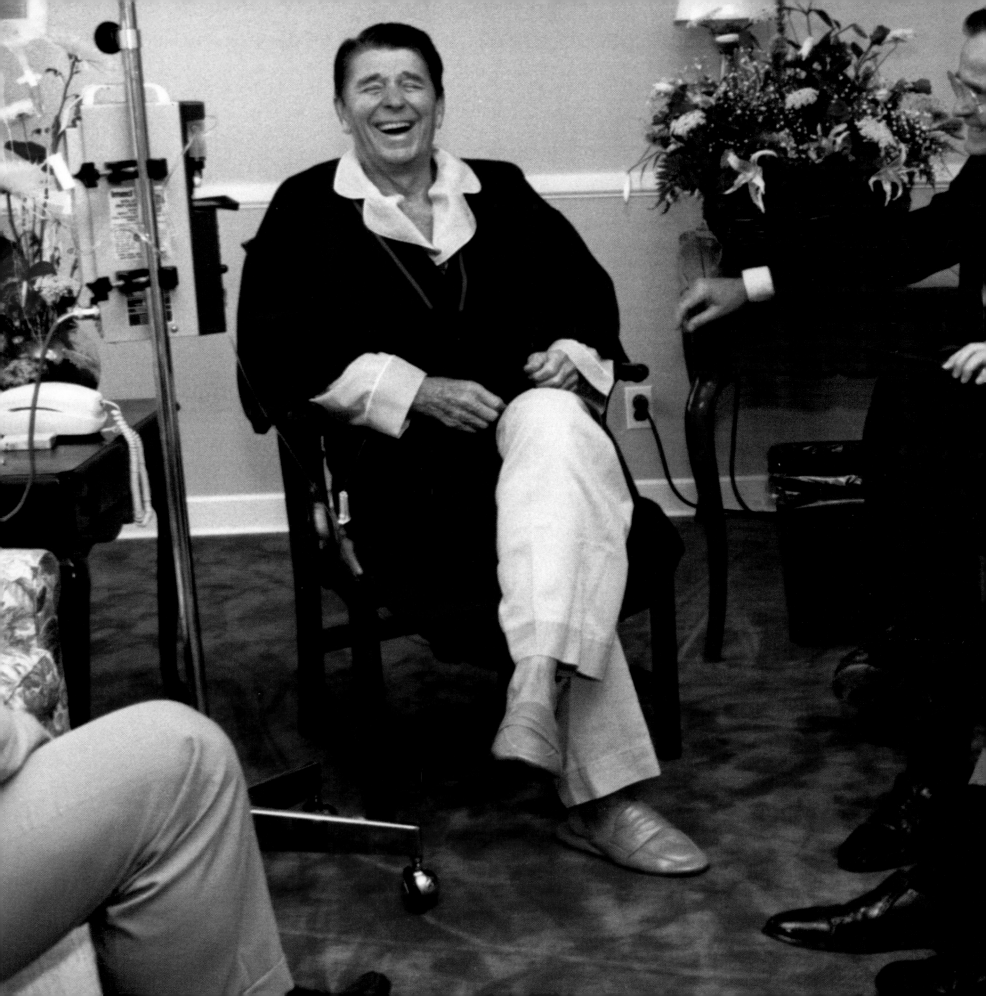

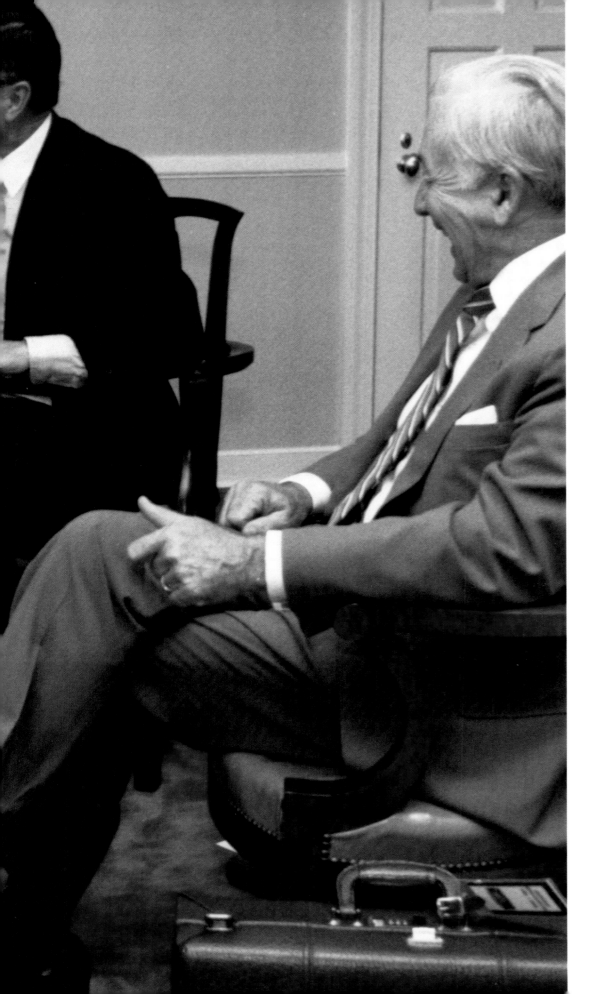

◀ The president laughs at the punch line to a new joke prior to a meeting with Vice President Bush and Don Regan. The White House released this picture that day as the world wondered how Reagan was recuperating from his cancer surgery. Several people didn't want this particular picture released because Reagan's eyes were closed. But the counterargument was that it really showed him in a true reaction of laughter; thus, he was doing just fine. The compromise was to release this picture as well as a second picture of him talking during the meeting. Most newspapers used this picture on their front pages.

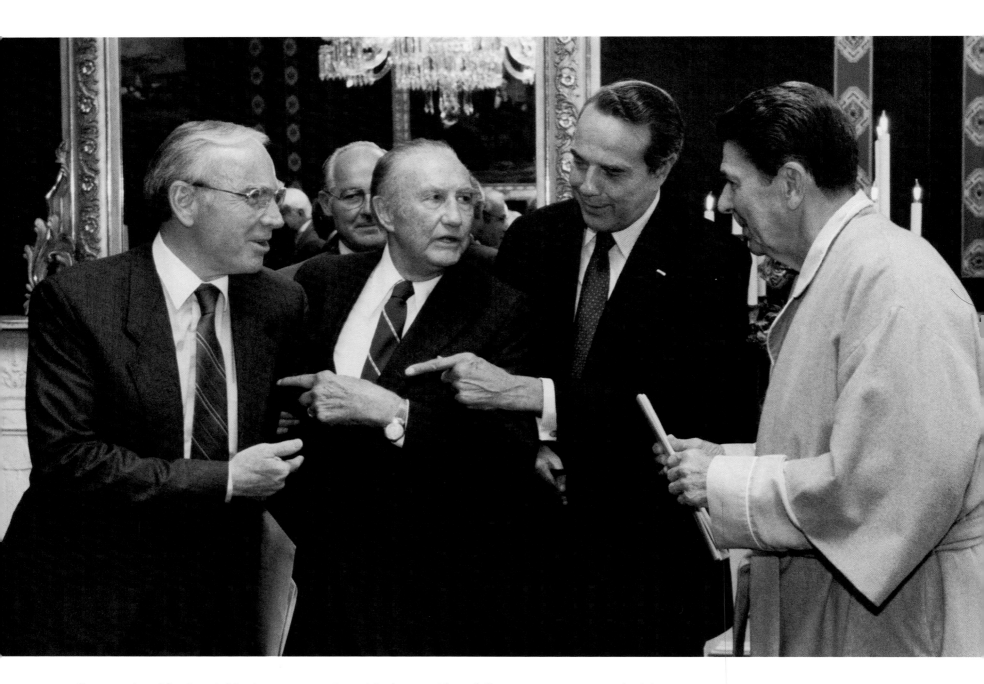

▲ Congressional leaders jokingly argue a point with the president following a meeting in the Treaty Room of the White House residence, where Reagan was recuperating from his cancer surgery. The president used this picture in a slide presentation at the 1988 White House News Photographers' Association's annual dinner with the caption, "While I was recuperating, the congressional leadership came to see me. Here I am asking for a colon donor." From left to right are Representative Jim Wright, Senator Strom Thurmond, and Senator Bob Dole. In the background is Representative Bob Michel.

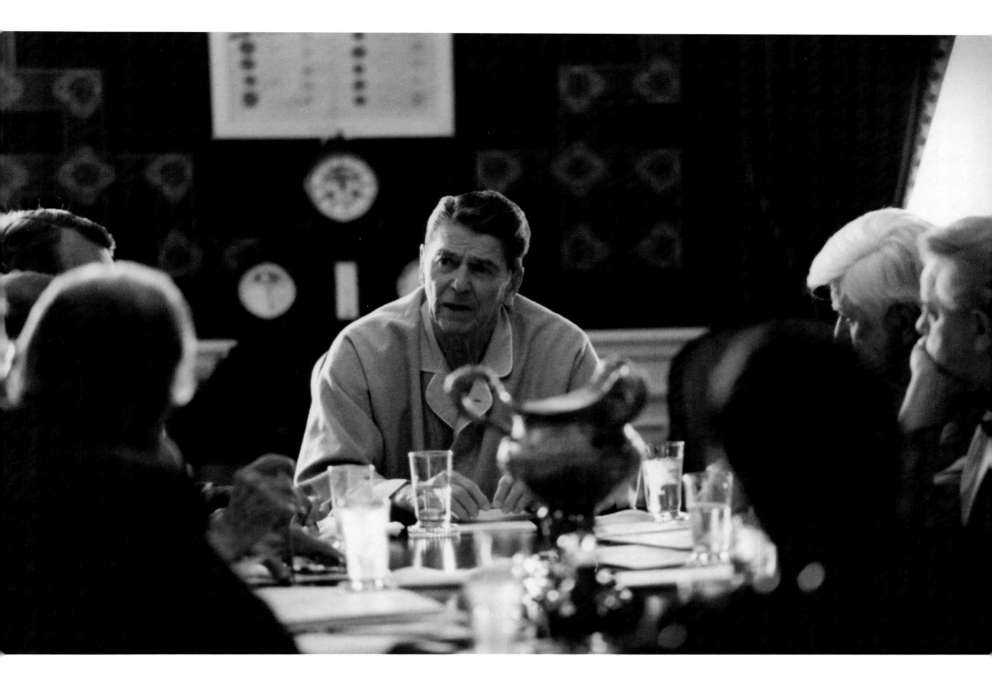

▲ Reagan meets with congressional leaders less than 10 days after his cancer surgery.

▸ The president kisses Mrs. Reagan in her bed at Bethesda Naval Hospital. This was her second day of recovery from breast cancer surgery. Mrs. Reagan was upset that some in the news media were criticizing her for choosing to have a mastectomy rather than a lumpectomy. They said she was sending the wrong signal to the women of America. I sent Mrs. Reagan a card and wrote that my cousin's wife had gone through breast cancer and chose to have a lumpectomy; she didn't survive. I further wrote that she shouldn't listen to what others were saying; she had done what she felt was best for her and no one had the right to question that decision. On this day, I had accompanied the president on the *Marine One* helicopter from the White House to the hospital. When we walked into her hospital room, Mrs. Reagan greeted *me* first. "Oh Pete," she said. "Thank you so much for your card." I felt somewhat embarrassed, but was still able to capture this poignant moment between her and the president.

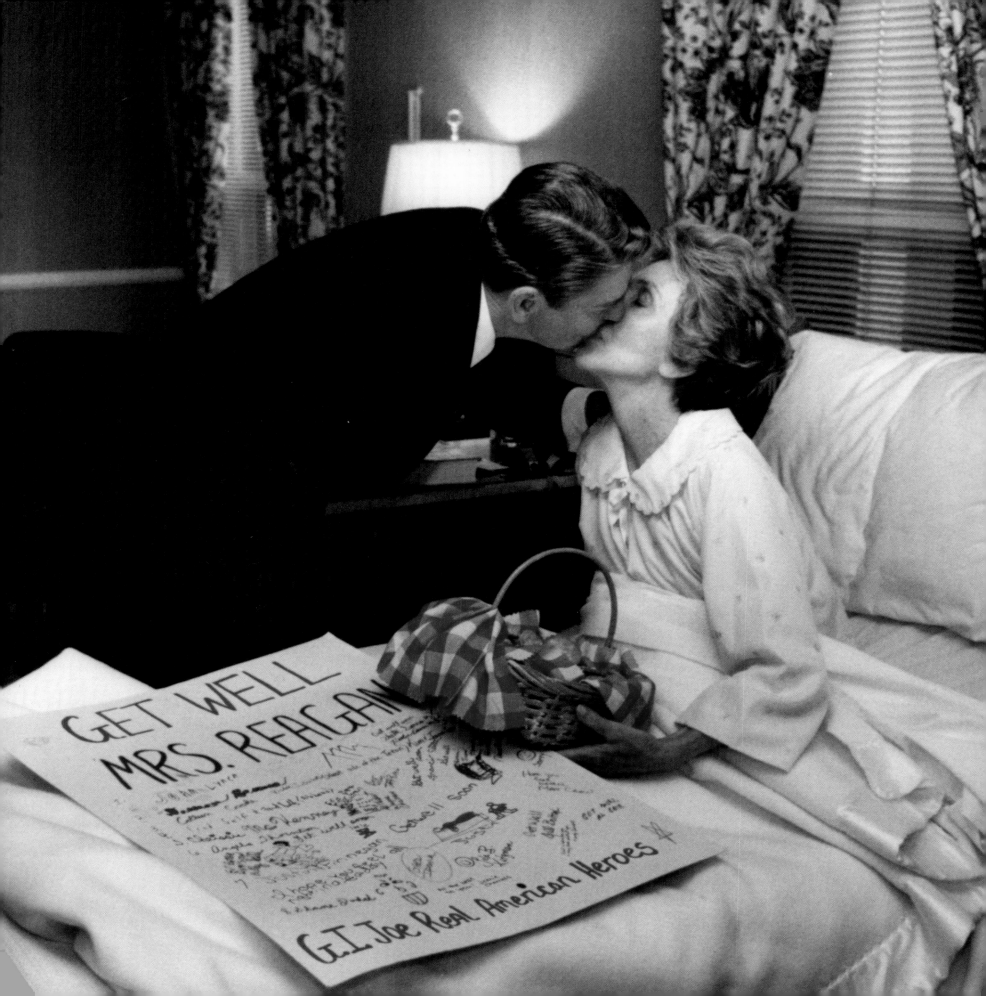

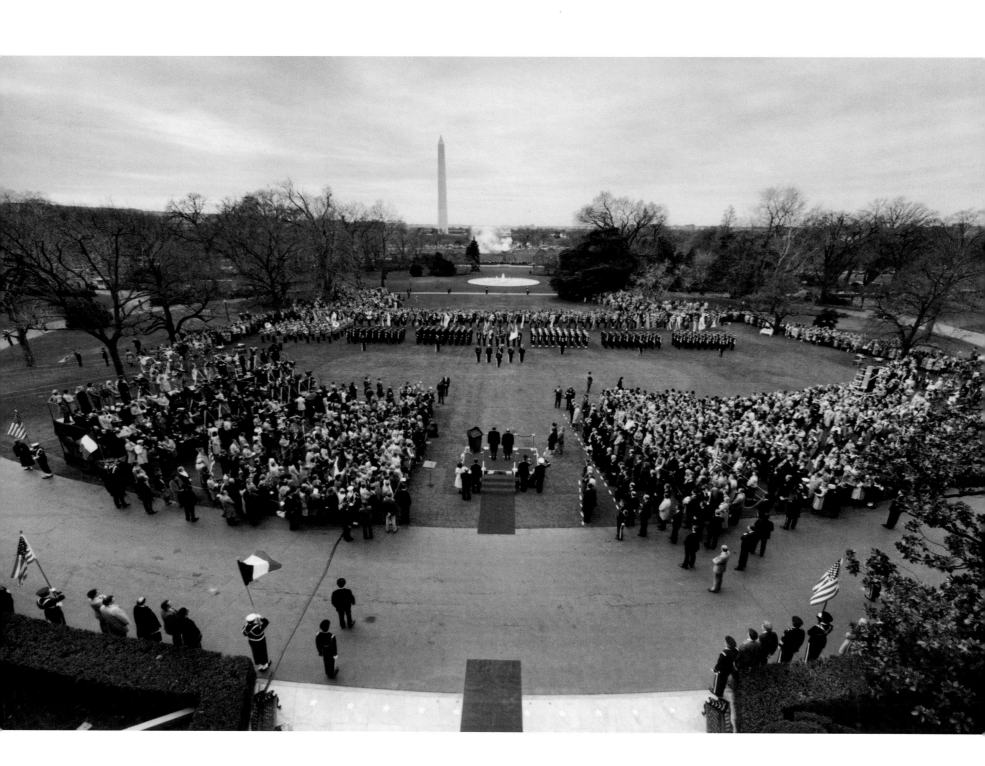

CEREMONY

◄ The Reagans wait to welcome Francois Mitterand, president of France, before a formal state arrival at the White House in 1984. A formal state visit was just that—a formal visit from a foreign head of state. It would include all the pomp and circumstance including an arrival ceremony like this one on the South Lawn, an Oval Office meeting with the two principals, and a Cabinet Room meeting and luncheon with the two principals and their aides . . . all followed that night by a black-tie state dinner on the second floor of the White House residence. This picture was taken from the Truman Balcony.

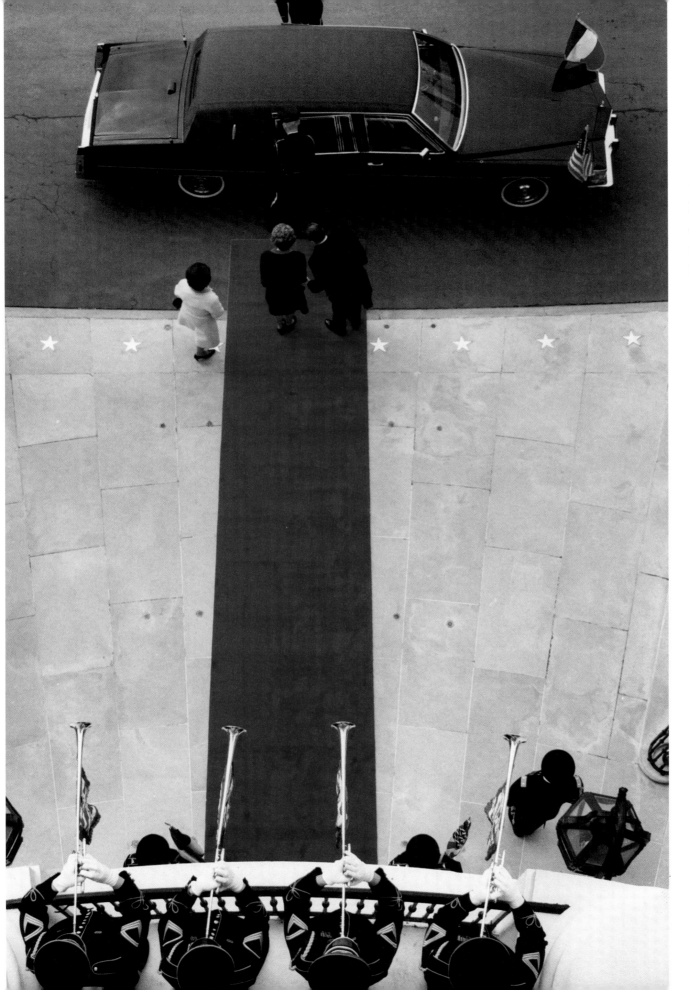

◄ The Reagans welcome
Francois Mitterand, president
of France. This picture was
taken from the Truman
Balcony.

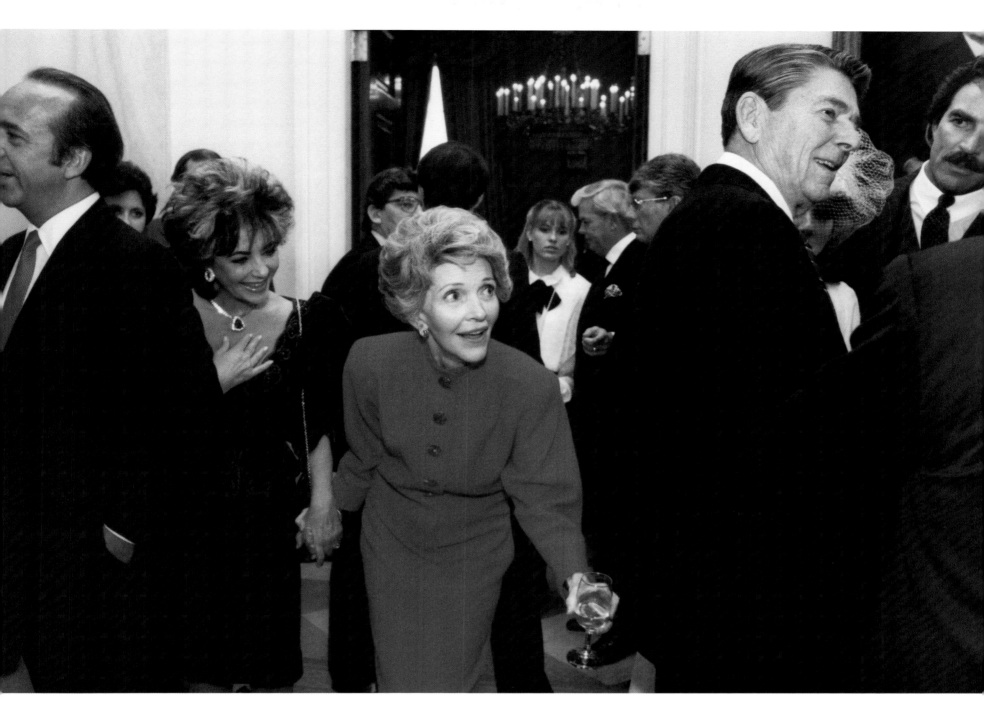

▲ With Elizabeth Taylor in tow, First Lady Nancy Reagan sneaks up behind the president and tugs on the back of his suit coat during a reception at the White House. Celebrities and friends, including actor Tom Selleck, far right, were in attendance for the reception that followed the private swearing-in ceremony for the president's second term. Mrs. Reagan's mischievous tug was just another example of the playfulness that was so much a part of their relationship.

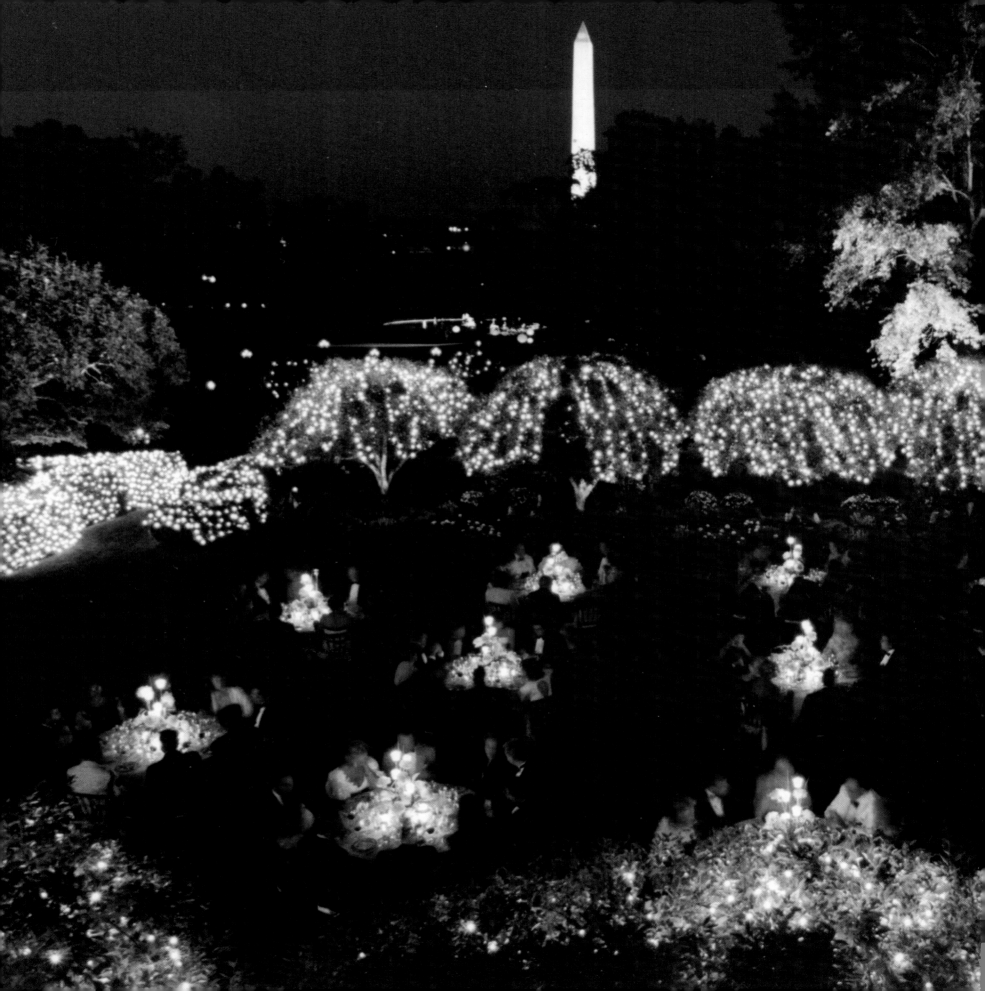

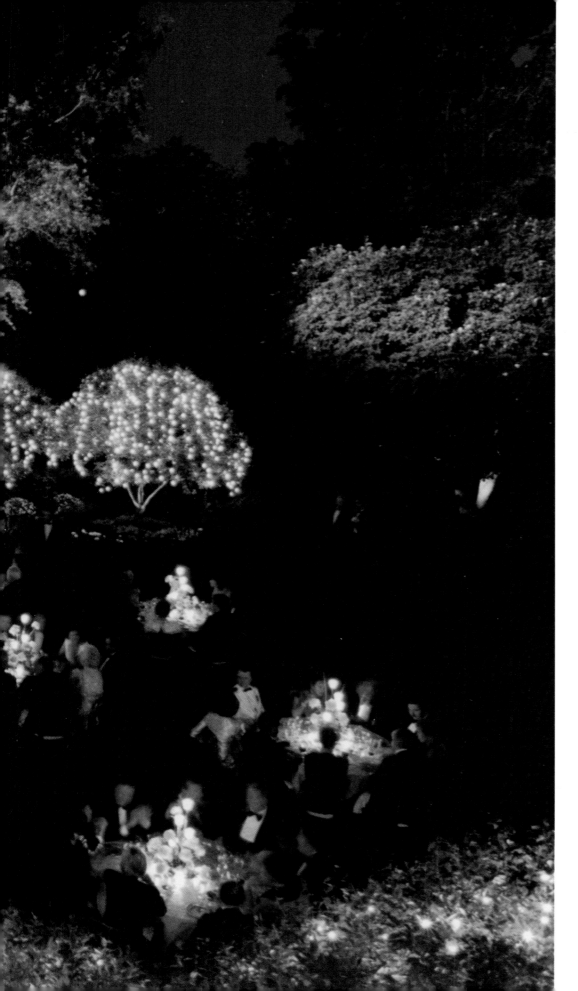

◄ A rare outdoor state dinner in the Rose Garden of the White House. The Washington Monument is in the background. I had to secure permission from the Secret Service to climb a staircase that allowed access to the roof of the West Wing colonnade. (I always let the Secret Service know when I was doing something out of the ordinary like this.) I set up my camera and tripod just as the sun was setting and watched the candles start to glow as it got darker and darker. This picture was taken about 20 minutes after sunset, when there was still a little blue left in the sky.

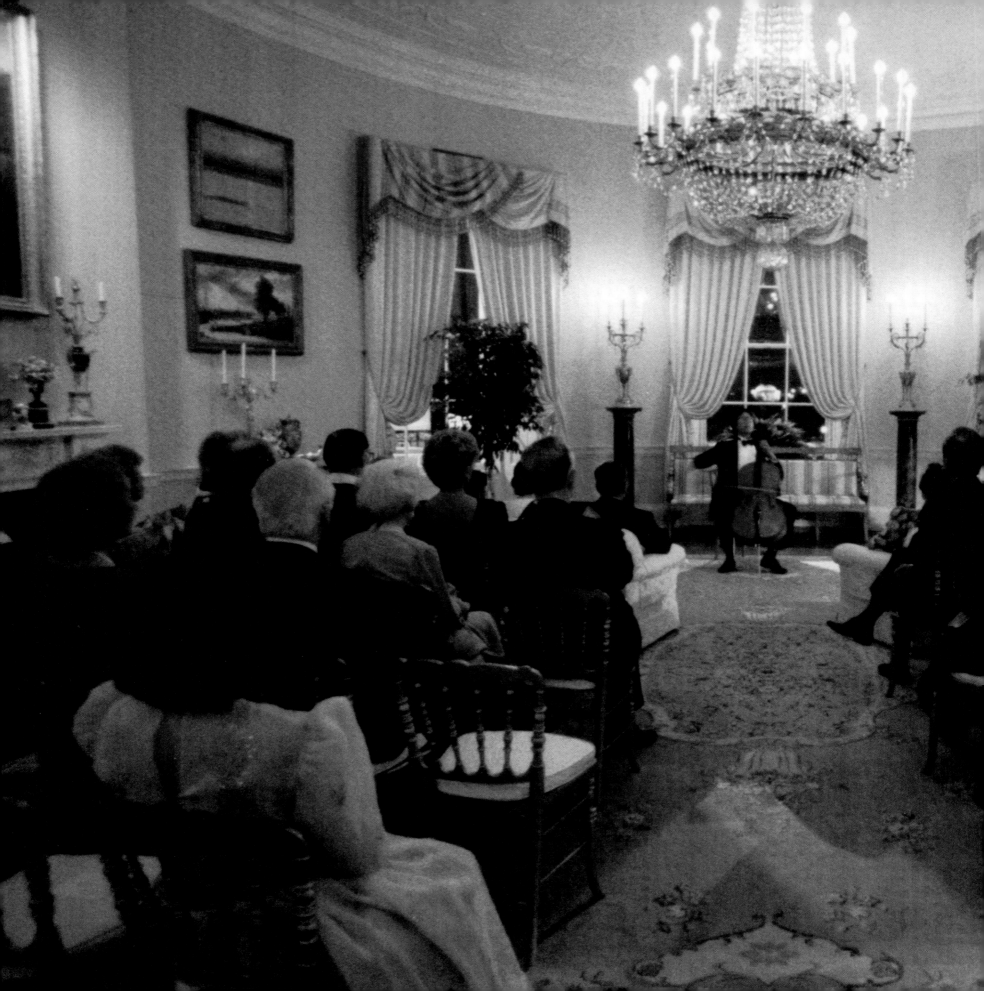

◂ In a very intimate setting, cellist Yo-Yo Ma provides the entertainment in the Yellow Oval Room following a formal dinner for the crown prince and princess of Japan. The Jefferson Memorial can be seen out the window in the background. Normally, a formal state dinner was held on the second floor—the state floor—of the White House. But Mrs. Reagan wanted a more special dinner for the crown prince and princess. Thus, they used the more intimate setting on the third floor, which was the Reagans' living quarters. The acoustics and setting for this occasion were amazing, though I must confess that I didn't have a clue who Yo-Yo Ma was at the time.

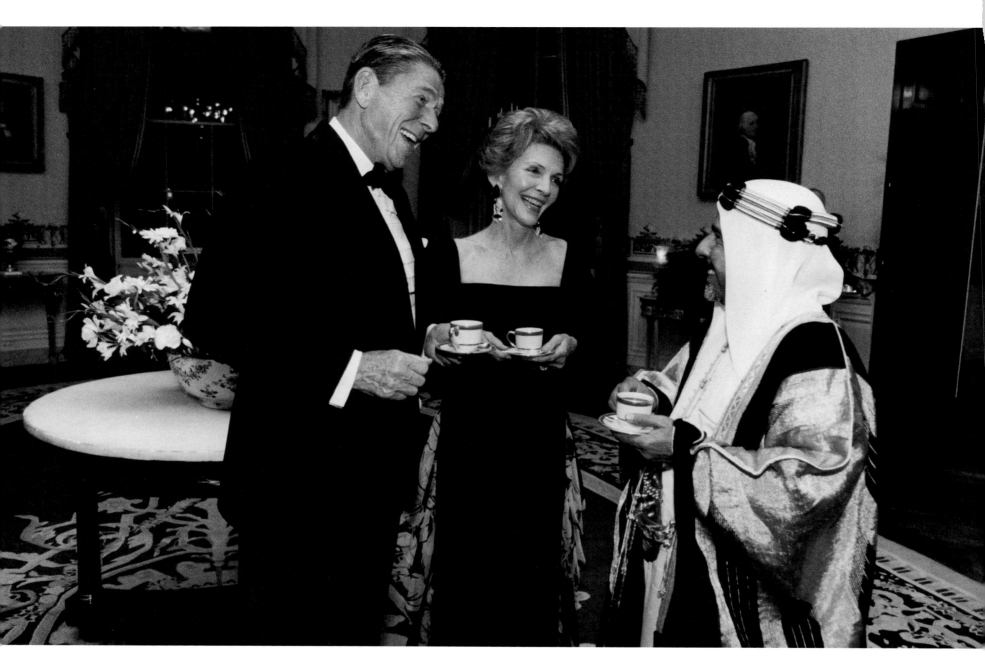

▲ The Reagans have after-dinner coffee with the Emir of Bahrain in the Blue Room as part of a formal state dinner.

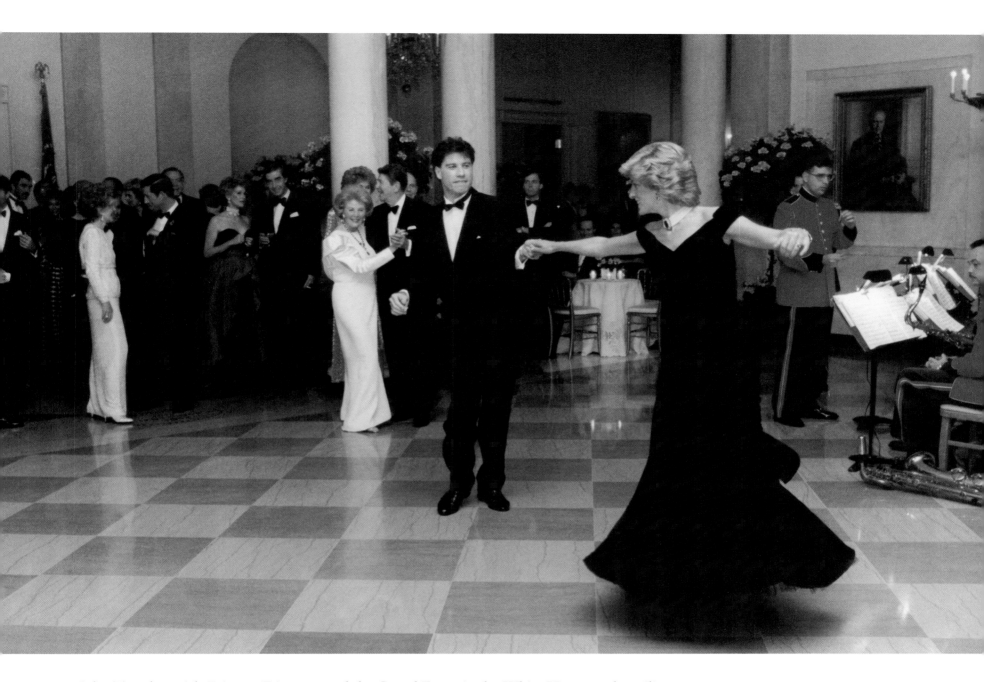

▲ John Travolta twirls Princess Diana around the Grand Foyer in the White House as the military band plays a medley of songs from his movie *Saturday Night Fever*. In the background, President Reagan half-dances with Lenora Annenberg, and Mrs. Reagan chats with Prince Charles. A London tabloid offered me the equivalent of a year's salary to give them pictures from this dance (which, of course, I couldn't do, nor would I have even considered it).

Somehow, a few weeks later, a black-and-white version of the picture did appear in one of the London tabloids along with a big story. The White House photo office checked our records, which showed that prints were sent only to the princess and John Travolta. Several years later, *Life* magazine published a special issue about the 1980s, and they received permission from the Reagans and from representatives of the prince and princess to print the photo officially for the first time.

◄ The president watches the evening news in the White House residence. The Reagans usually had cocktails upstairs in the residence of the White House with only the principal invitees of a state dinner. I had taken the elevator upstairs early and found the president alone, already dressed in his tuxedo, watching Dan Rather anchor the nightly news.

He often watched the news shows when he had a spare moment. On one of these occasions, he came over to me to complain about their coverage. "They always show a correspondent telling people what I said instead of showing me saying what I said."

Another time, upset at another news story, he told me he'd sometimes like to "bash Congress over the head."

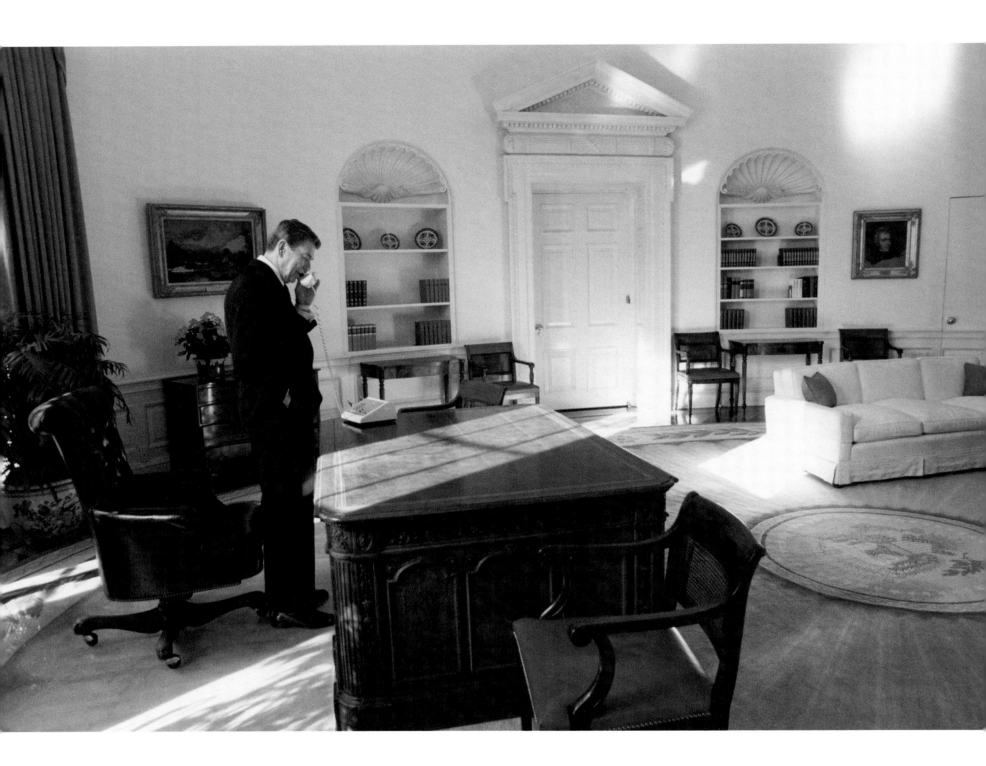

THE FINAL DAY

◄ Ronald Reagan makes his last phone call as president from the Oval Office on the morning of January 20, 1989—his last day in office. The nation's 40th president of the United States was standing behind his historic desk, now cleared of his personal mementos. He was calling the daughter of a former aide who was in the hospital with cancer. A few minutes later, he opened the top drawer of the desk to make sure the handwritten note he had left inside for President-elect Bush was still there. It was. Printed at the top of the stationery were the words, "Don't let the turkeys get you down," and the president had written:

> *Dear George,*
> *You'll have moments when you want to use this particular stationery. Well,*
> *go for it. George, I treasure the memories we share and wish you all the*
> *very best. You'll be in my prayers. God bless you and Barbara. I'll miss our*
> *Thursday lunches.*
>
> *Ron*

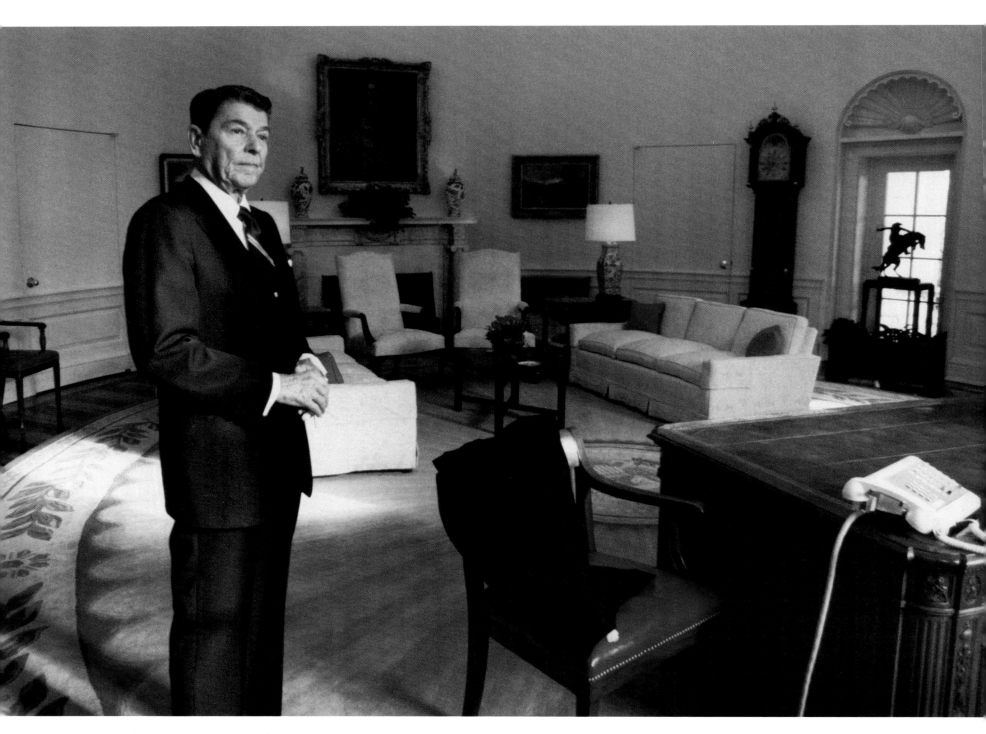

▲ President Reagan takes a silent last look around the Oval Office before aides come streaming in. National Security Advisor Colin Powell later gave him his final national security briefing: "The world is quiet today, Mr. President."

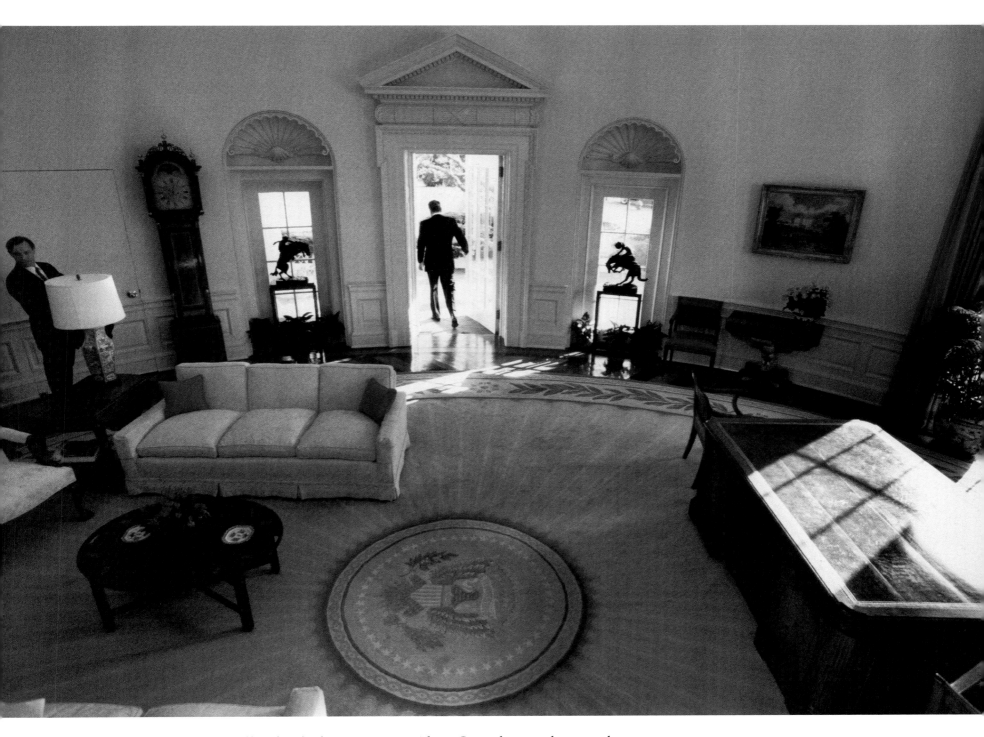

▲ Reagan leaves the Oval Office for the last time as president. Several press photographers were allowed in to capture this moment. Reagan, who had been standing behind the desk when the photographers came into the room, then made his way to the door leading outside to the white-pillared colonnade. He paused as he grasped the doorknob, turned around, and took one last look. His "temporary custody" of the Oval Office had come to an end. (To get something different for this historic moment, I had stashed a 12-foot ladder in the president's private study and set it up in the Oval when he was ready to leave.)

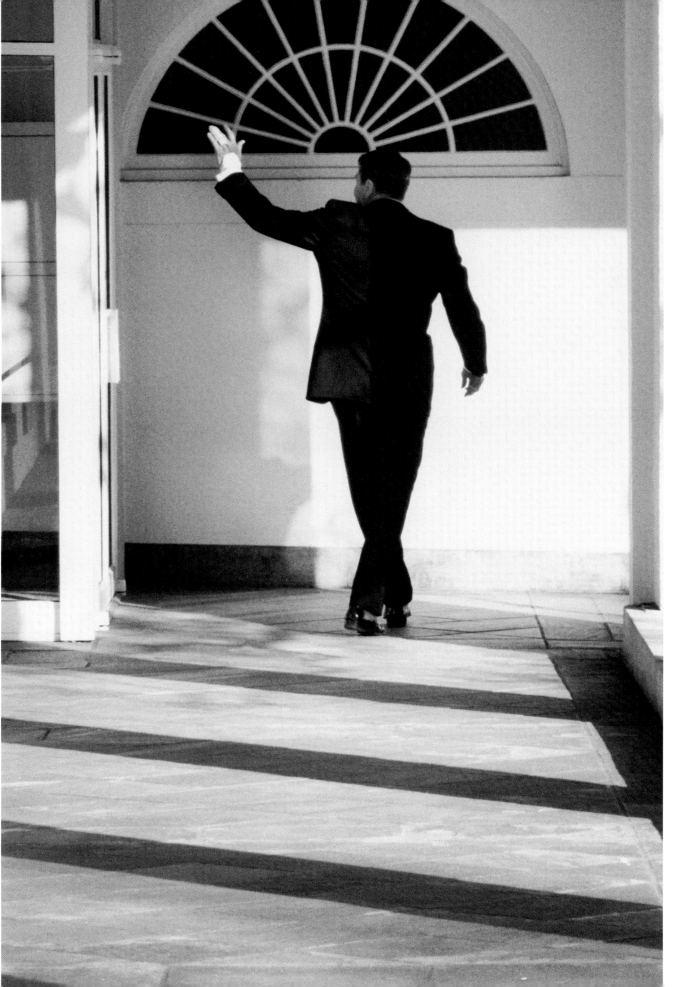

◂ On the colonnade, the president waves to press office aides en route to the White House residence. Edmund Morris used this photo on the cover of his book, *Dutch*, his memoir of Ronald Reagan.

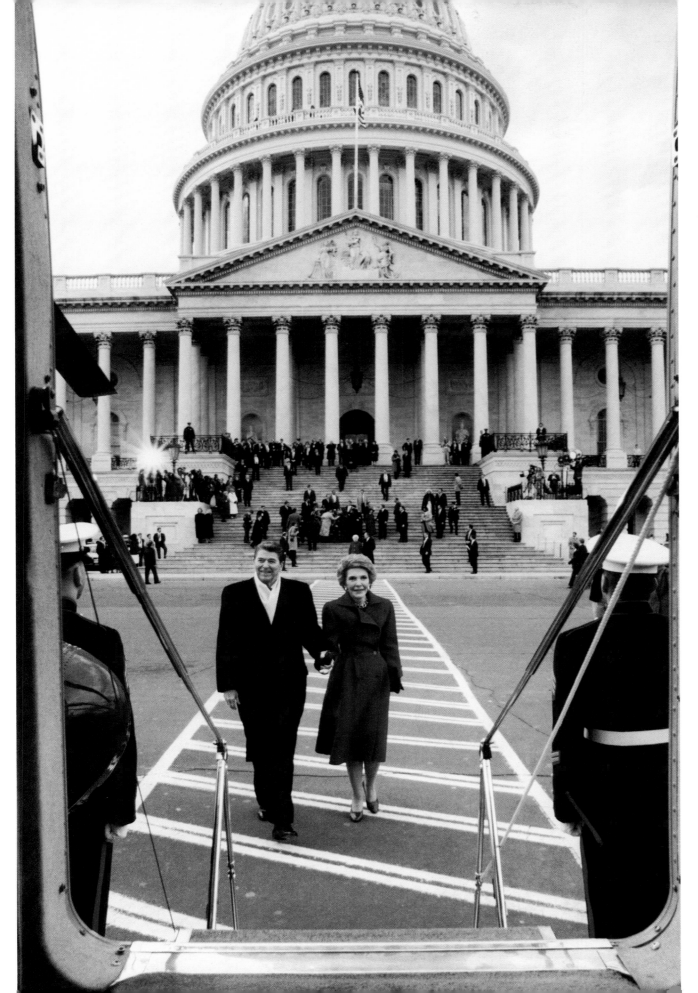

◀ The Reagans board *Nighthawk One* following the inauguration of George Bush as 41st president of the United States. (You can see the Bushes just above Mrs. Reagan's head.) I had been hoping to get a better picture than this when the Reagans were closer to the staircase of the helicopter. But just after this picture was taken, Mrs. Reagan spotted a Secret Service agent who had worked on her detail and she veered to her left to give him a hug. This was the same helicopter as *Marine One*, but because Reagan was no longer president, it was now called *Nighthawk One*.

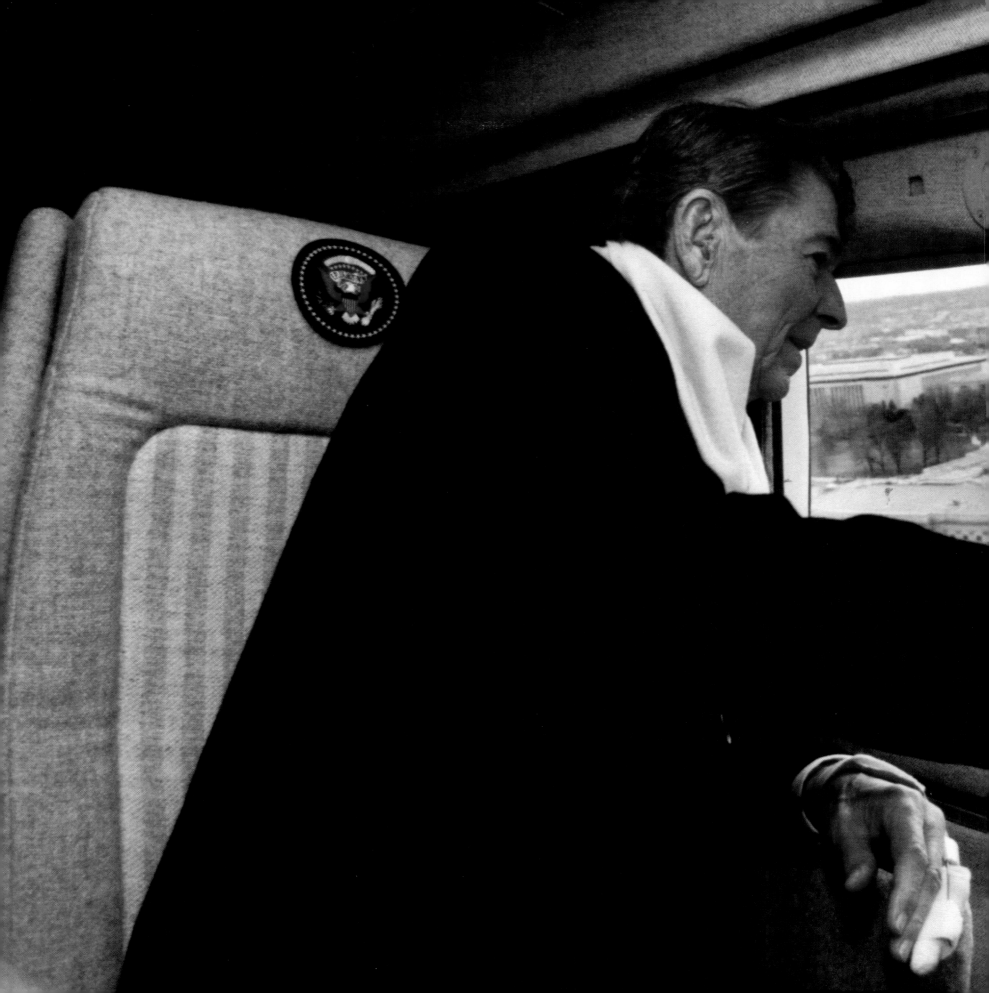

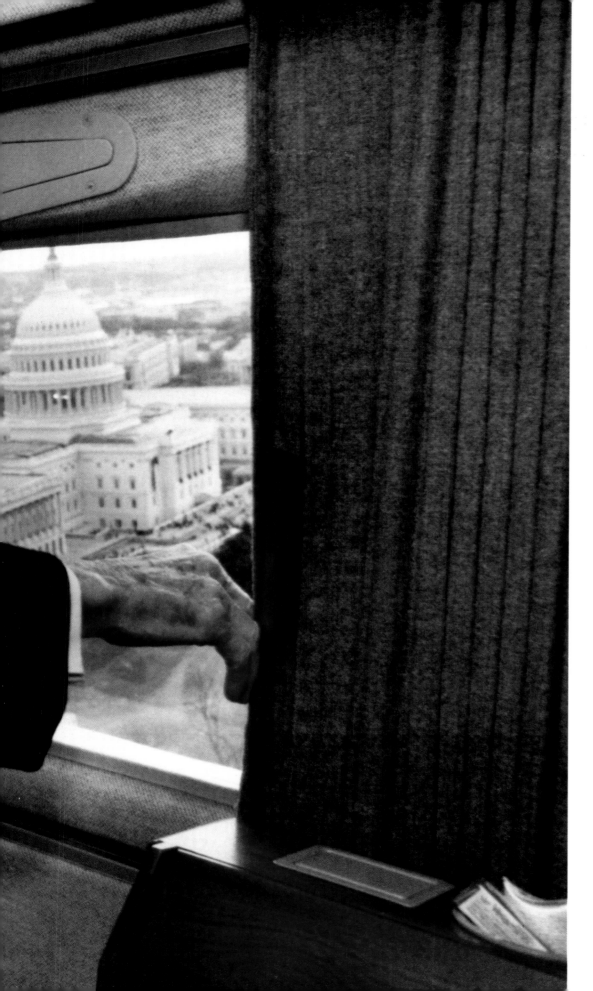

◄ En route to Andrews Air Force Base, Reagan takes a last look at the U.S. Capitol from the helicopter. The pilot then flew above Pennsylvania Avenue toward the White House. Both the Reagans were quiet as they gazed out the window. As the helicopter flew over what had been their home for the past eight years, the now-former president said to the now-former first lady, "Honey, there's our little bungalow down there."

Ronald Wilson Reagan
1911–2004

AMERICANS SAY THEIR FINAL GOODBYE TO RONALD REAGAN

The outpouring of love and affection Americans showed for Ronald Reagan at his death demonstrated again the unique ability this remarkable man had to connect with ordinary citizens from all walks of life. From California, where people waited patiently for up to twelve hours to file respectfully past the bier, to Washington, where thousands lined the streets to watch the somber procession with the horse-drawn caisson go by, Americans, and indeed, many from around the world were united in paying tribute to the man who many believe will be regarded by future historians as one of the greatest leaders of the twentieth century.

What someone said of Dr. Johnson, the 18th century man of letters, might also be said of Ronald Reagan: "[his death] has made a chasm, which … nothing can fill up."

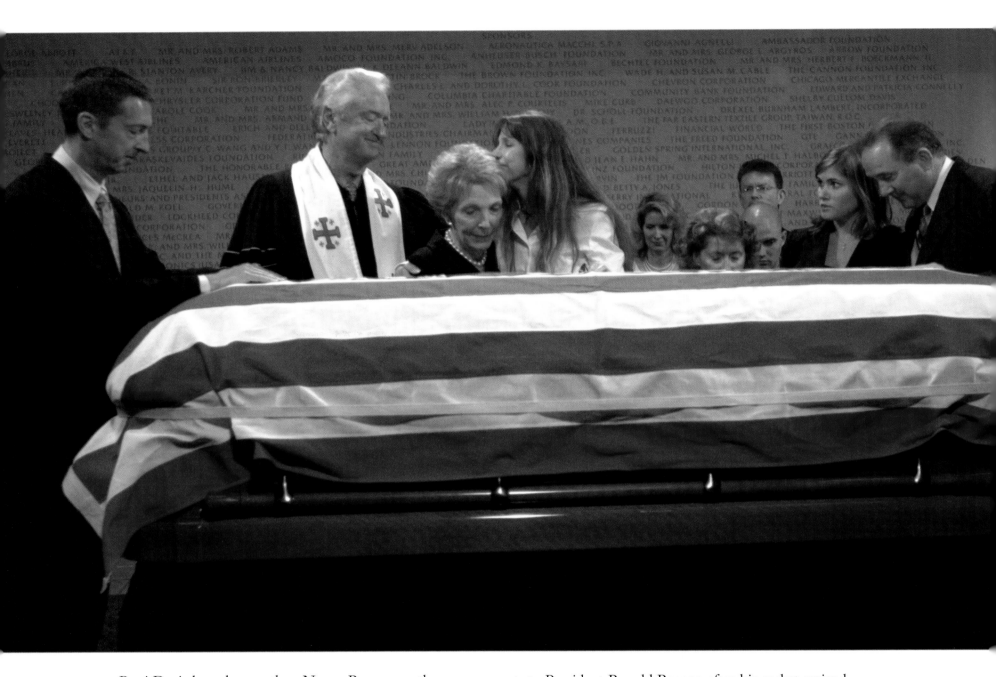

▲ Patti Davis hugs her mother, Nancy Reagan, as they pay respects to President Ronald Reagan after his casket arrived June 7, 2004 at the Ronald Reagan Presidential Library in Simi Valley, California. At far left is Reagan's son, Ronald Prescott Reagan; at far right is Michael Reagan, and next to him is his daughter, Ashley. Rev. Michael Wenning is next to Nancy Reagan. *Photo courtesy of Pete Souza/©2004 Ronald Reagan Presidential Foundation*

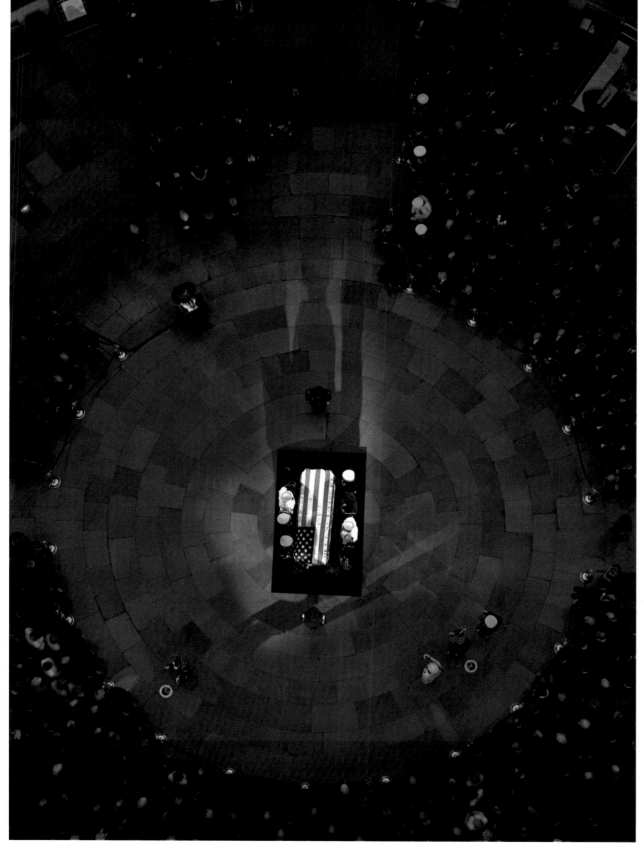

◂ The casket of former President Reagan lies in state in the rotunda of the United States Capitol in Washington, D.C. on June 9, 2004. *(Photo courtesy of Chuck Kennedy)*

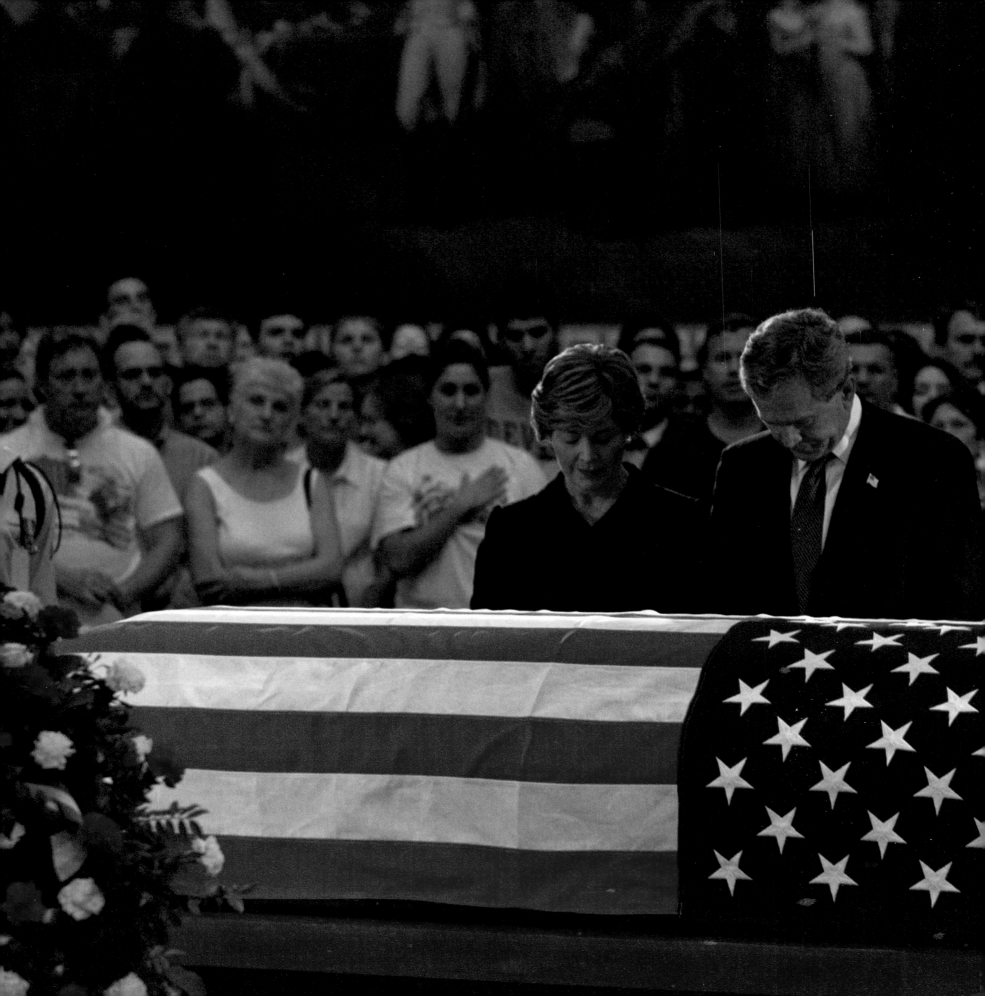